The WEDDING ALBUM

ALICE HARRIS

Text by
SARA BLISS

Photography Editor
SARINA N. FINKELSTEIN

Design by
YUKO UCHIKAWA

powerHouse Books
Brooklyn, New York

For my son, Ben: You have taught me what courage and strength really mean. You are a blessing to me and I am so proud of the man you have become.

For my daughter-in-law, Jessie: You are an extraordinary woman. A gift to me that I am grateful for. I am thrilled for our future and I love you both so very much!

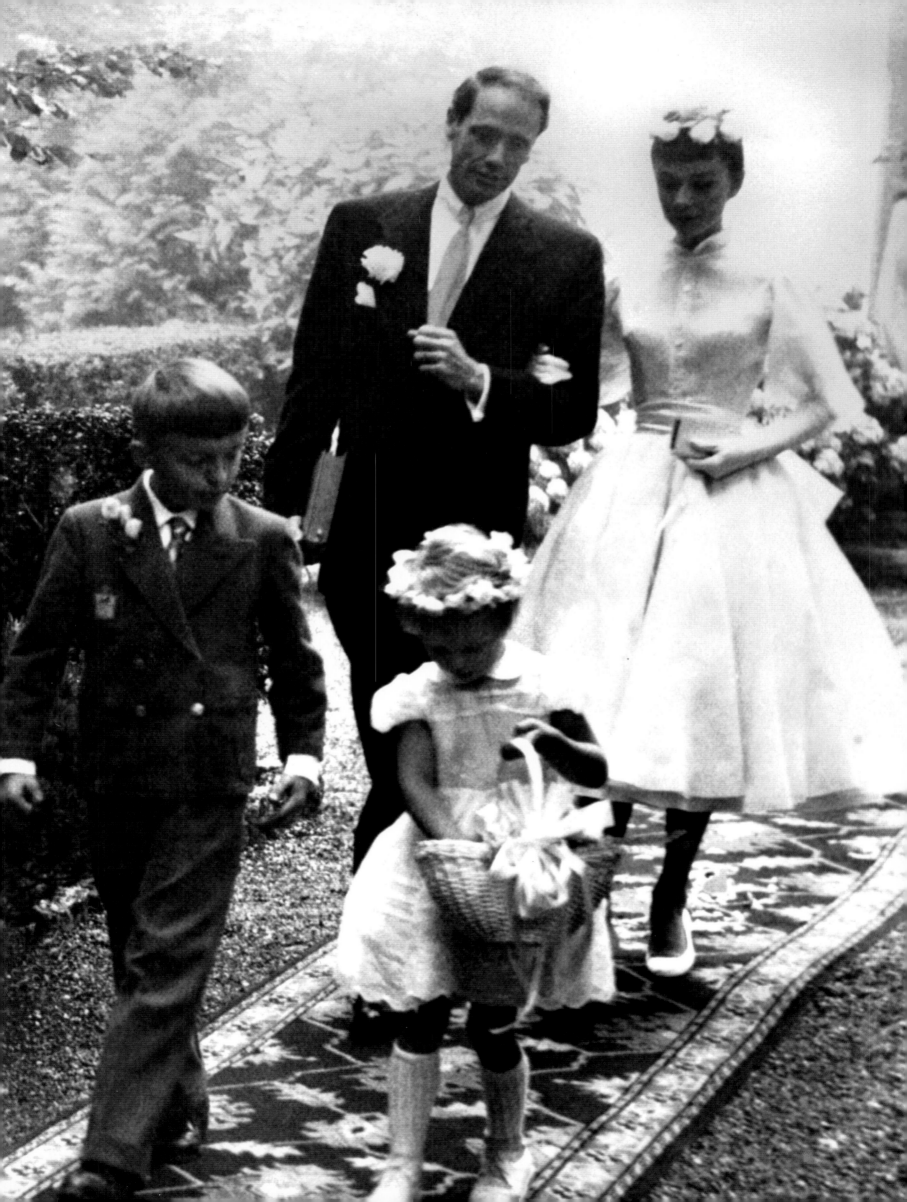

Everybody loves a wedding. We take months to plan a few magical hours so that our wedding day is the most beautiful and joyful it can possibly be. From Bombay to Borneo, weddings are a reason to look our most glamorous, serve the most divine food, dust off the best champagne, and kick up our heels. For centuries weddings have been a rite of passage, an international tradition that has endured despite wars, poverty, or trends. No matter who we are, despite our differences, we're united in our belief in love, family, and marriage.

How we join together as husband and wife is what distinguishes weddings around the world. Our culture, our religion, our age, our financial status, our family, our beliefs all determine how we say "I do." All these factors go into choosing the many details that give each wedding its own spirit. But no matter how many weddings we go to, whether they take place in a temple, church, or at city hall, it's each bride and groom forming their own unique partnership that is the soul of every service.

This book is filled with an amazing array of wedding photographs that beautifully capture the individuality of weddings all over the globe. Some of the pictures are outrageous, some hopeful, some breathtaking, some simply romantic—these images are relevant and intriguing because they showcase the range of emotions that weddings bring out in us—optimism, longing, excitement, naiveté, daring, pride, joy, and of course, love.

Audrey Hepburn and Mel Ferrer leave the chapel after their wedding at Burgenstock Mountain, overlooking Lake Lucerne, Switzerland.

There is no more lovely,
friendly, and charming
relationship, communion
or company than a
good marriage.

–Martin Luther

Sharing wedding vows and rings on March 20, 2004 in Atlanta, Georgia.

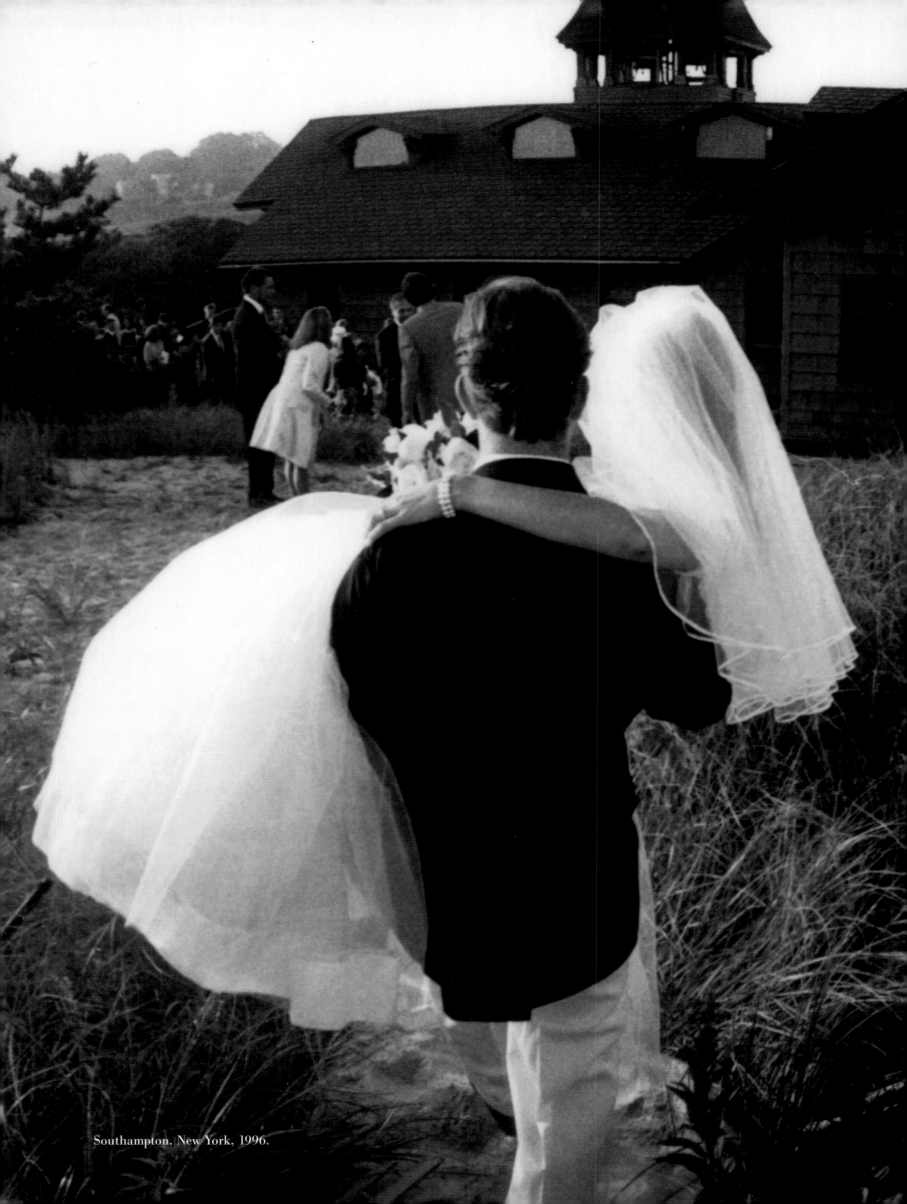

Southampton, New York, 1996.

Do you take…

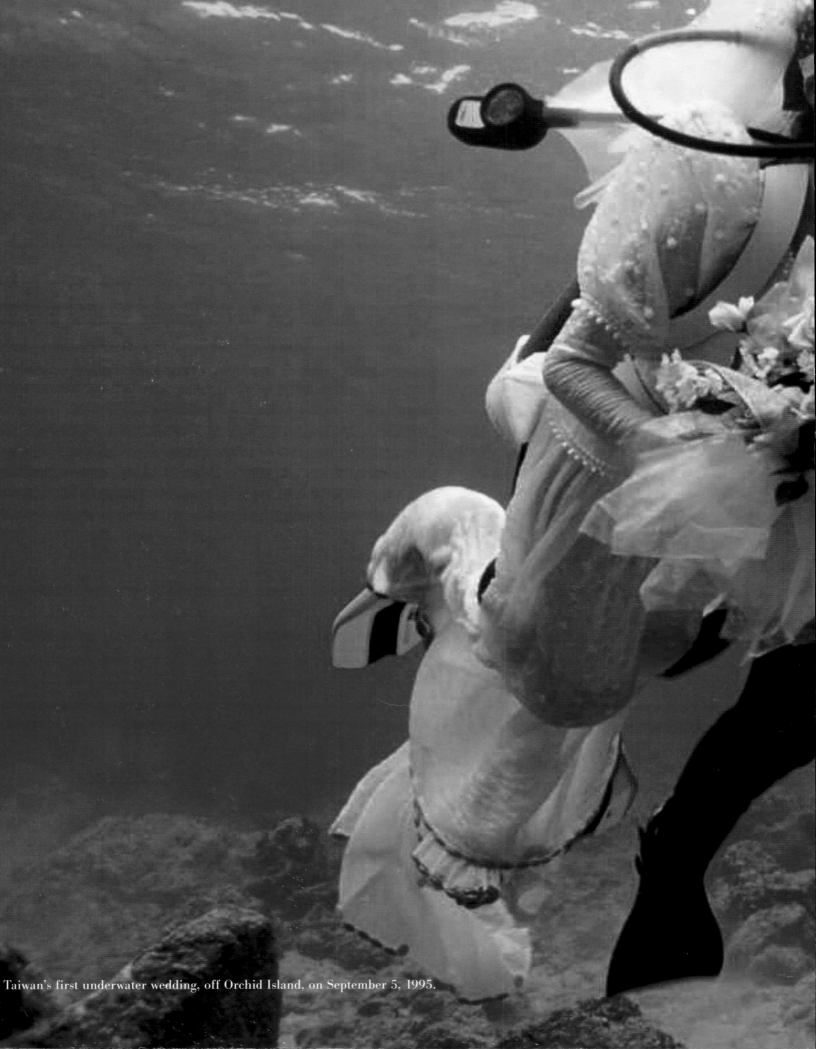

this woman...

Taiwan's first underwater wedding, off Orchid Island, on September 5, 1995.

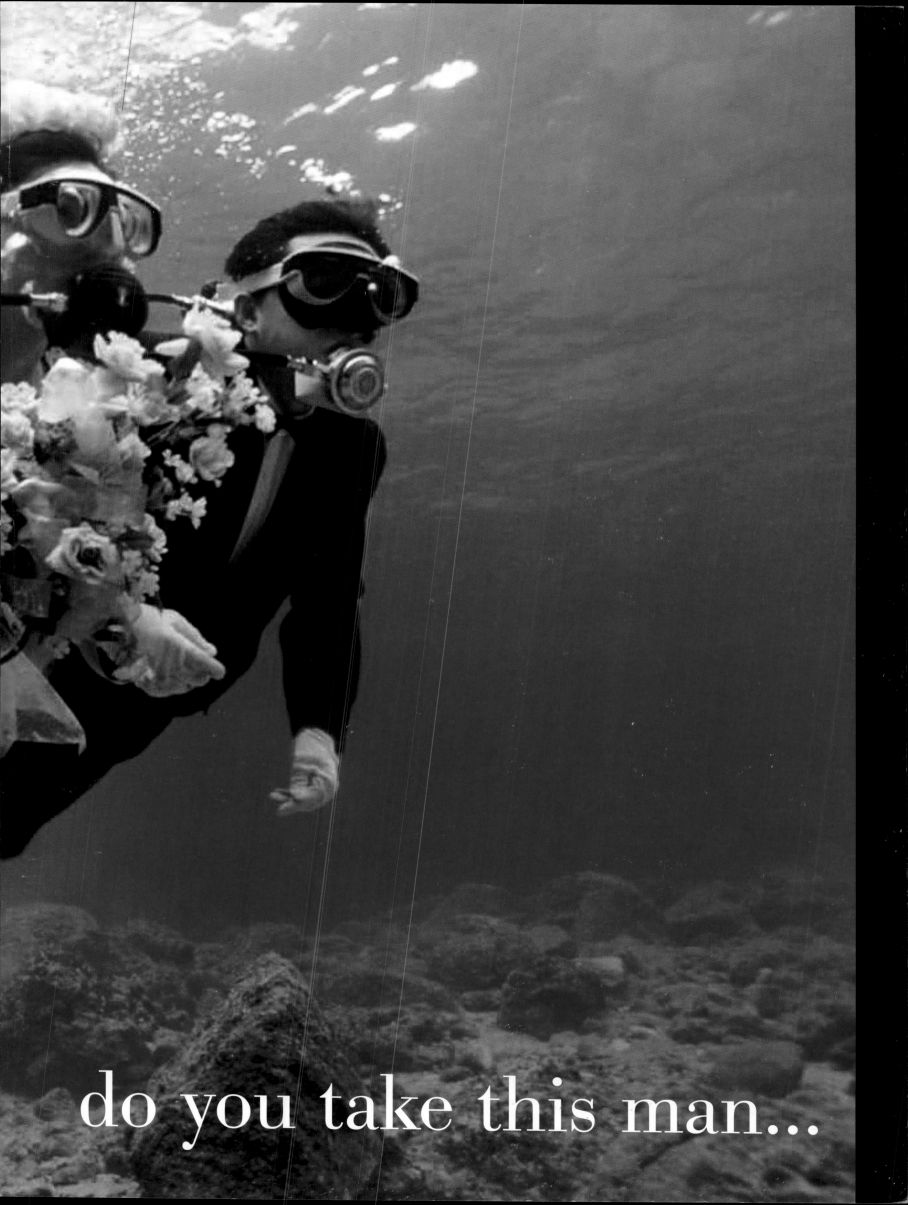

do you take this man...

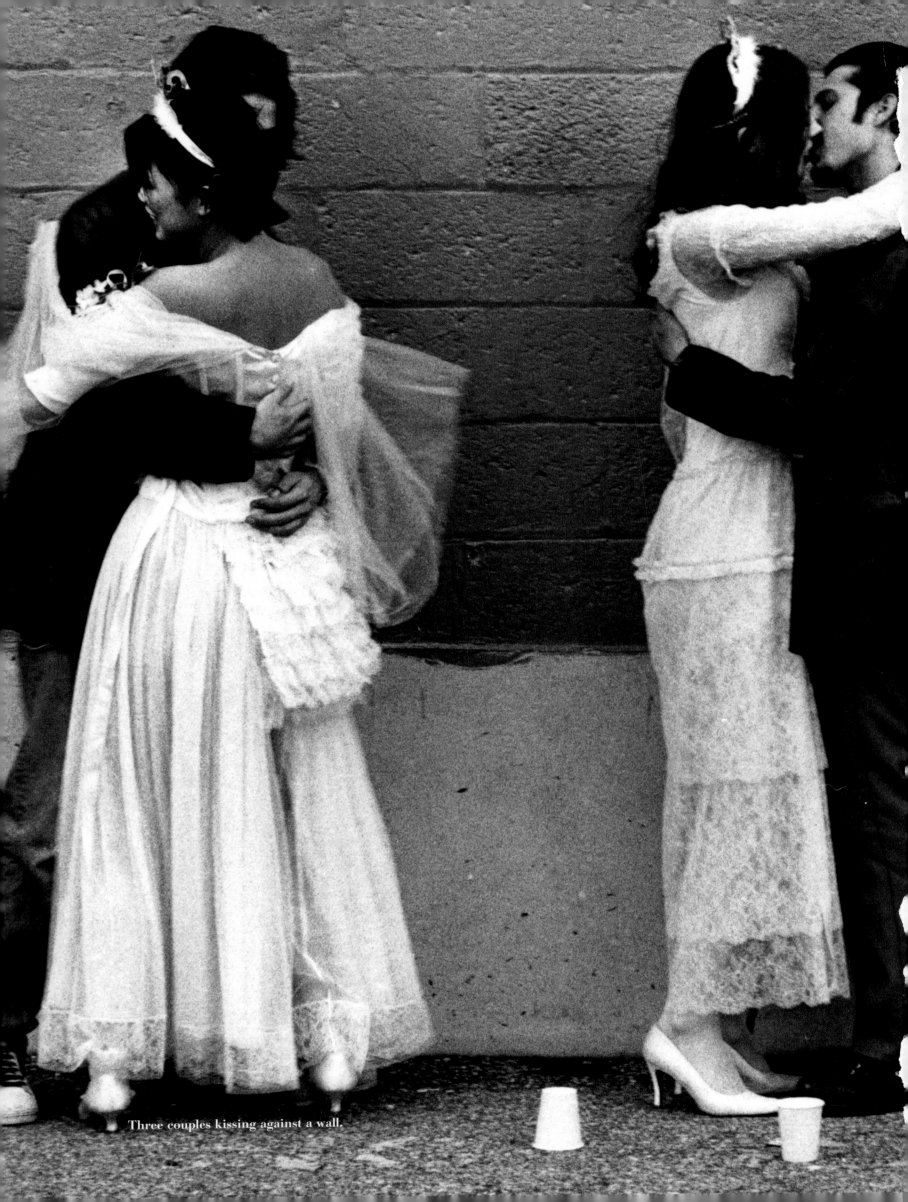

Three couples kissing against a wall.

to have and to hold...

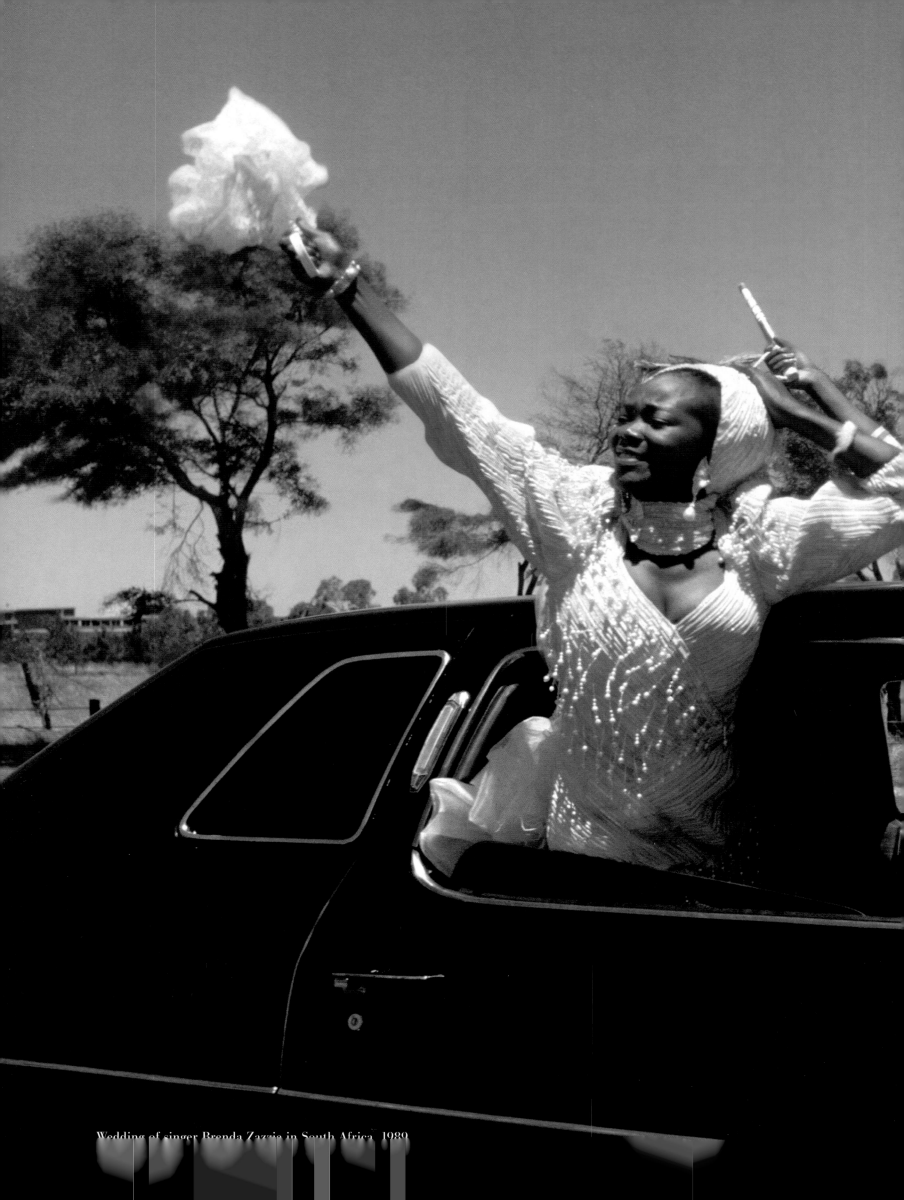

Wedding of singer Brenda Zazzie in South Africa, 1989

from this day forward...

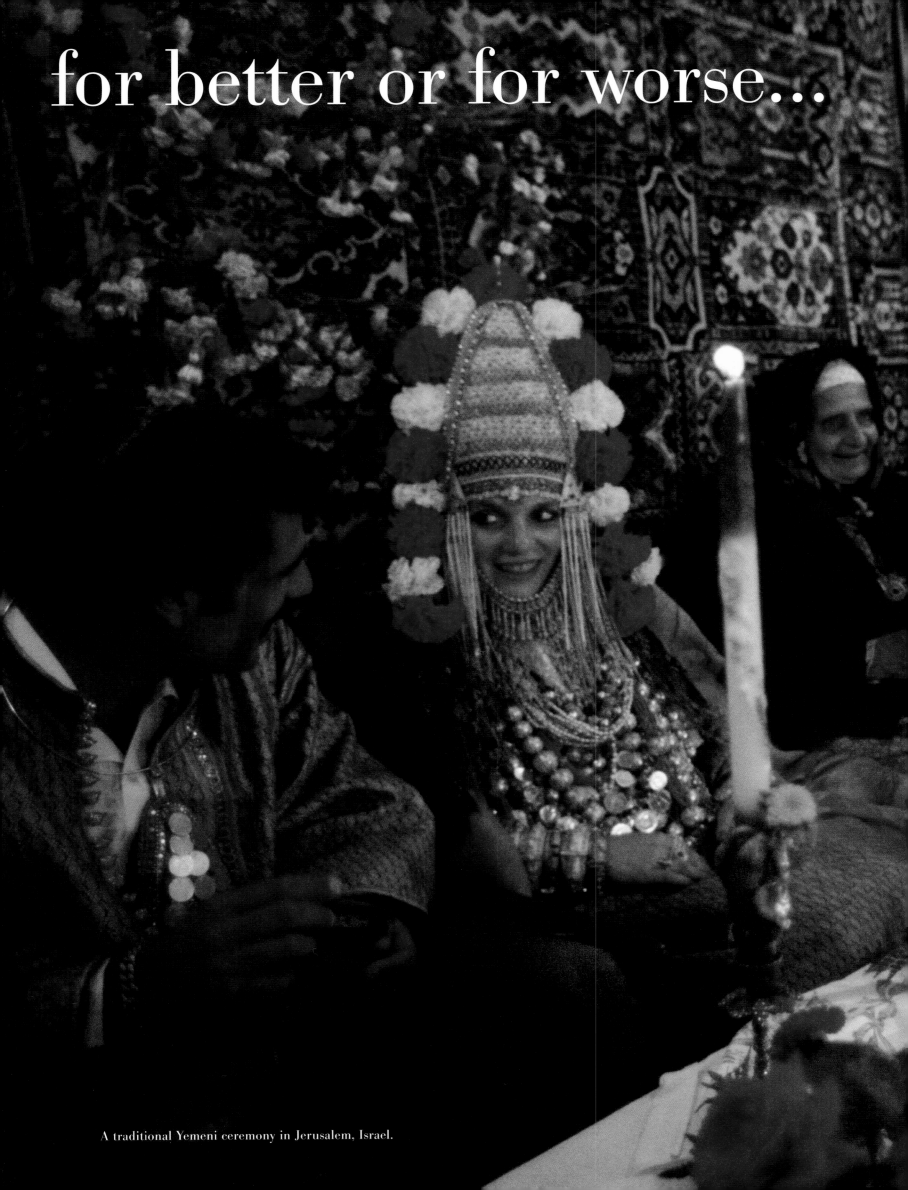

for better or for worse...

A traditional Yemeni ceremony in Jerusalem, Israel.

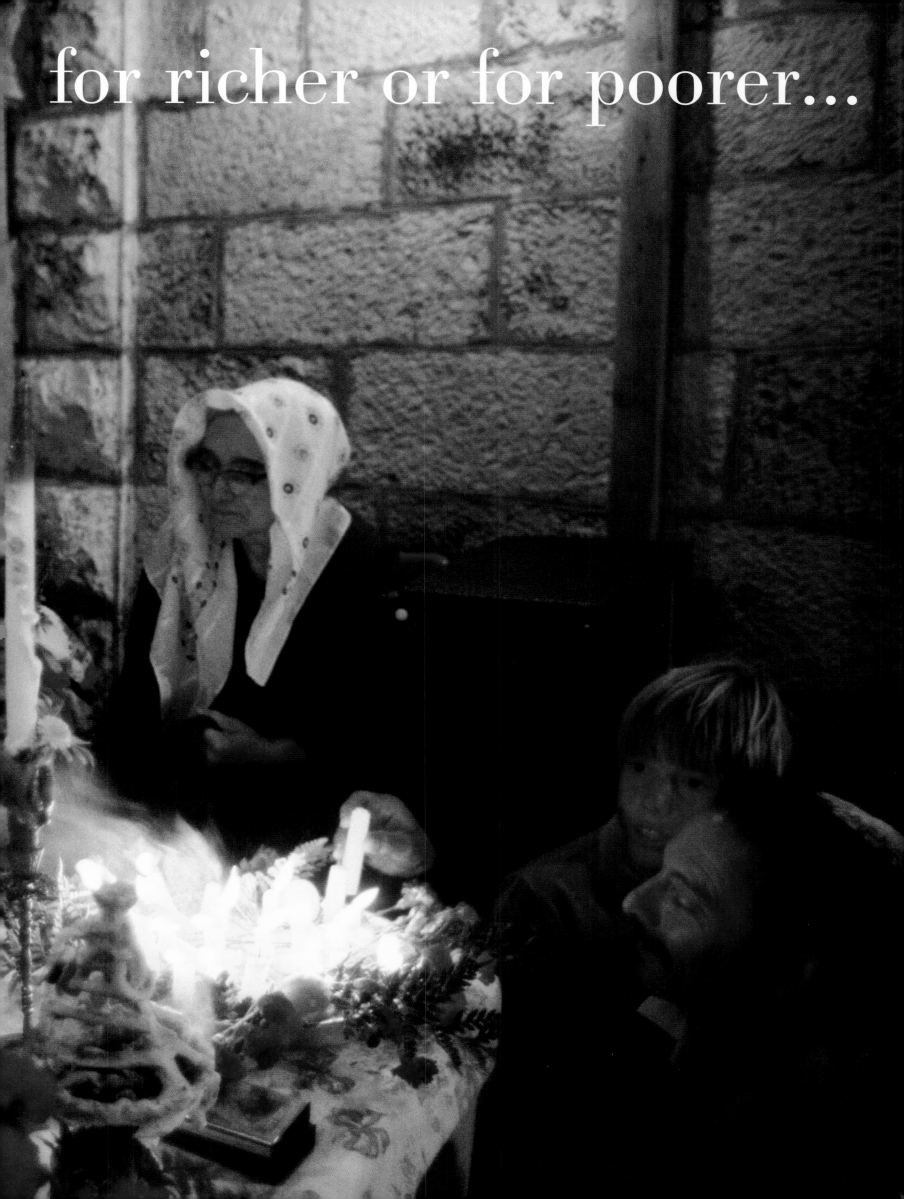

for richer or for poorer...

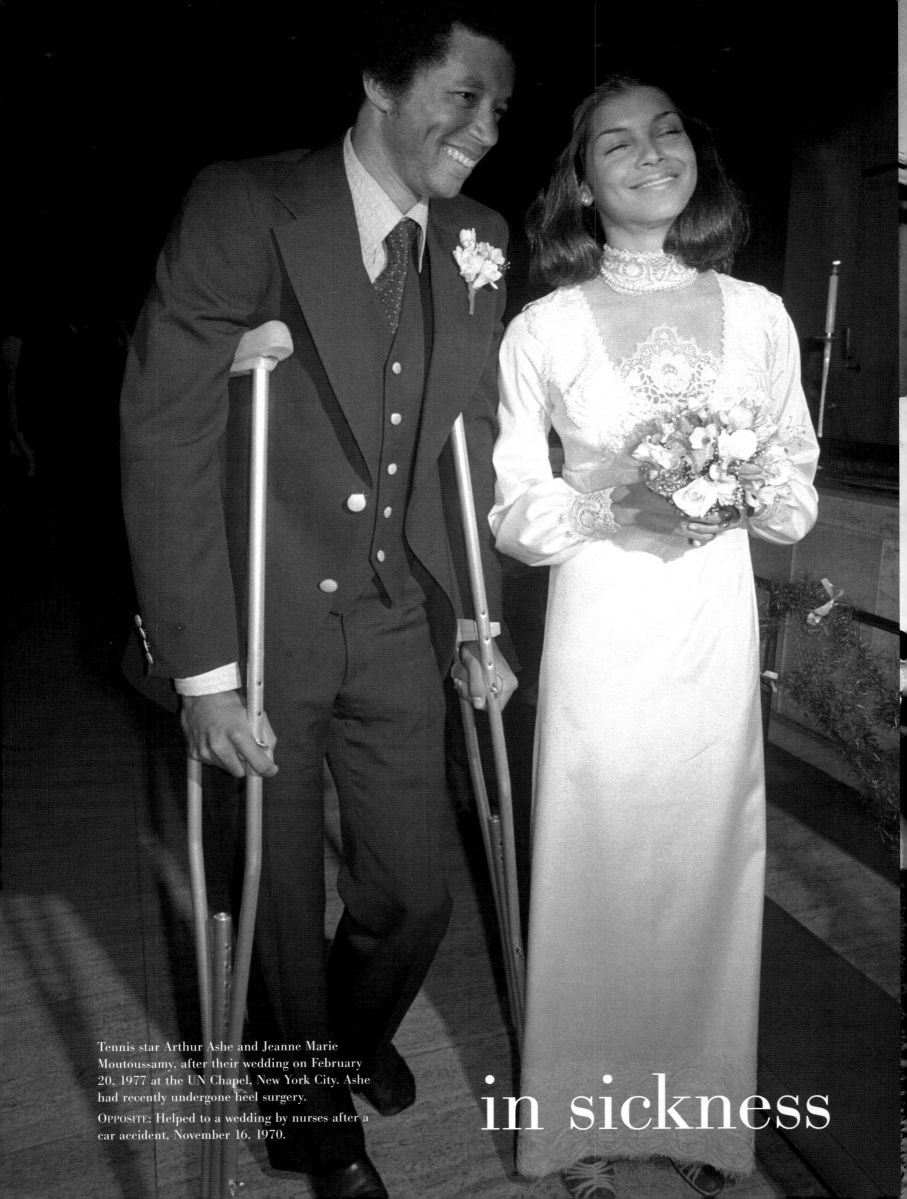

Tennis star Arthur Ashe and Jeanne Marie Moutoussamy, after their wedding on February 20, 1977 at the UN Chapel, New York City. Ashe had recently undergone heel surgery.

OPPOSITE: Helped to a wedding by nurses after a car accident, November 16, 1970.

in sickness

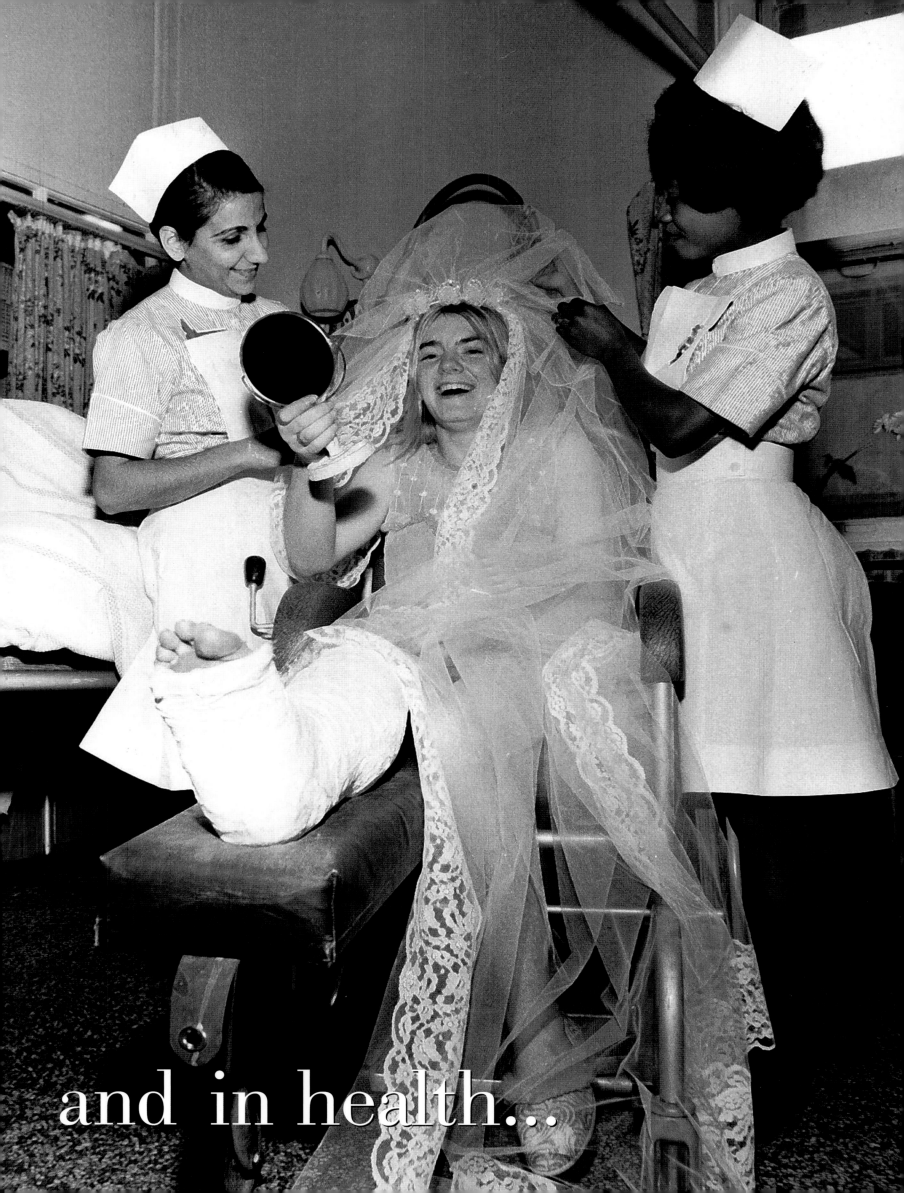

and in health...

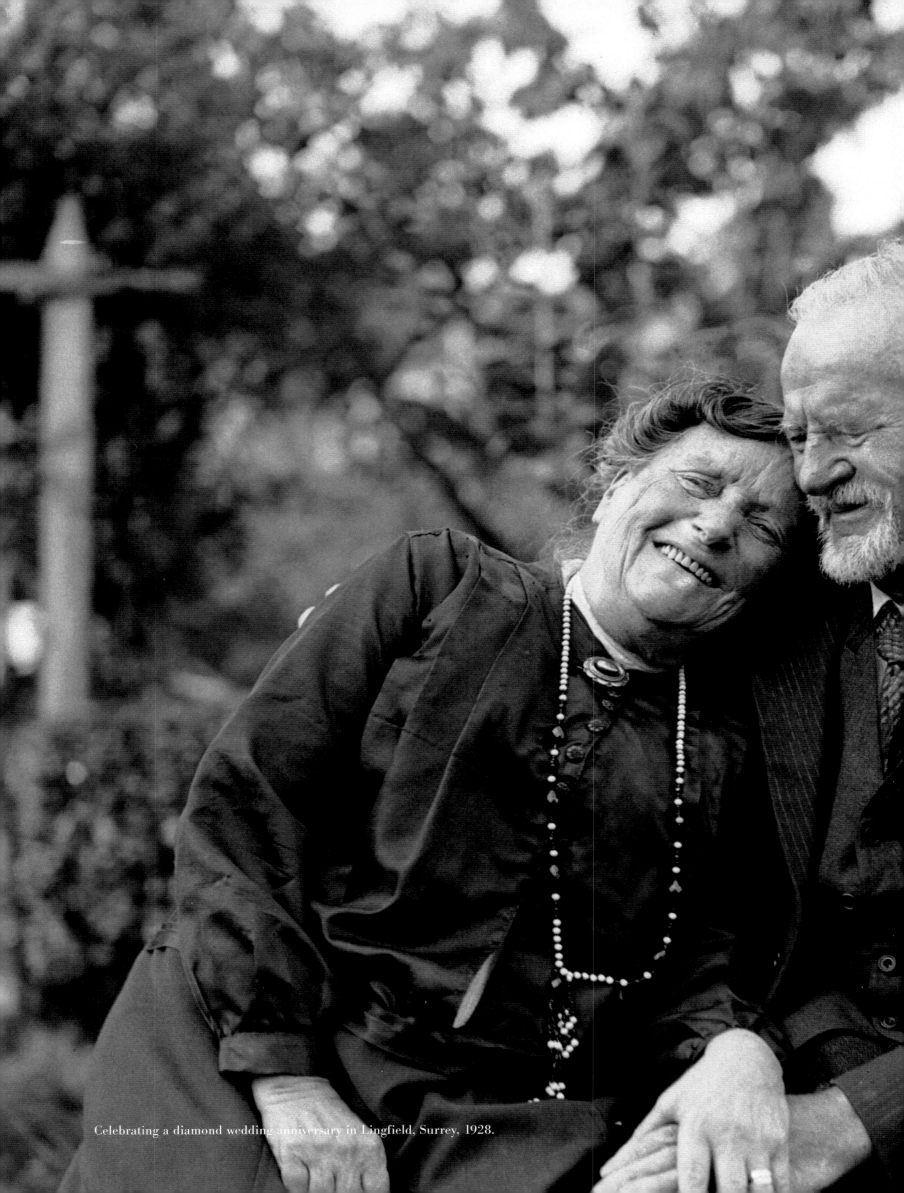

Celebrating a diamond wedding anniversary in Lingfield, Surrey, 1928.

to love and to cherish...

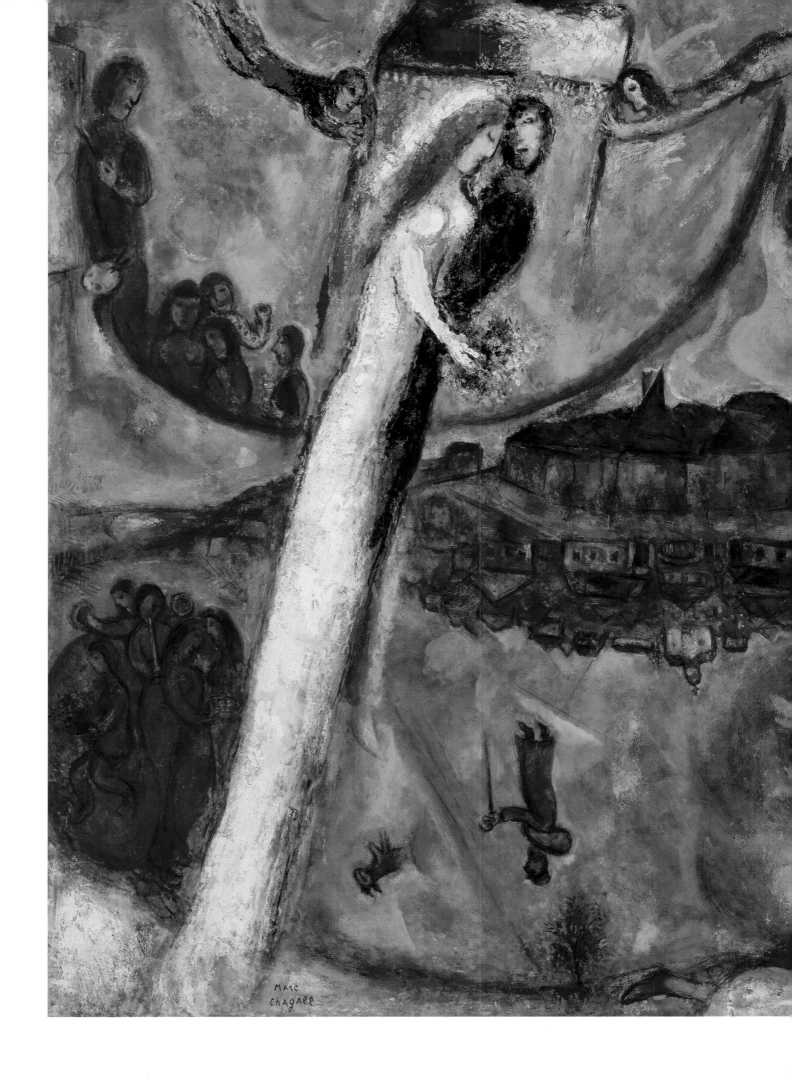

Chagall, Marc (1887-1985). The Song of Songs III. 1949. Oil on paper, laid down on canvas.

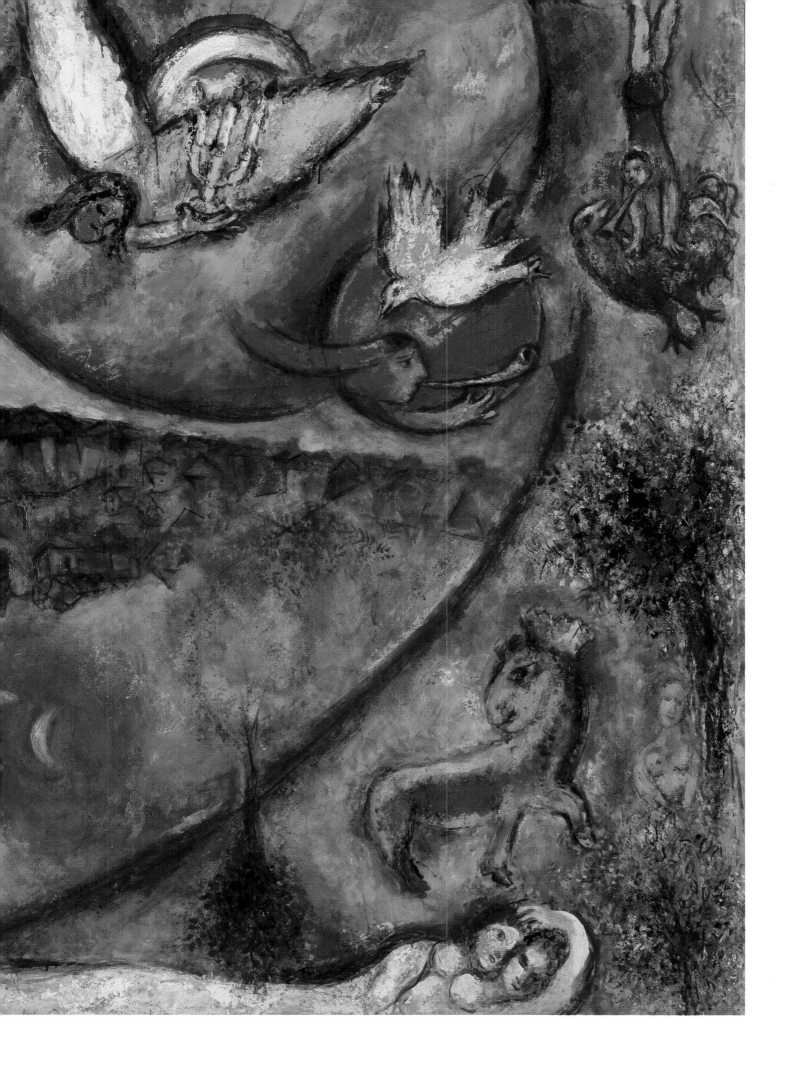

until death do you part...

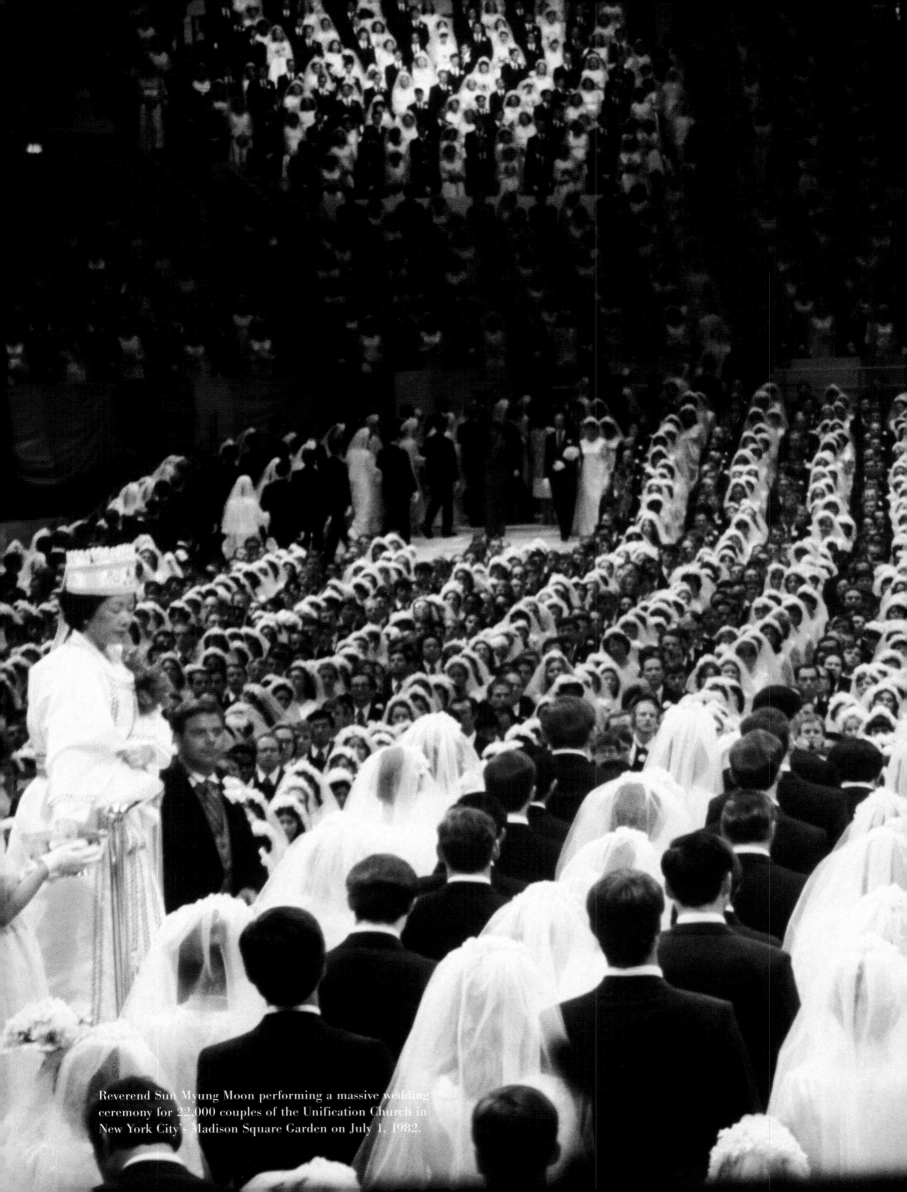

Reverend Sun Myung Moon performing a massive wedding ceremony for 22,000 couples of the Unification Church in New York City's Madison Square Garden on July 1, 1982.

I do.

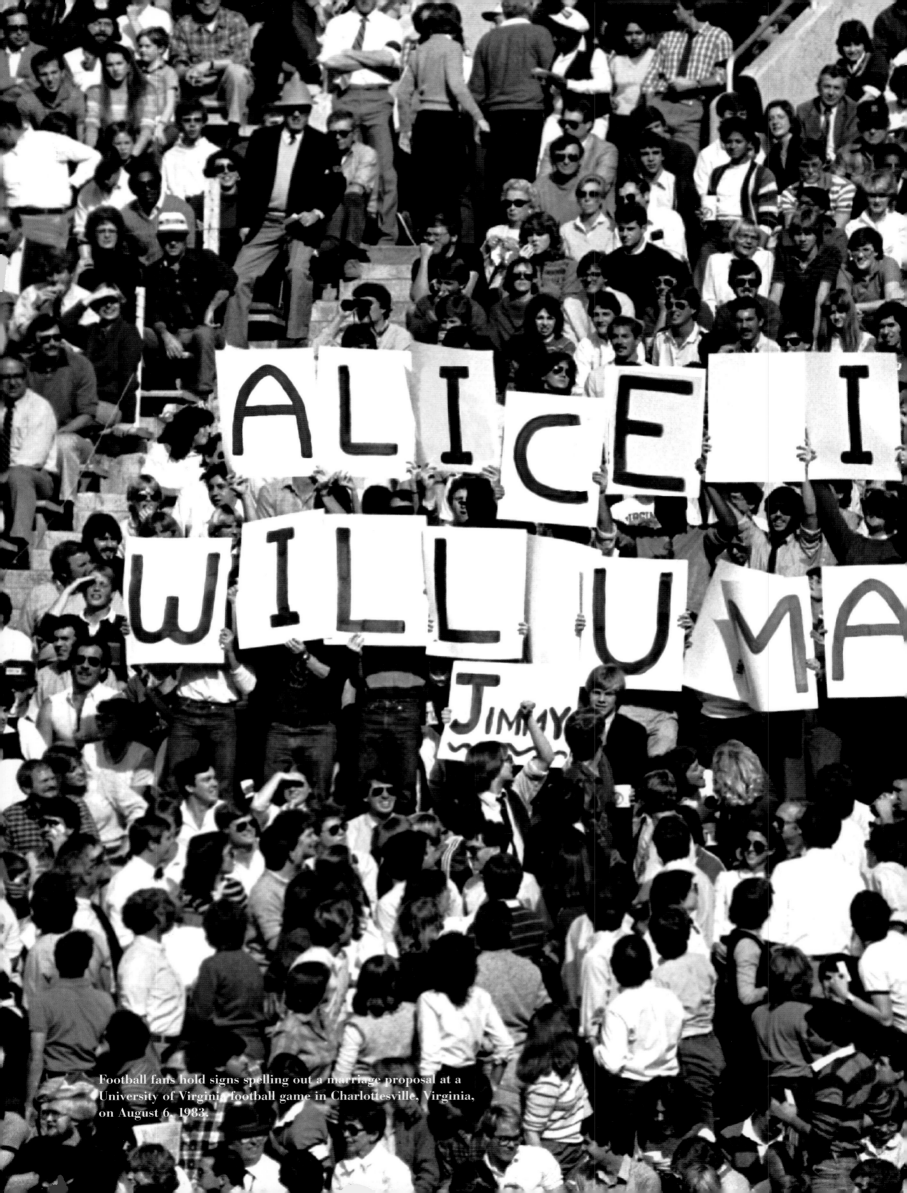

Football fans hold signs spelling out a marriage proposal at a University of Virginia football game in Charlottesville, Virginia, on August 6, 1983.

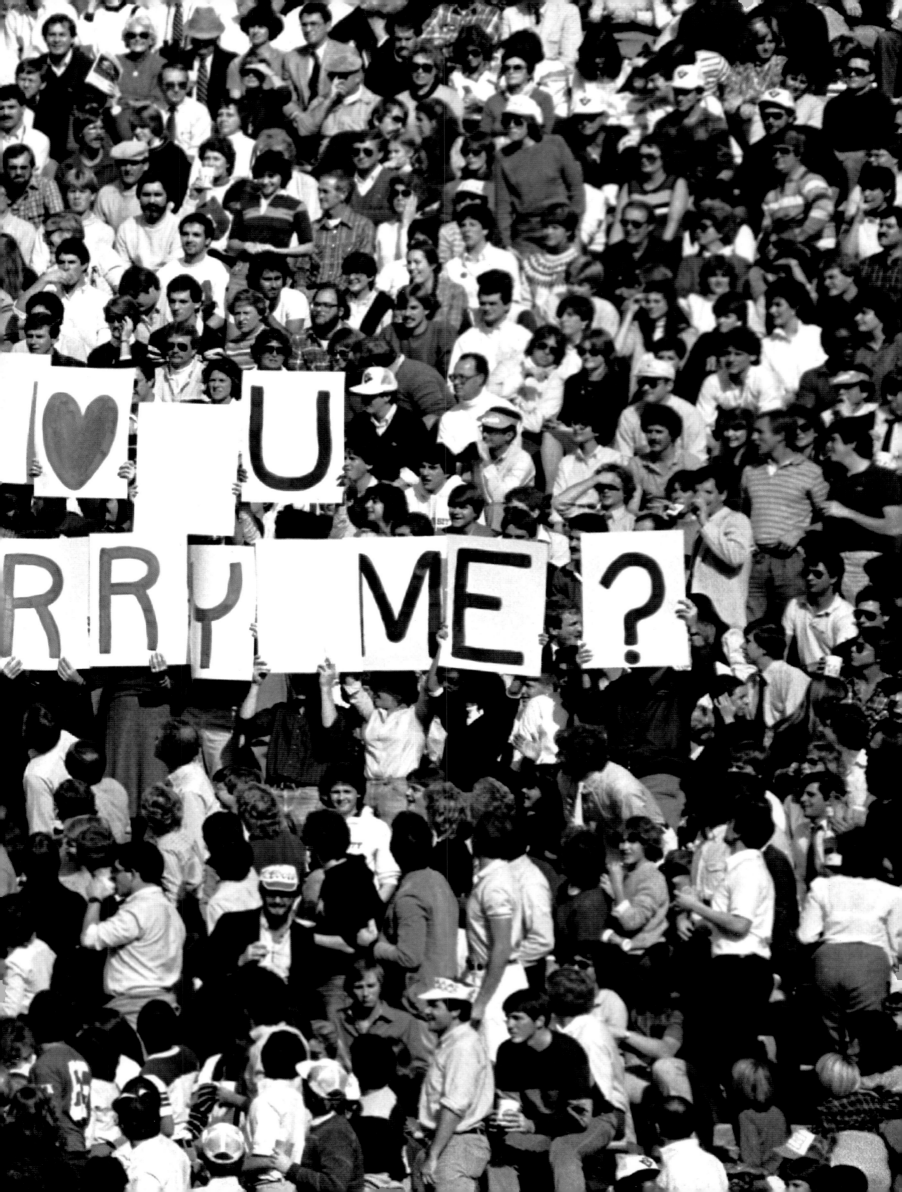

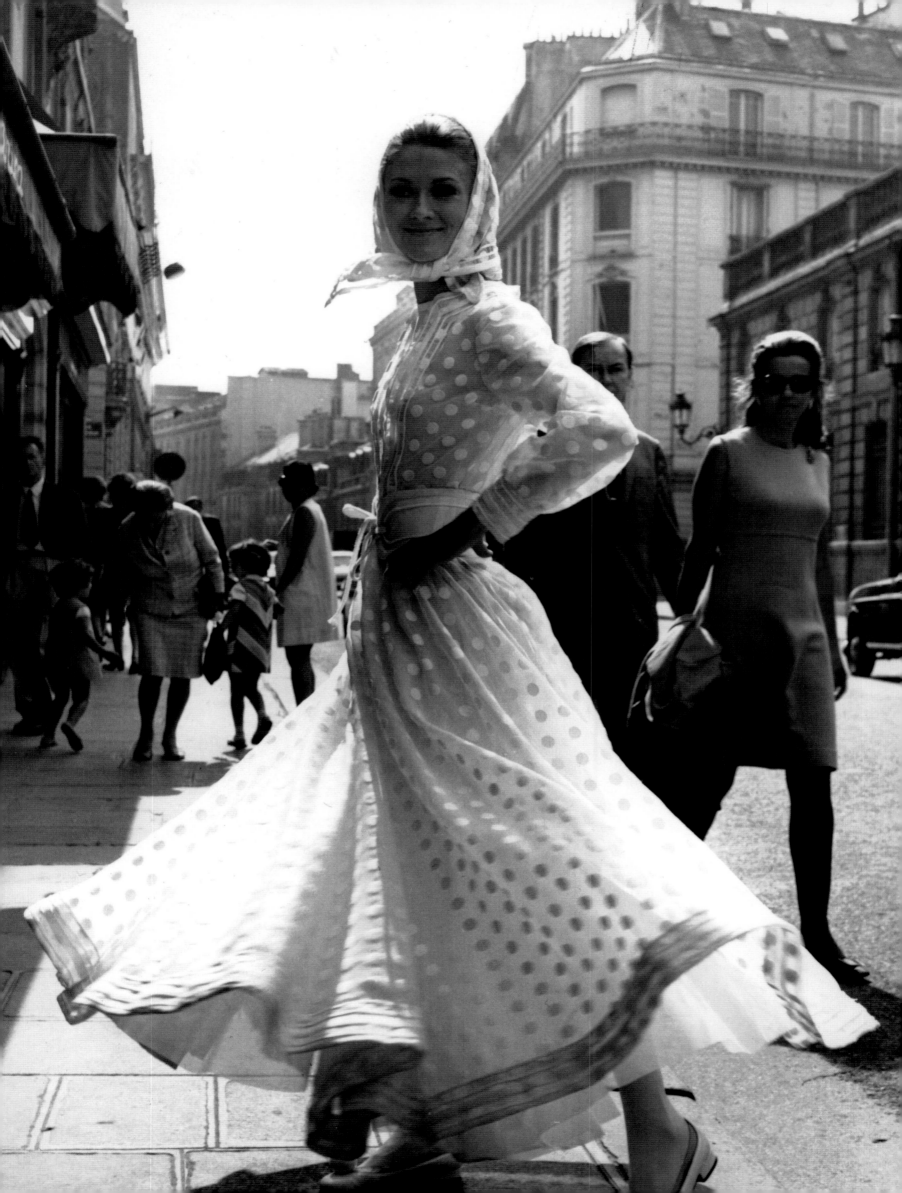

Fashion

inspires the bride—whether she wears long or short, dress or pantsuit, white or blue, fashion is a major factor in selecting the look of a lifetime. Rich or poor, young or young at heart, the bride will be forever remembered in that gown in pictures, videos, and memories.

What the bride wears on one of the most important days of her life says as much about her as it does about the cultural mood of the moment. Victorian brides went down the aisle completely covered up with long sleeves and high-necked gowns—to expose any skin in that era would have been considered positively sinful. But by 1968 Yves Saint Laurent paid homage to the sexual revolution and sent models down the runways in floral bikinis. In the 20th century, designers used wedding dress styles to make bold statements about not only fashion but also sexual politics. By the early 1920s Coco Chanel stirred things up with a knee-length dress paired with a long veil to befit a modern, roaring twenties girl. 1970s bridal pantsuits were a reflection of that era's brand of equal rights feminism. And by the 1980s that decade's excesses were echoed in poufy, over-the-top silhouettes and Madonna's scandalous send-up of the virginal bride.

A common assumption is that brides have always worn white, but before Queen Victoria wore white on her wedding day in 1840, starting the first celebrity wedding trend, many brides wore blue. White wasn't considered a practical option for most women, since their "wedding" dress would most likely be worn again—yellow, orange, and even grey were common options. The queen's choice of white wasn't a show of purity but instead a display of her incredible wealth and noble status—she could afford to wear a dress only once. In the late 19th century the arrival of the department store and mass-produced, cheaper fabrics paved the way for more and more brides to don white. With the exception of the Depression era, when it was considered excessive to wear a new white dress, the trend continues to this day. For now, in many parts of the Western world, white is so linked with brides that many people assume it's been that way forever.

Today a bride has the option to choose her own unique look for her wedding day, and her choice makes a bold statement about who she is. All brides want to be stunning, to take his breath away, to shine—but the individual dress, its style, its drape, what it hides and what it reveals, should capture her essence. Whether she's playful or reverent, peaceful or spirited, it's all in the dress.

A traditional wedding dress ends the presentation of Louis Feraud's collection in Paris, France on July 22, 1968.

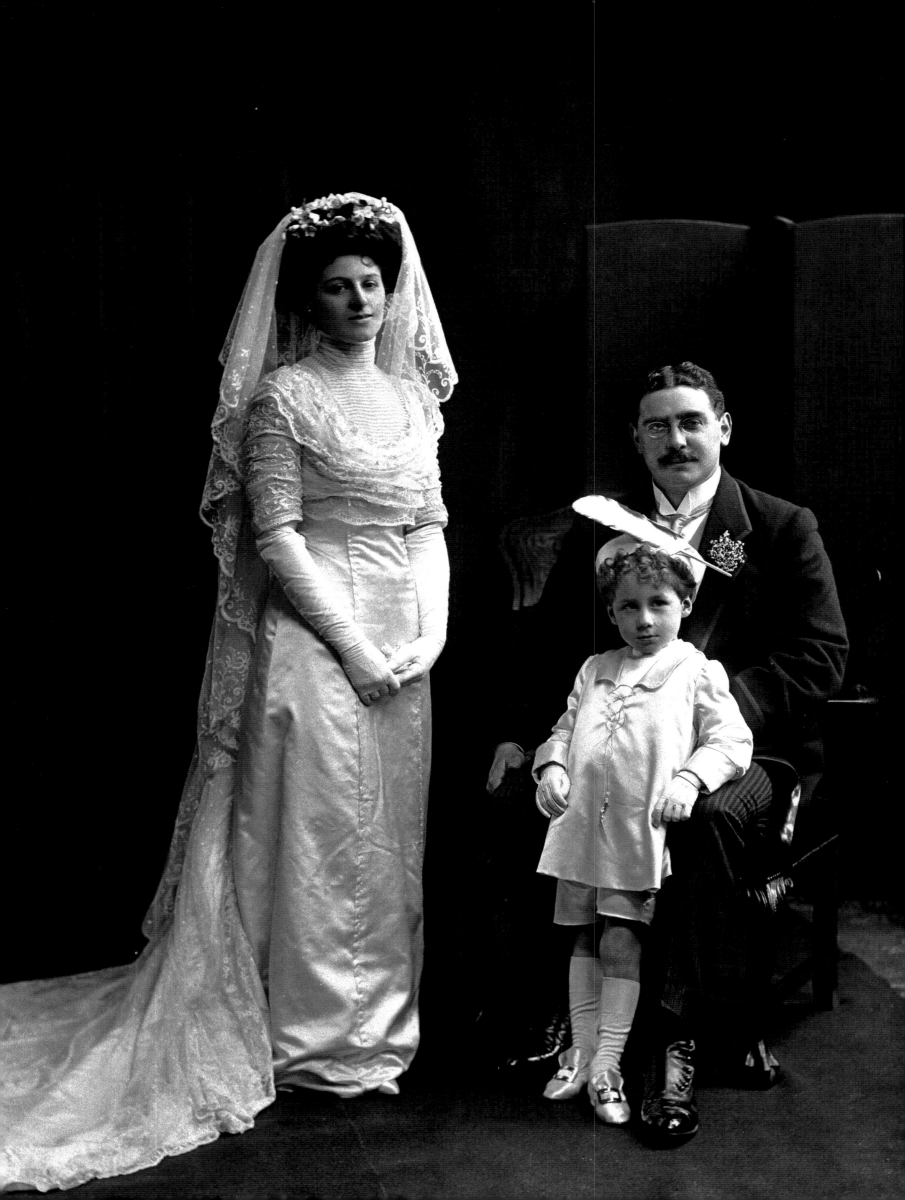

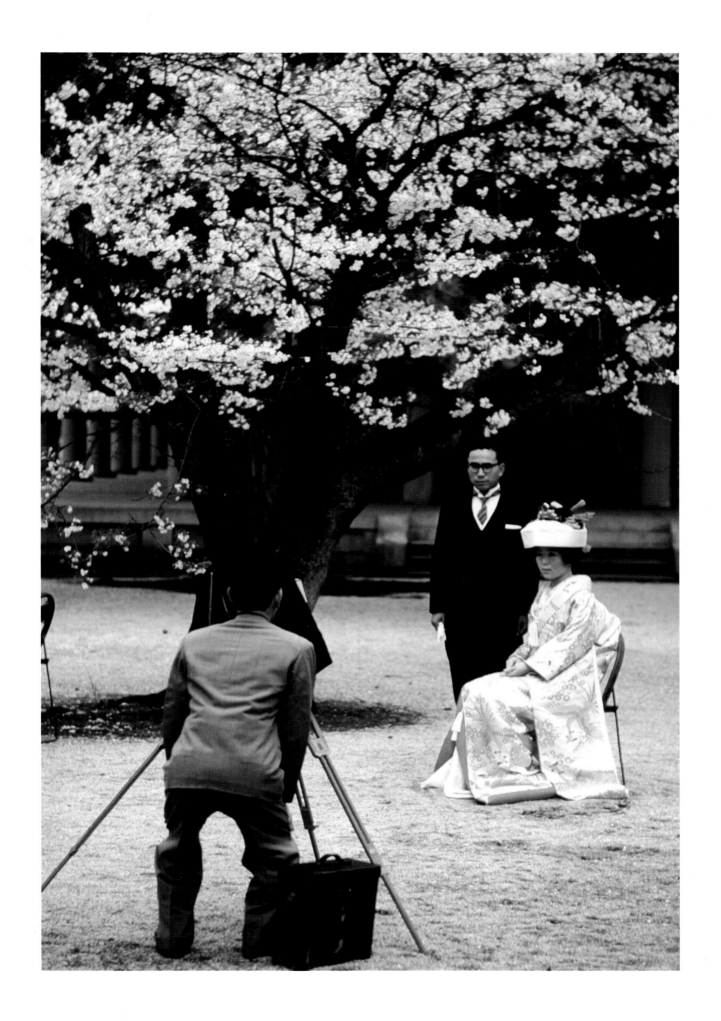

Japanese wedding at the Heian Jingu Shrine in Kyoto, Japan, 1961.

OPPOSITE: Mr. and Mrs. Ernstein shortly after their wedding, circa 1910.

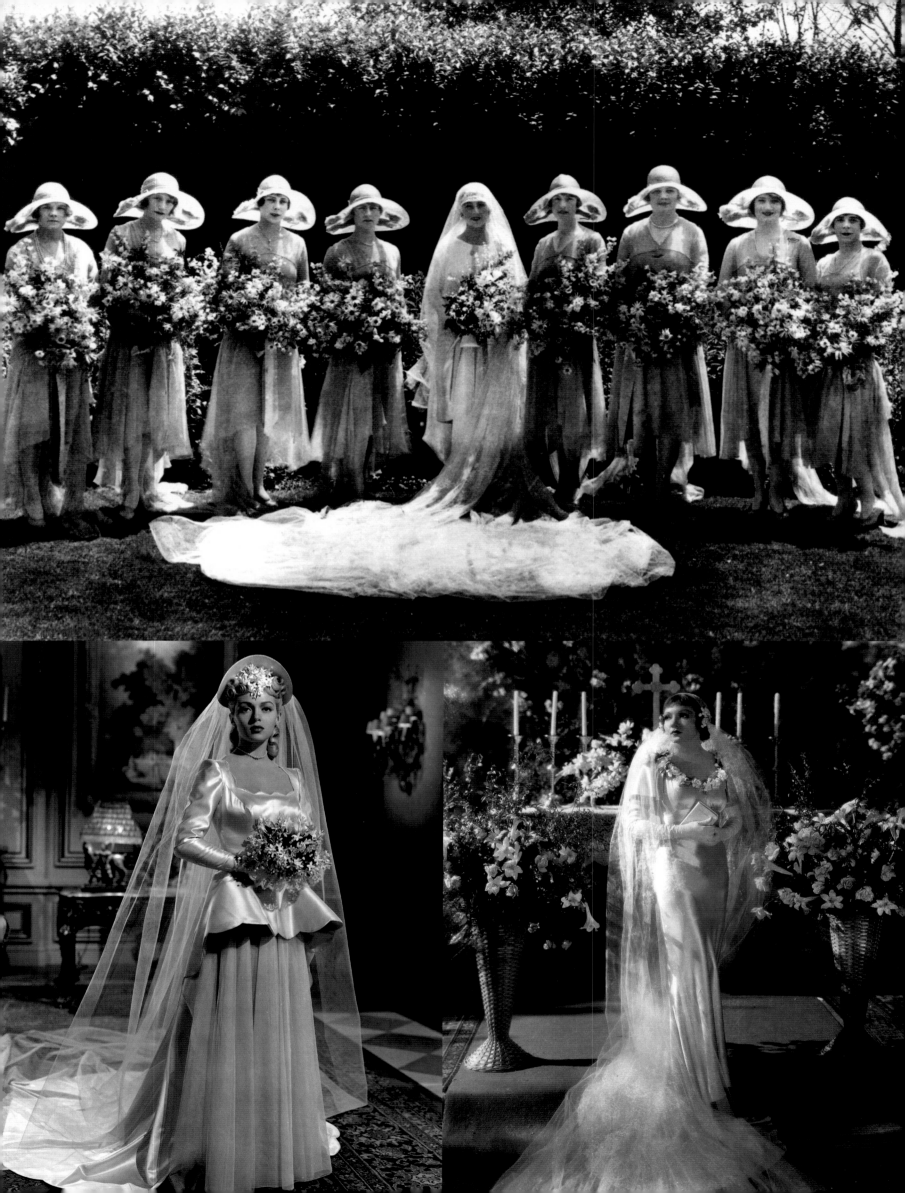

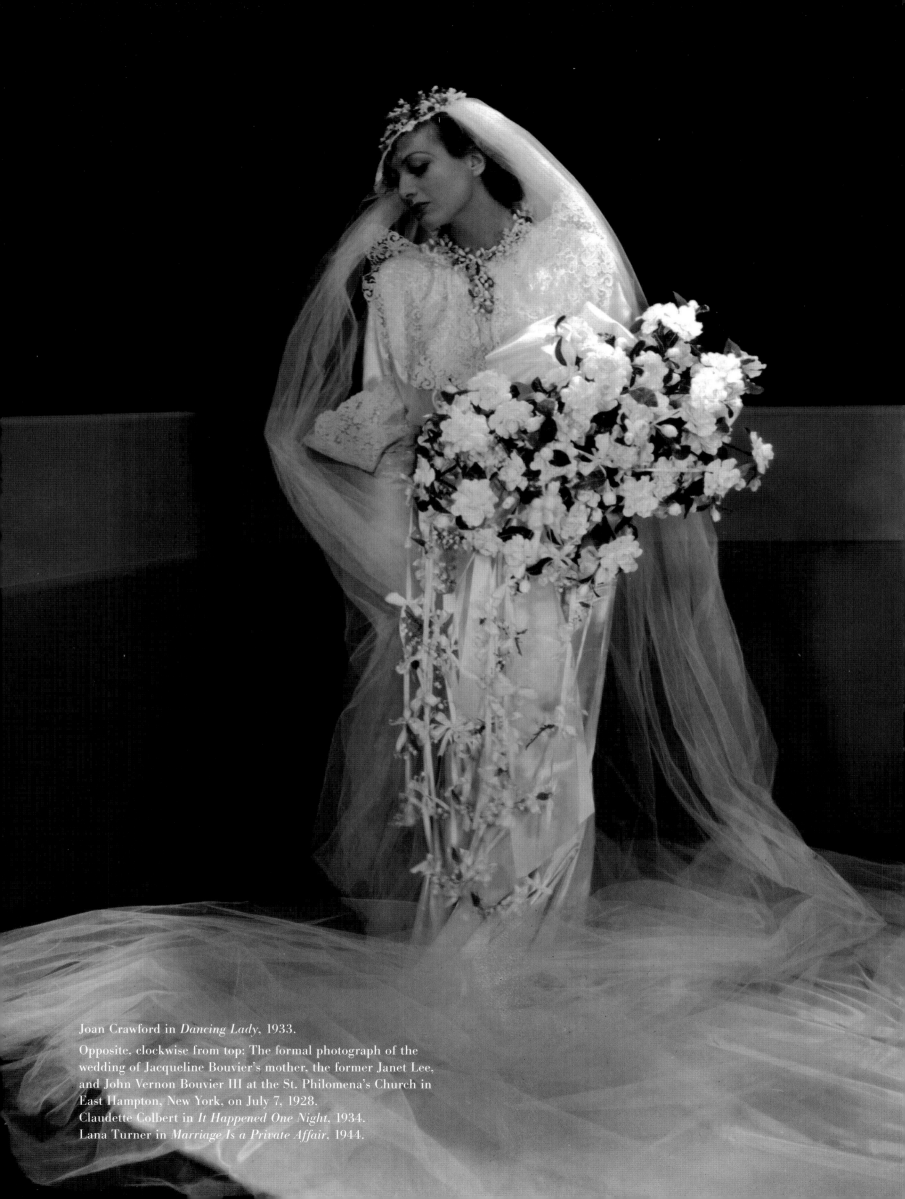

Joan Crawford in *Dancing Lady*, 1933.

Opposite, clockwise from top: The formal photograph of the wedding of Jacqueline Bouvier's mother, the former Janet Lee, and John Vernon Bouvier III at the St. Philomena's Church in East Hampton, New York, on July 7, 1928.
Claudette Colbert in *It Happened One Night*, 1934.
Lana Turner in *Marriage Is a Private Affair*, 1944.

Bette Davis in *Dark Victory*, 1939.

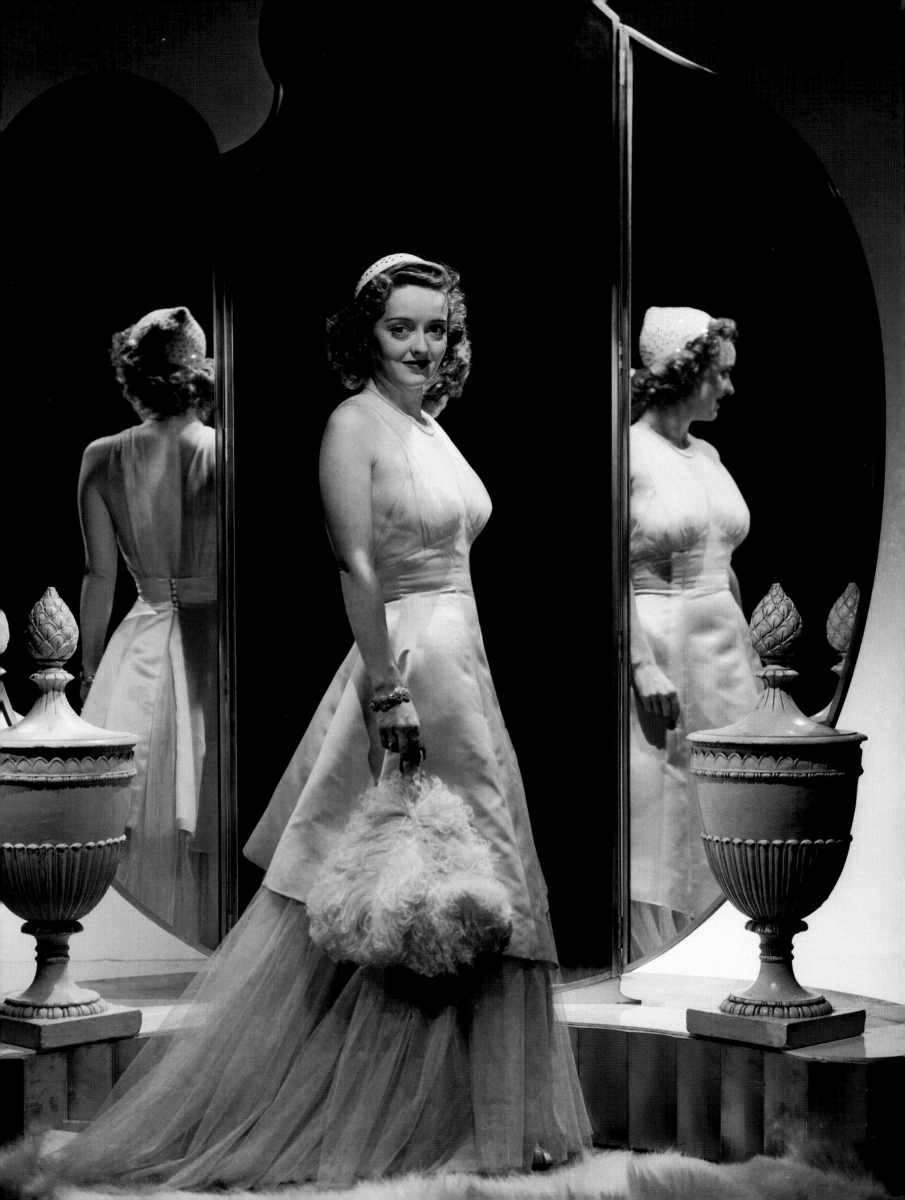

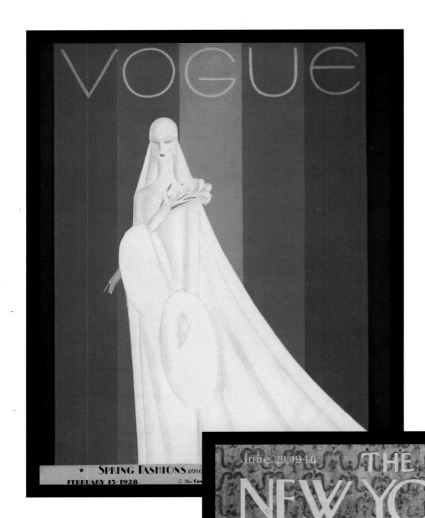

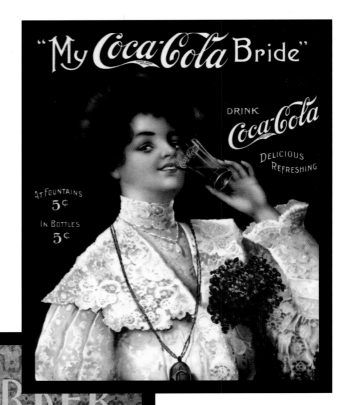

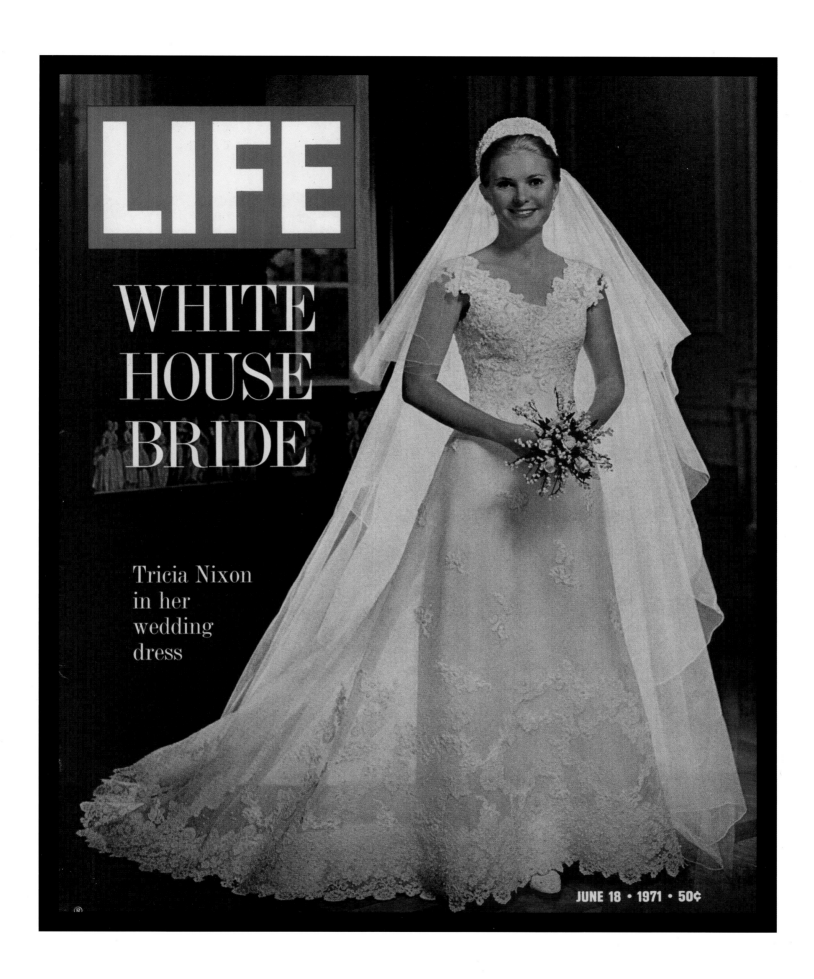

LIFE

WHITE
HOUSE
BRIDE

Tricia Nixon
in her
wedding
dress

JUNE 18 • 1971 • 50¢

President Nixon's daughter Tricia in her wedding gown.

OPPOSITE, CLOCKWISE FROM TOP LEFT:
"Bride Against Red Background," illustration by Eduardo Garcia Benito, *Vogue*, February 15, 1928.
Coca-Cola Victorian Bride, 1890s.
"Bride on stairway throwing bouquet," illustration by Mary Petty, *The New Yorker*, June 29, 1940.

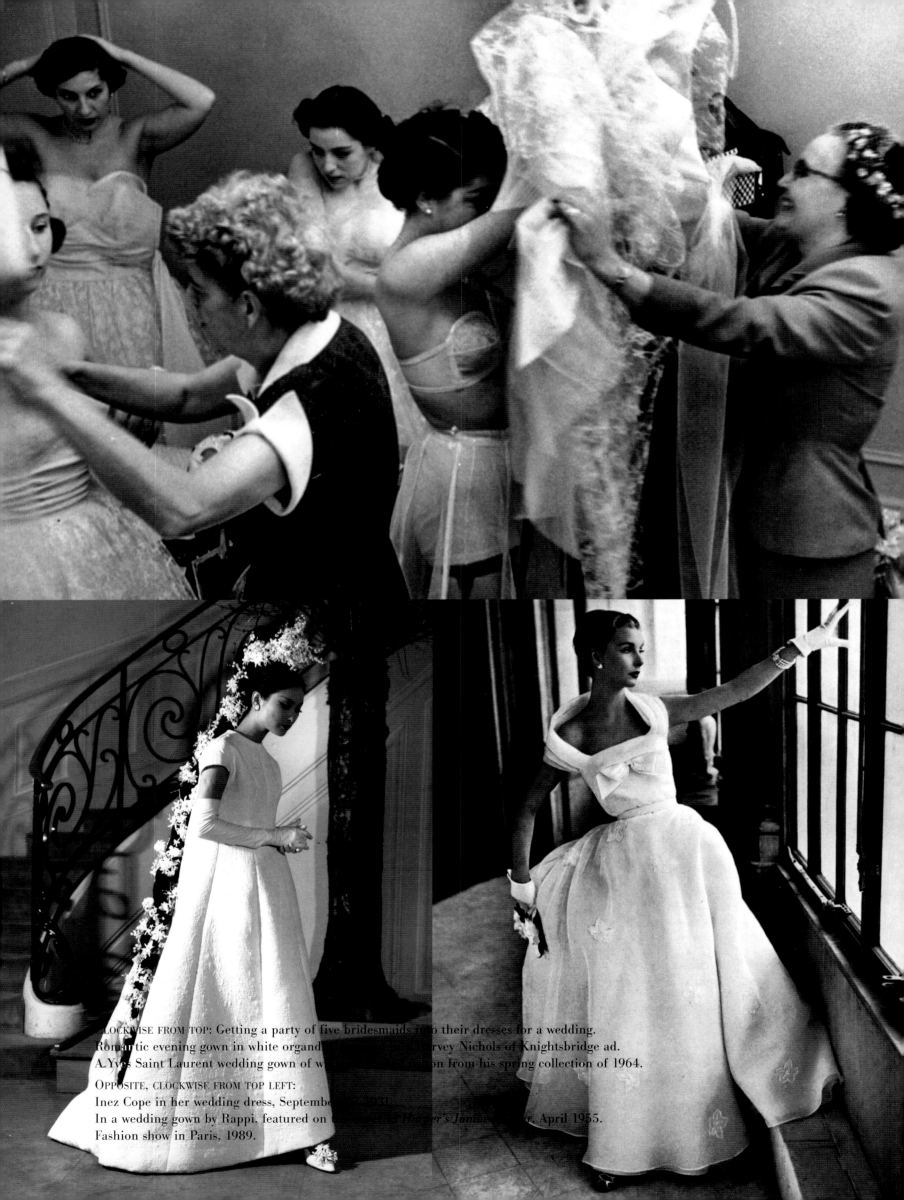

CLOCKWISE FROM TOP: Getting a party of five bridesmaids into their dresses for a wedding.
Romantic evening gown in white organdy, [...] Harvey Nichols of Knightsbridge ad.
A Yves Saint Laurent wedding gown of w[...] on from his spring collection of 1964.

OPPOSITE, CLOCKWISE FROM TOP LEFT:
Inez Cope in her wedding dress, September [...]
In a wedding gown by Rappi, featured on [...] of Harper's Junior [...], April 1955.
Fashion show in Paris, 1989.

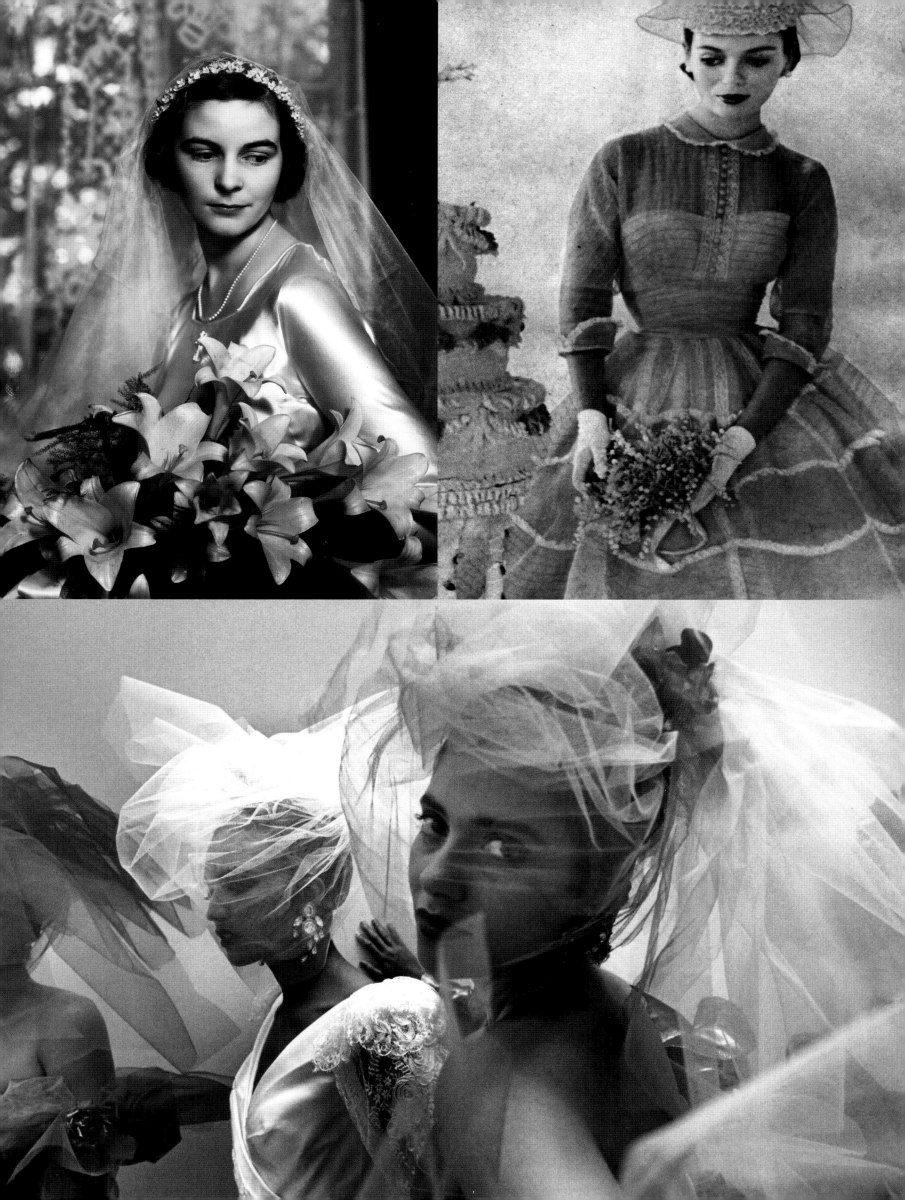

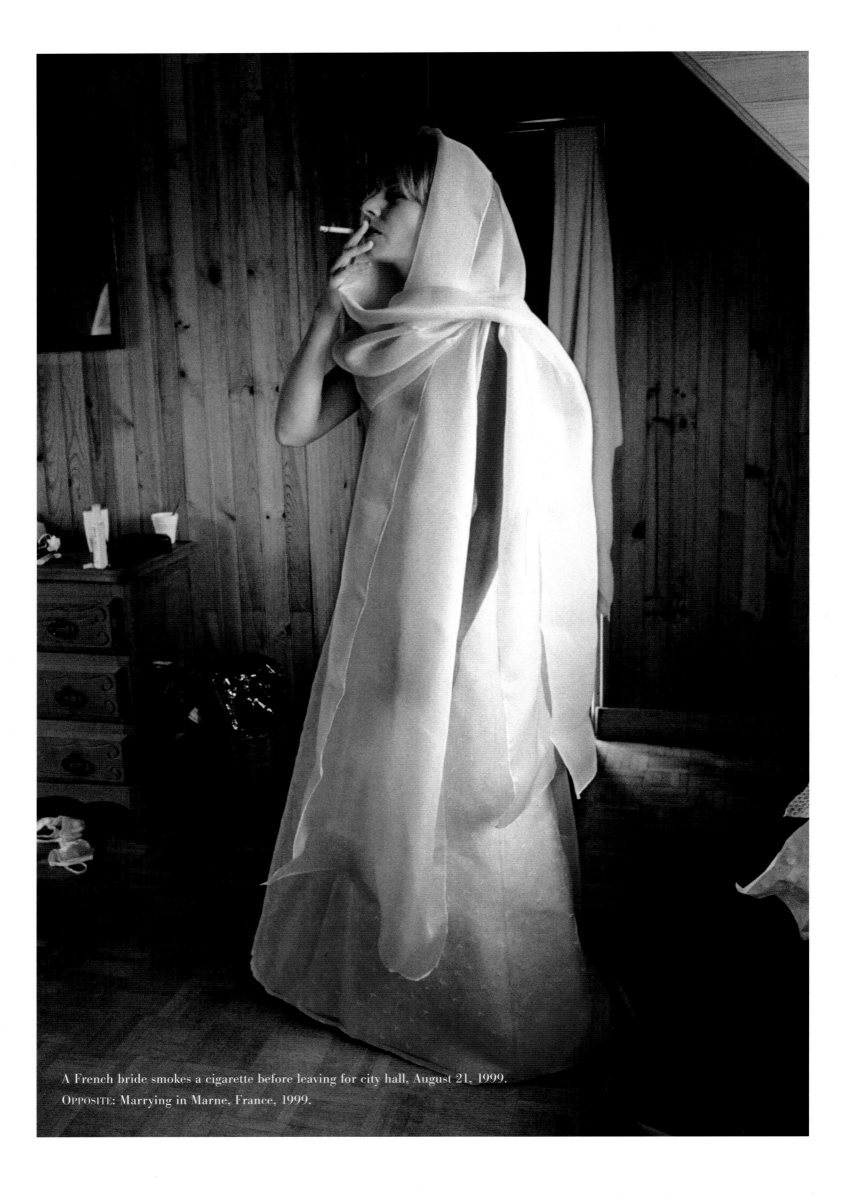

A French bride smokes a cigarette before leaving for city hall, August 21, 1999.
OPPOSITE: Marrying in Marne, France, 1999.

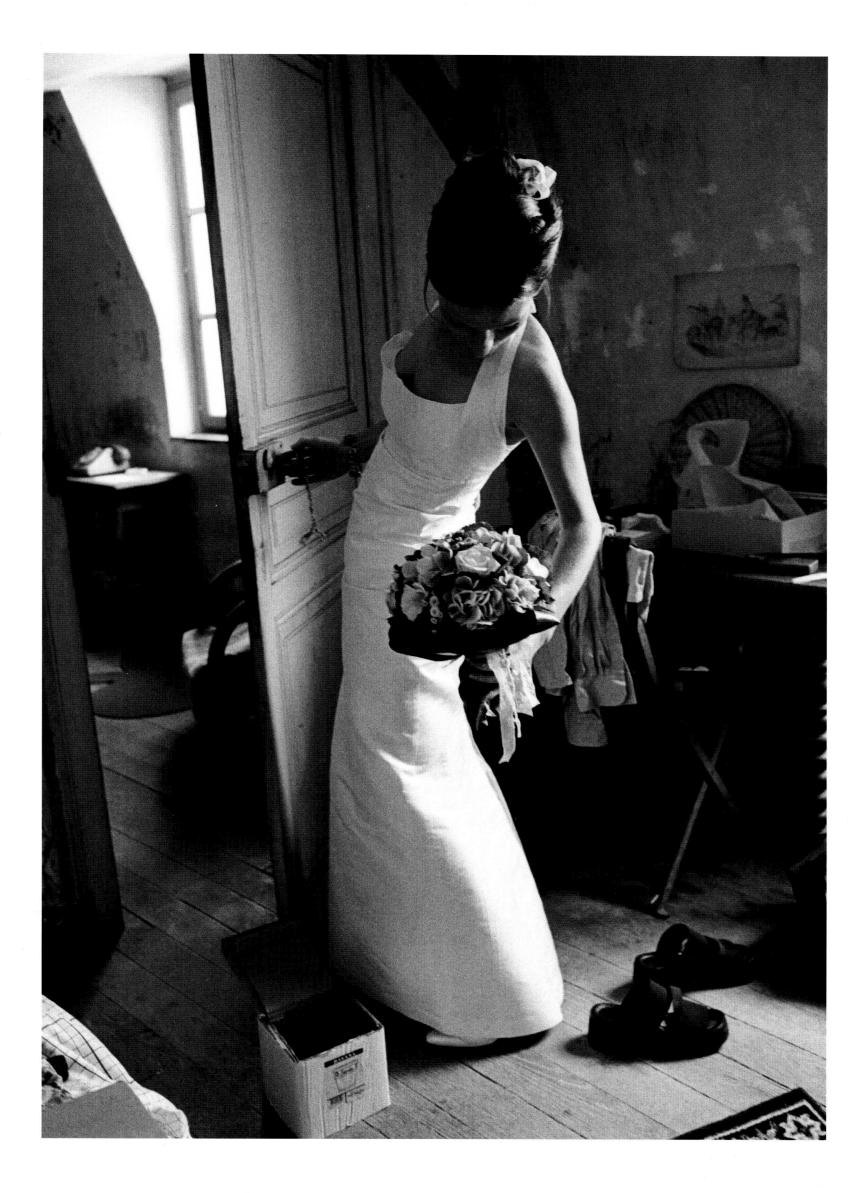

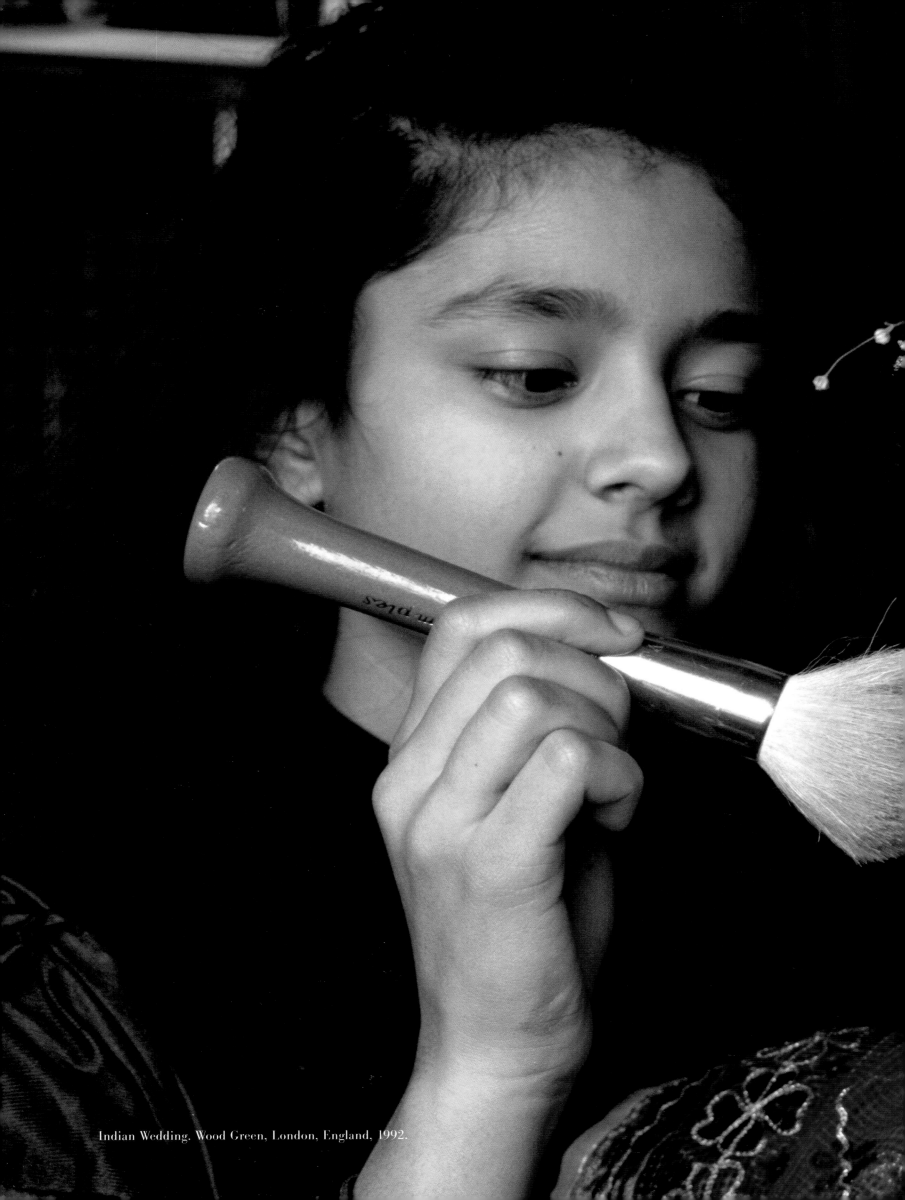

Indian Wedding. Wood Green, London, England, 1992.

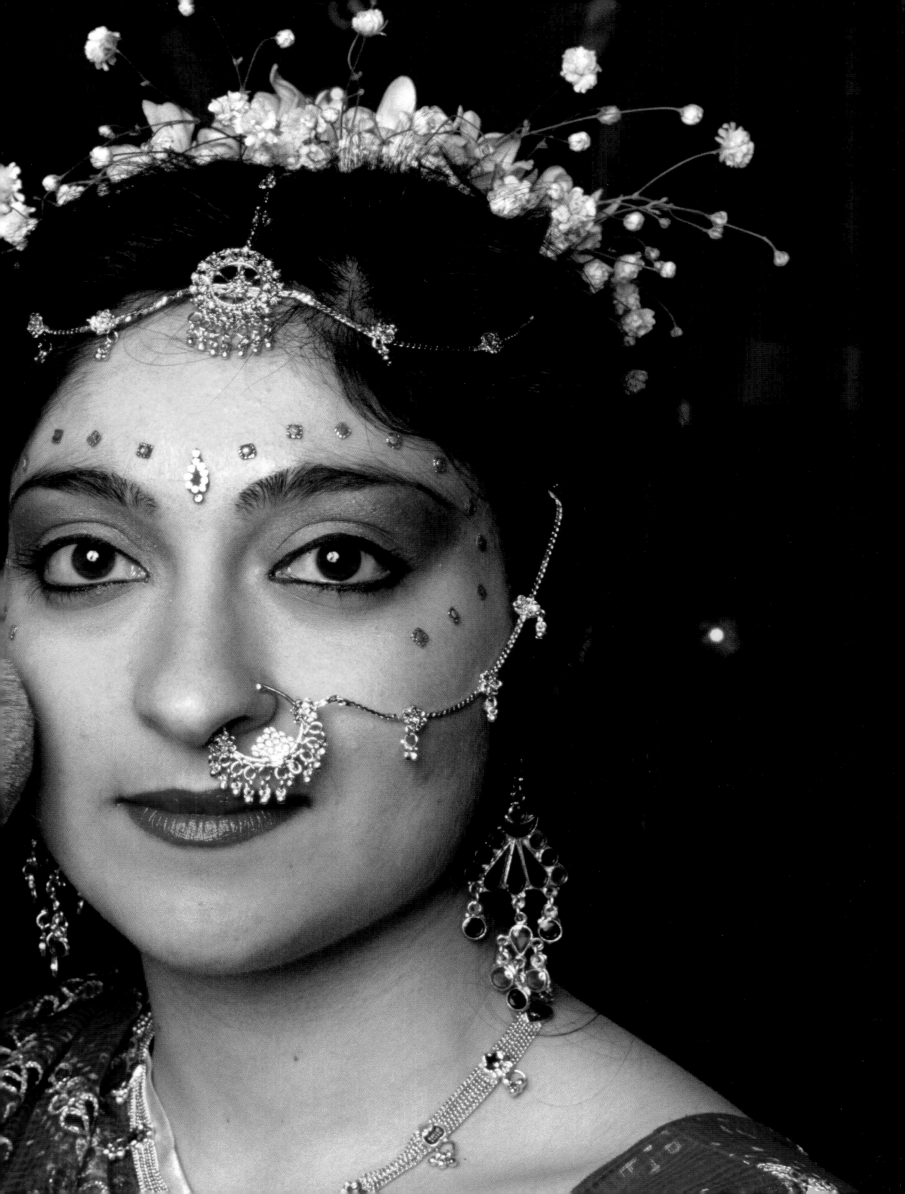

French actress Brigitte Bardot wearing a wedding veil, July, 1, 1956.

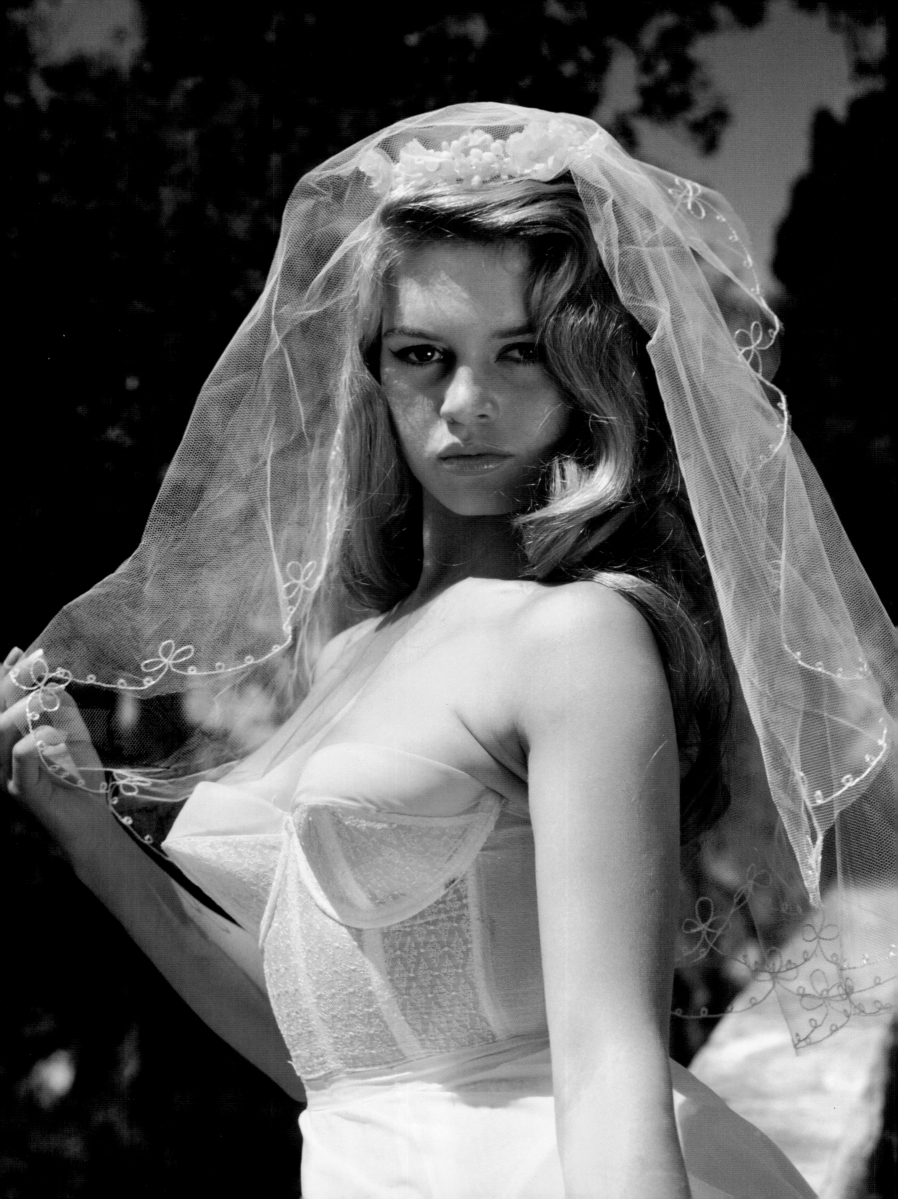

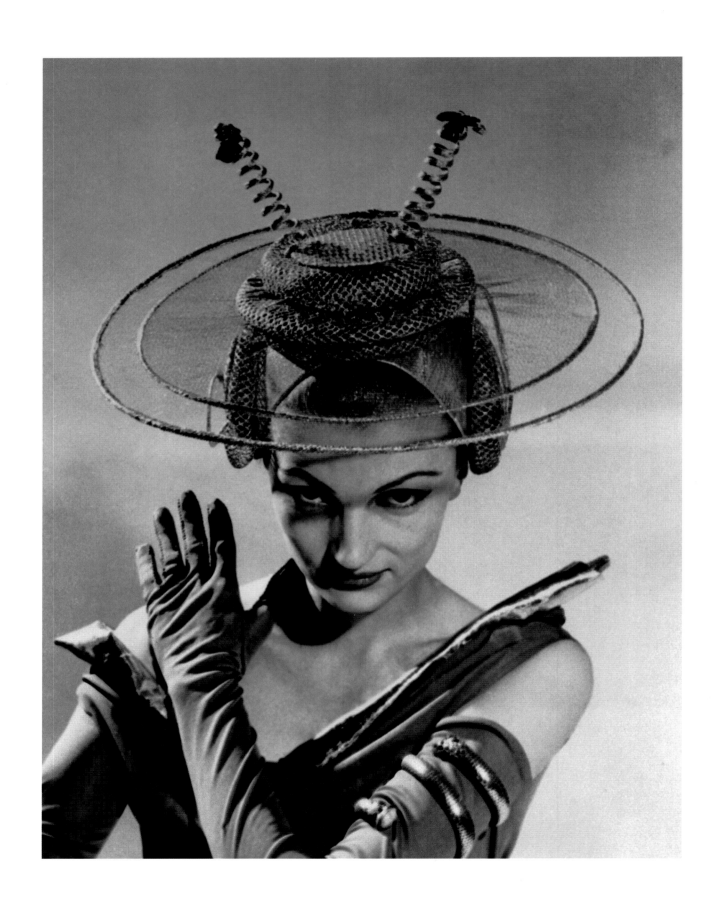

A futuristic hat for brides from the famed Golden Wedding
collection of bridal gowns and accessories of the past, present,
and future, Boston, Massachusetts, April 4, 1956.

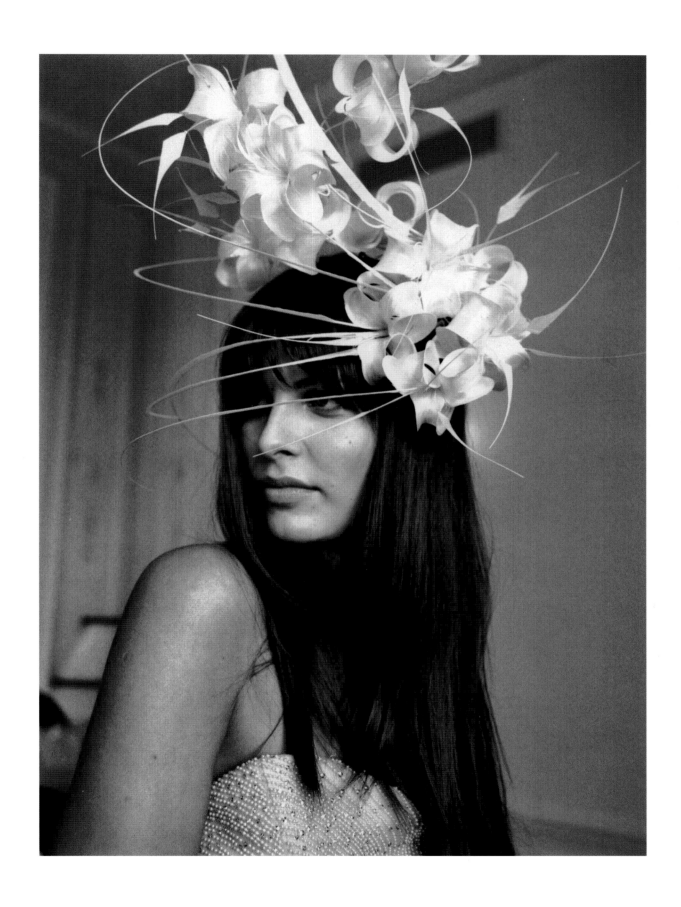

Bride in a contemporary wedding veil, 2004.

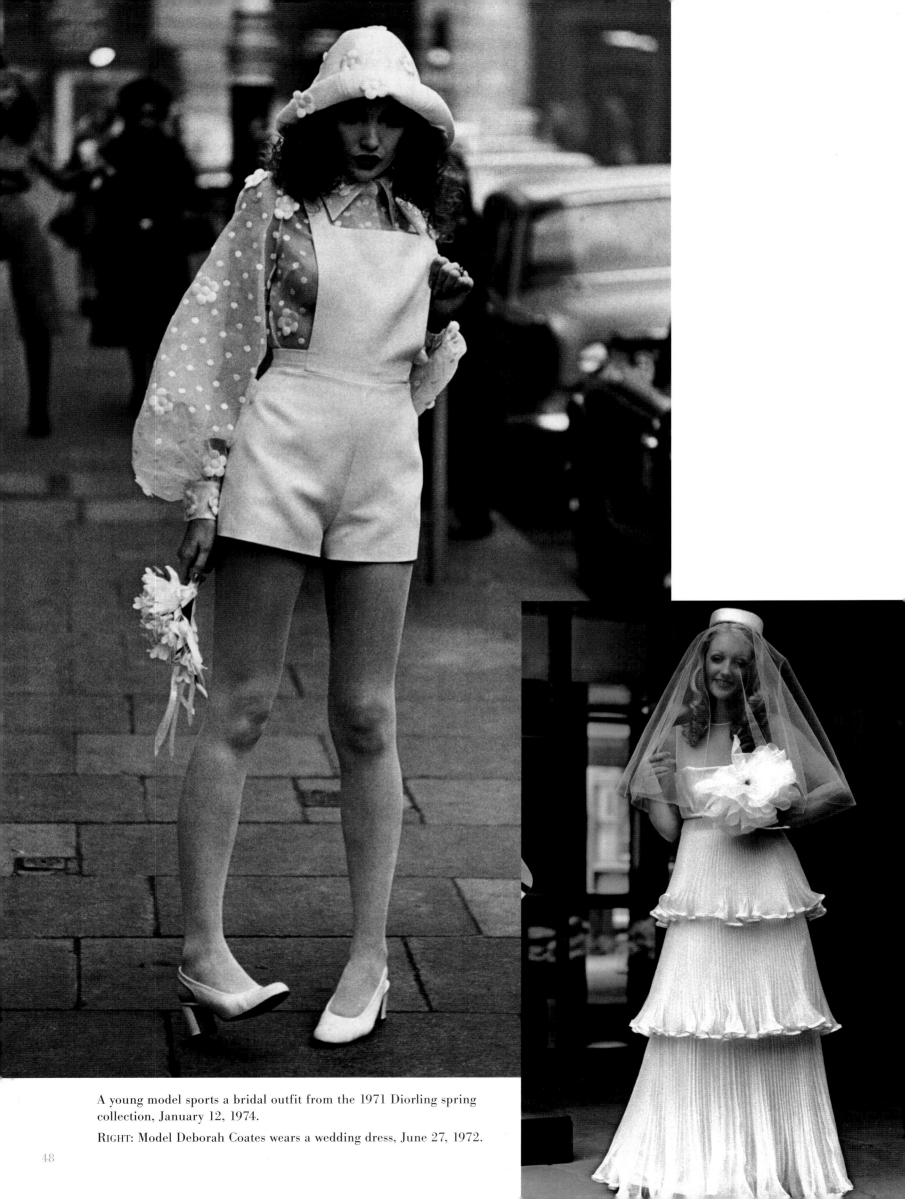

A young model sports a bridal outfit from the 1971 Diorling spring collection, January 12, 1974.

RIGHT: Model Deborah Coates wears a wedding dress, June 27, 1972.

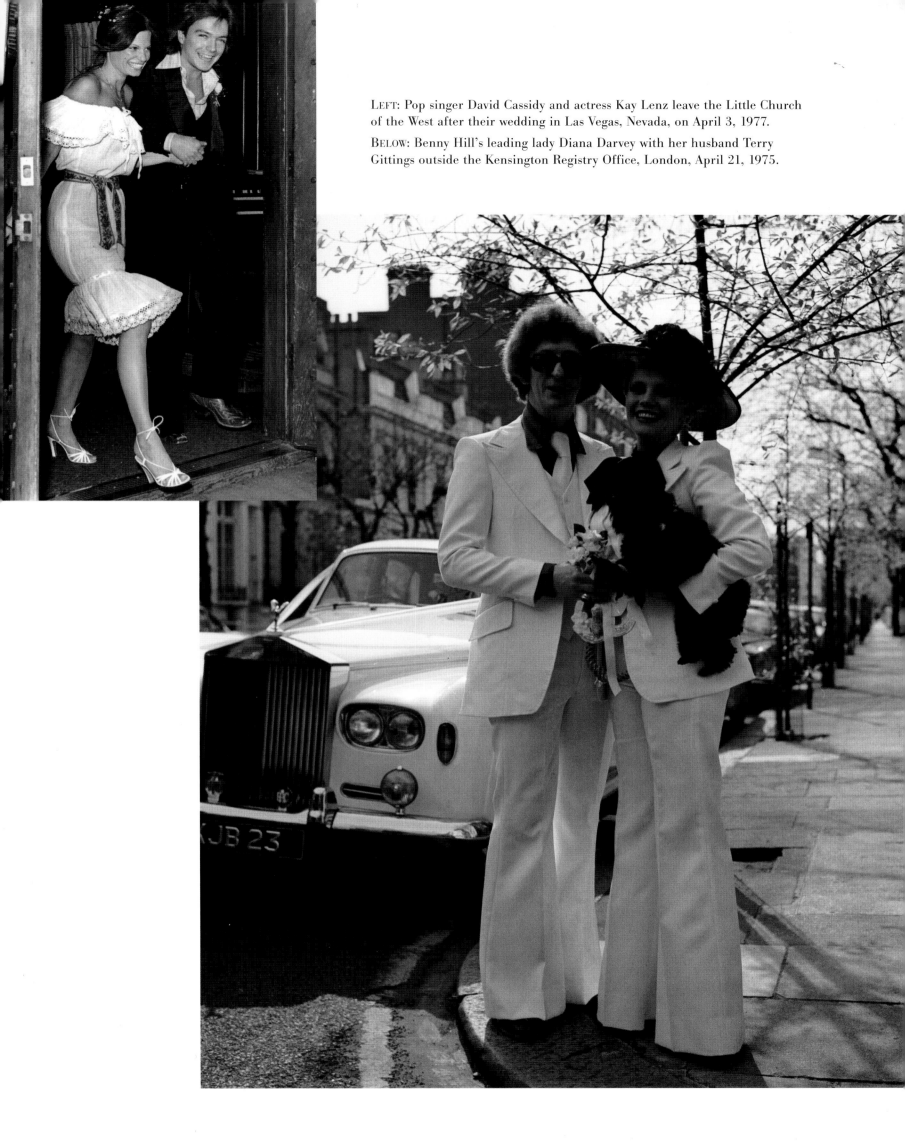

LEFT: Pop singer David Cassidy and actress Kay Lenz leave the Little Church of the West after their wedding in Las Vegas, Nevada, on April 3, 1977.

BELOW: Benny Hill's leading lady Diana Darvey with her husband Terry Gittings outside the Kensington Registry Office, London, April 21, 1975.

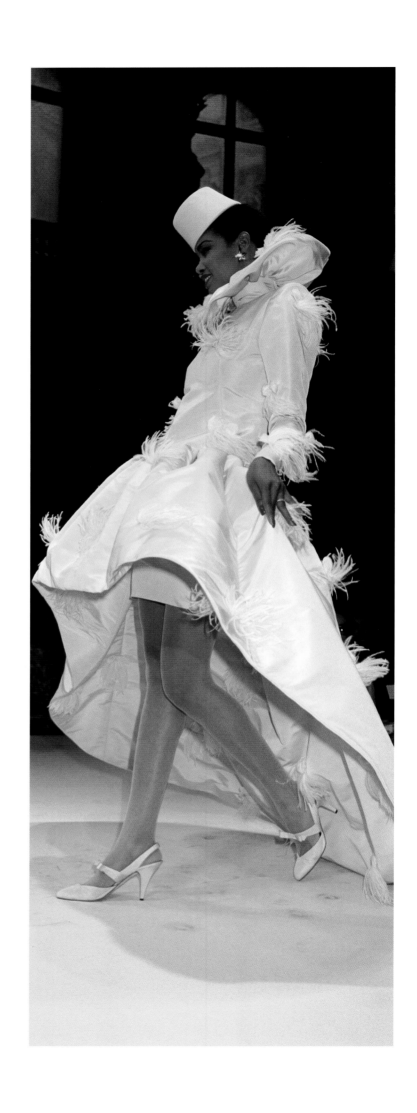

LEFT TO RIGHT: Givenchy, Fall/Winter 1987–1988.
Emanuel Ungaro, Spring/Summer 1987.
Sonia Rykiel, Spring/Summer 1988.

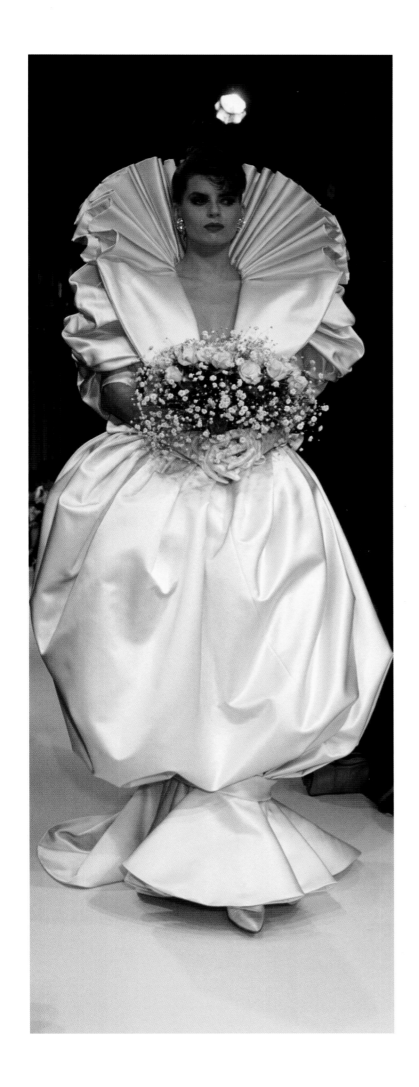
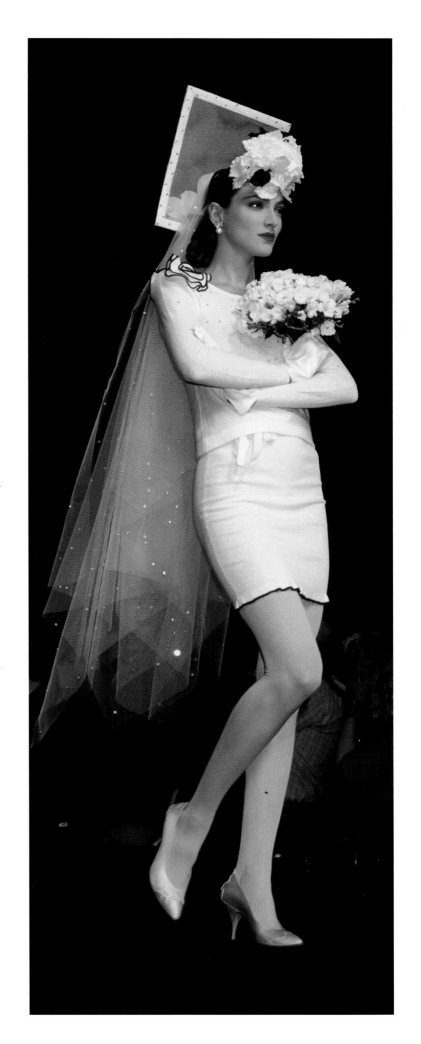

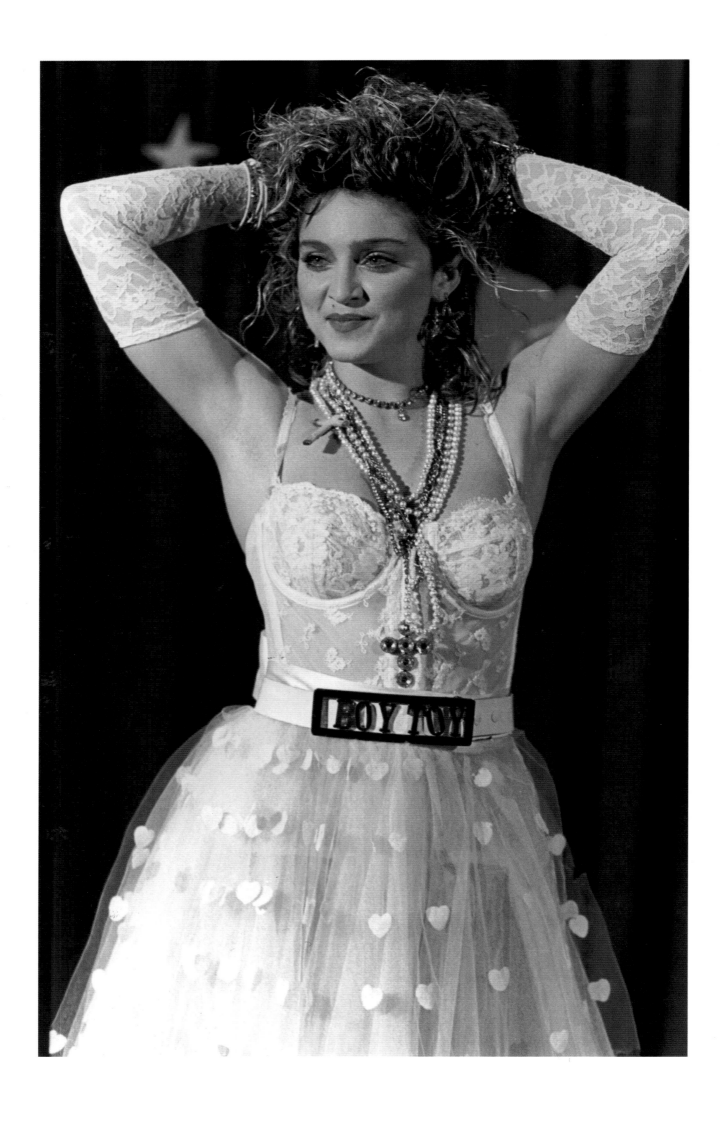

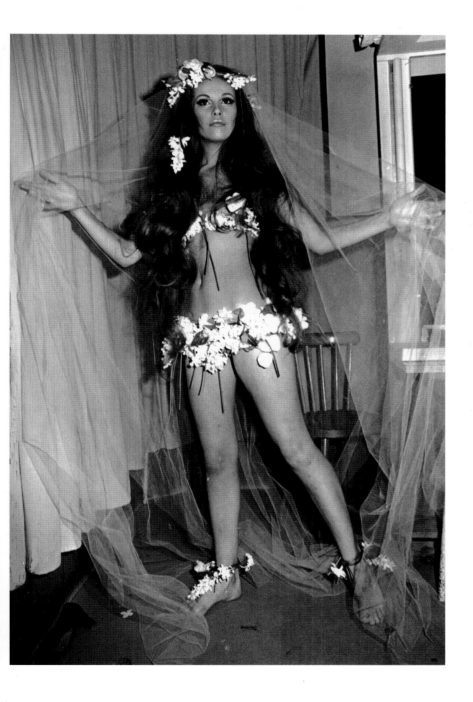

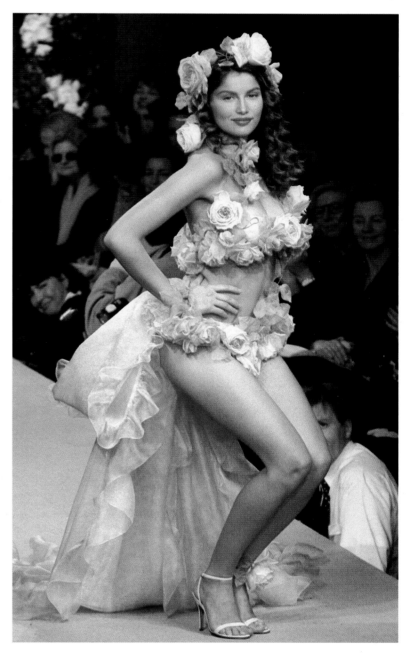

Yves Saint Laurent's "Eve in Paradise" wedding bikini, Paris, January 29, 1968.
Yves Saint Laurent, Spring/Summer 1999.

Opposite: Madonna at the 1st annual MTV Video Music Awards at Tavern on the Green, New York City, 1984.

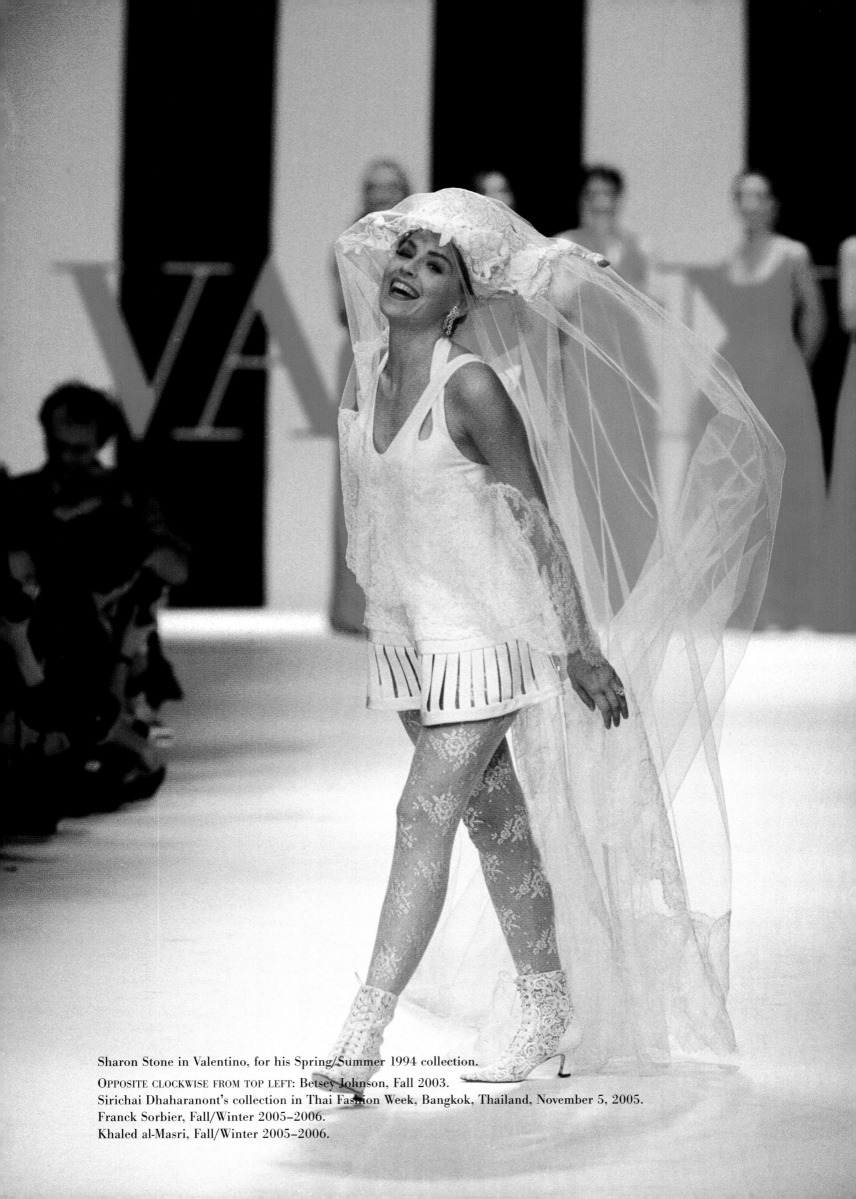

Sharon Stone in Valentino, for his Spring/Summer 1994 collection.

OPPOSITE CLOCKWISE FROM TOP LEFT: Betsey Johnson, Fall 2003.
Sirichai Dhaharanont's collection in Thai Fashion Week, Bangkok, Thailand, November 5, 2005.
Franck Sorbier, Fall/Winter 2005–2006.
Khaled al-Masri, Fall/Winter 2005–2006.

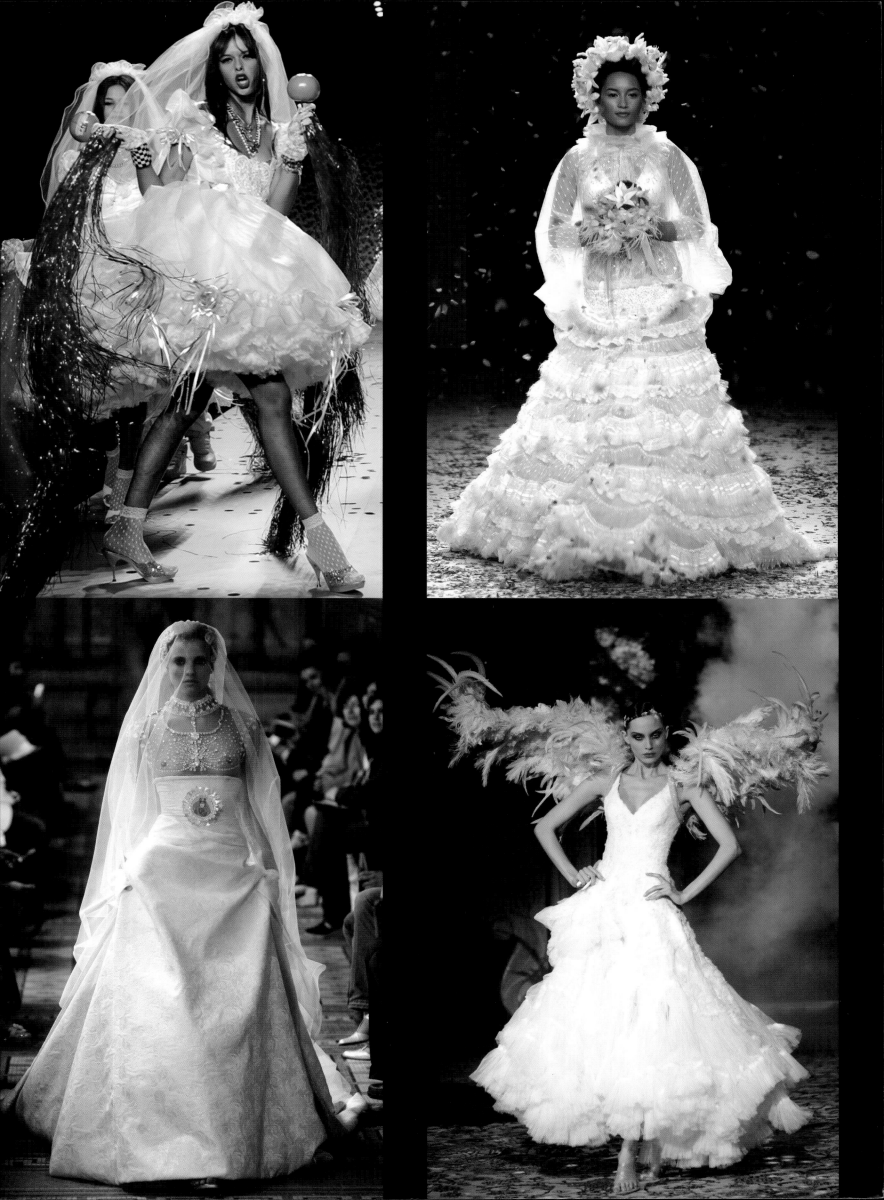

Bride on a red couch.

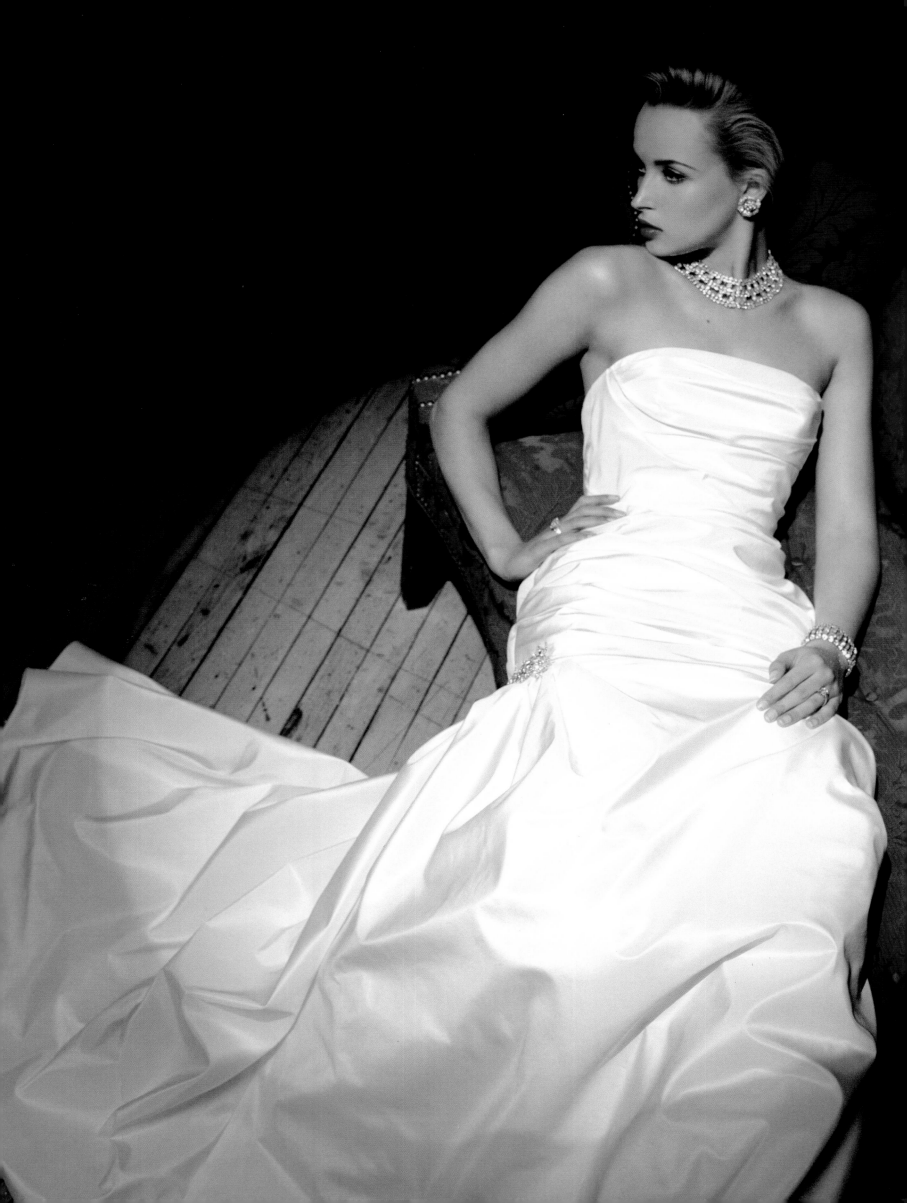

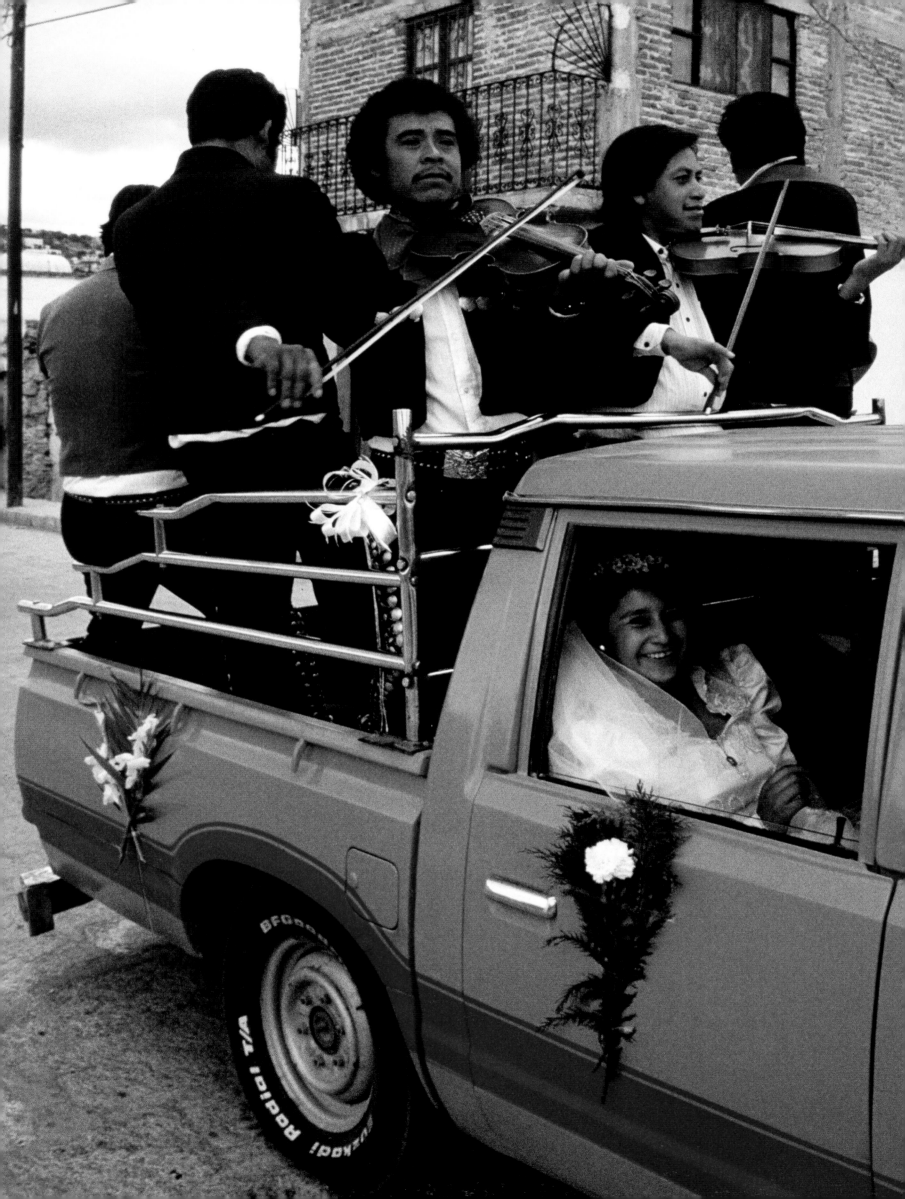

Global

weddings celebrate each culture's finest flowers, dresses, fabrics, colors, and feasts. Love may be universal, but the rituals and pageantry that surround global marriages are wonderfully distinct. Examining international wedding traditions, one is struck by the endless takes on the simple act of saying "I do." However the importance of family, friends, tradition, and superstition in becoming a married couple links all weddings across the globe. Breaking bread and sharing wine together, paired with music and dance, are practiced in most cultures. Celebrating love translates into any language.

Families play an important role in any wedding ceremony. In Fiji a bride's male relatives place her on an elaborate raft and steer her to the service. Ecuadorian parents of the bride both join their daughter as she walks down the aisle towards her new husband. In Hindu ceremonies the bride's father places her right hand in the right hand of her groom and then the couple is briefly tied together to represent their becoming one. In South Africa both sets of parents carry fire from their homes to light the couple's new hearth.

Weddings are shrouded in superstition, and to encourage a blessed union ceremonies and rituals are avidly followed. Getting hitched in China? Most brides wear red—the color of good fortune. But for women saying "I do" in Japan, a white wedding kimono that symbolizes virginal purity is a must. A Japanese sake ceremony is believed to bond couples together as they both drink three sips from each of three cups of sake. In Spain, grooms still present their wives with 13 gold coins blessed by a priest to demonstrate that they will provide for her. Guests at a Mexican wedding often form a heart-shaped circle during the couple's first dance. In India many Hindu brides and grooms walk around a blessed fire praying for love, wealth, fidelity, and the union of their souls. To encourage good luck, Chinese couples marry on the half hour so they begin their marriage on an upswing.

What's amazing about weddings the world over is that regardless of economic status or circumstance, for that one moment at least, they are always surrounded by joy. The couple's own happiness is magnified by the well wishes of those closest to them. Whether a couple makes it official in the midst of war or a young woman marries her true love from a country far from her own, hope unites all marriages no matter where they take place.

Mobile mariachis serenade newlyweds on the way to their wedding reception in San Miguel de Allende, Guanajuato, Mexico.

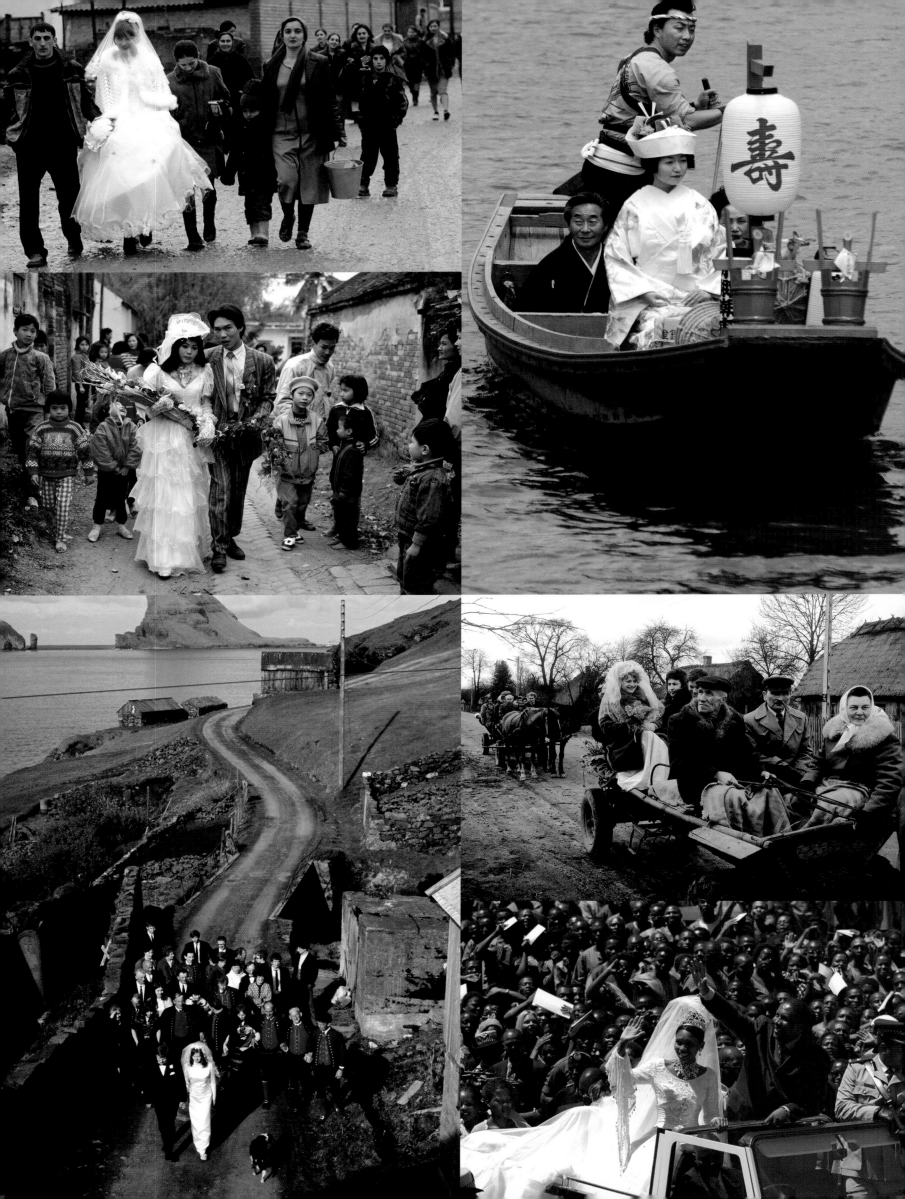

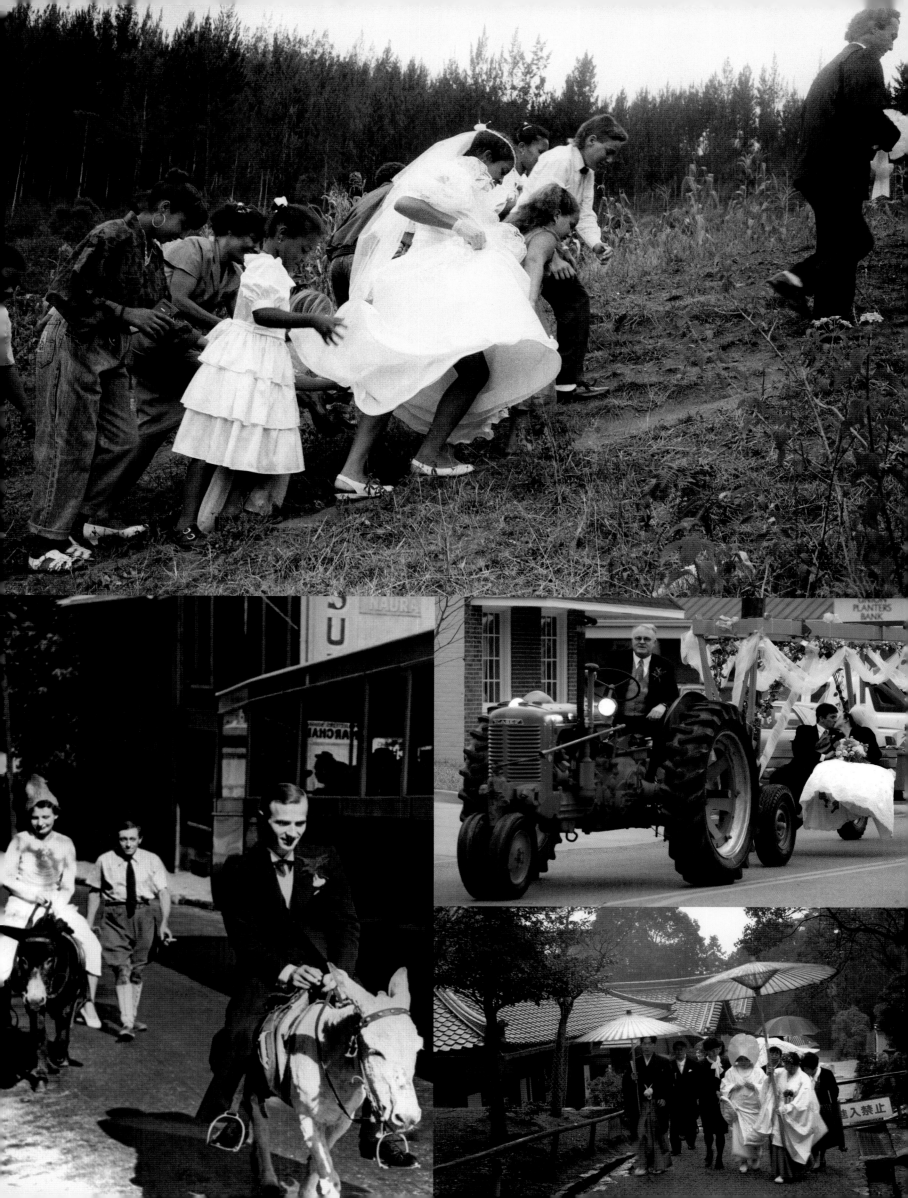

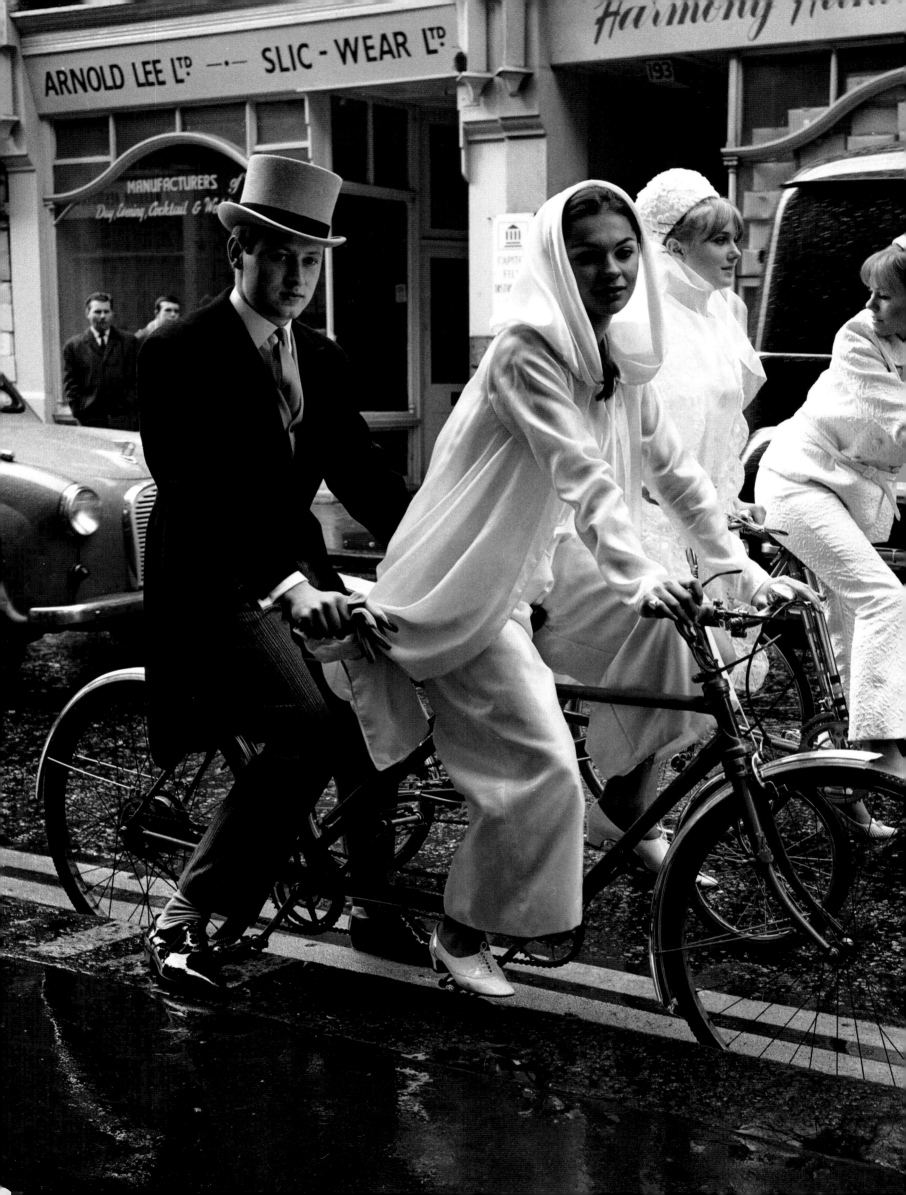

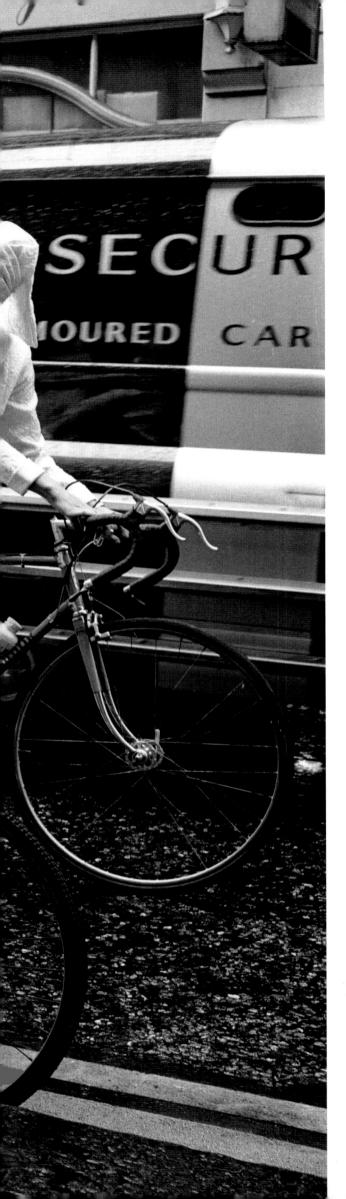

Models wearing wedding outfits from Youngs prove their practicality by riding on bikes through London, April 1966.

PREVIOUS PAGE LEFT, CLOCKWISE FROM TOP LEFT:
Grozny, Chechnya.
Itako, Japan, 2004.
Sandomierz, Poland, 1981.
Maseru, Lesotho, Denmark, 2000.
Faeroe Islands.
Hanoi, Vietnam.

PREVIOUS PAGE RIGHT, CLOCKWISE FROM TOP:
Ilet à Bourse, France, 1990.
Tupelo, Mississippi, 2004.
Nara, Japan, 2000.
France, circa 1940.

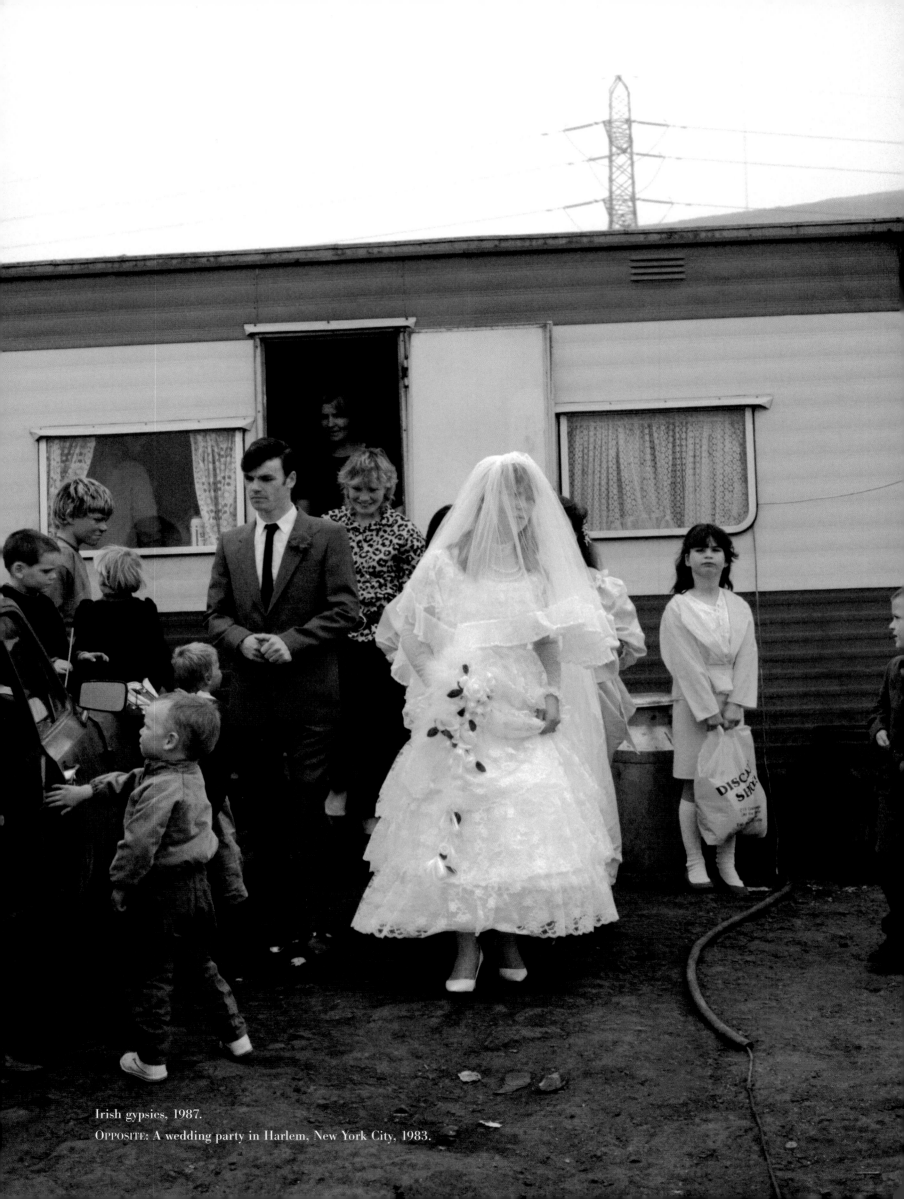

Irish gypsies, 1987.

OPPOSITE: A wedding party in Harlem, New York City, 1983.

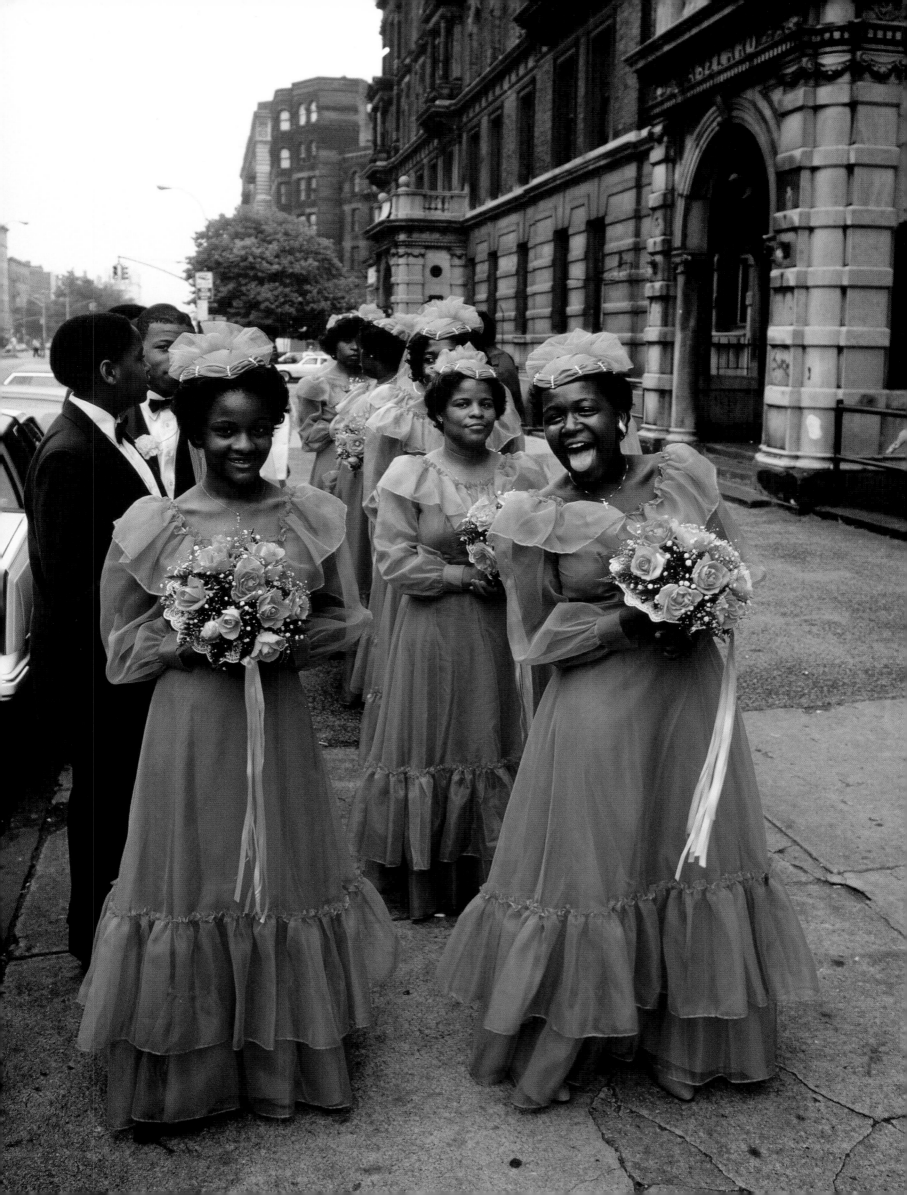

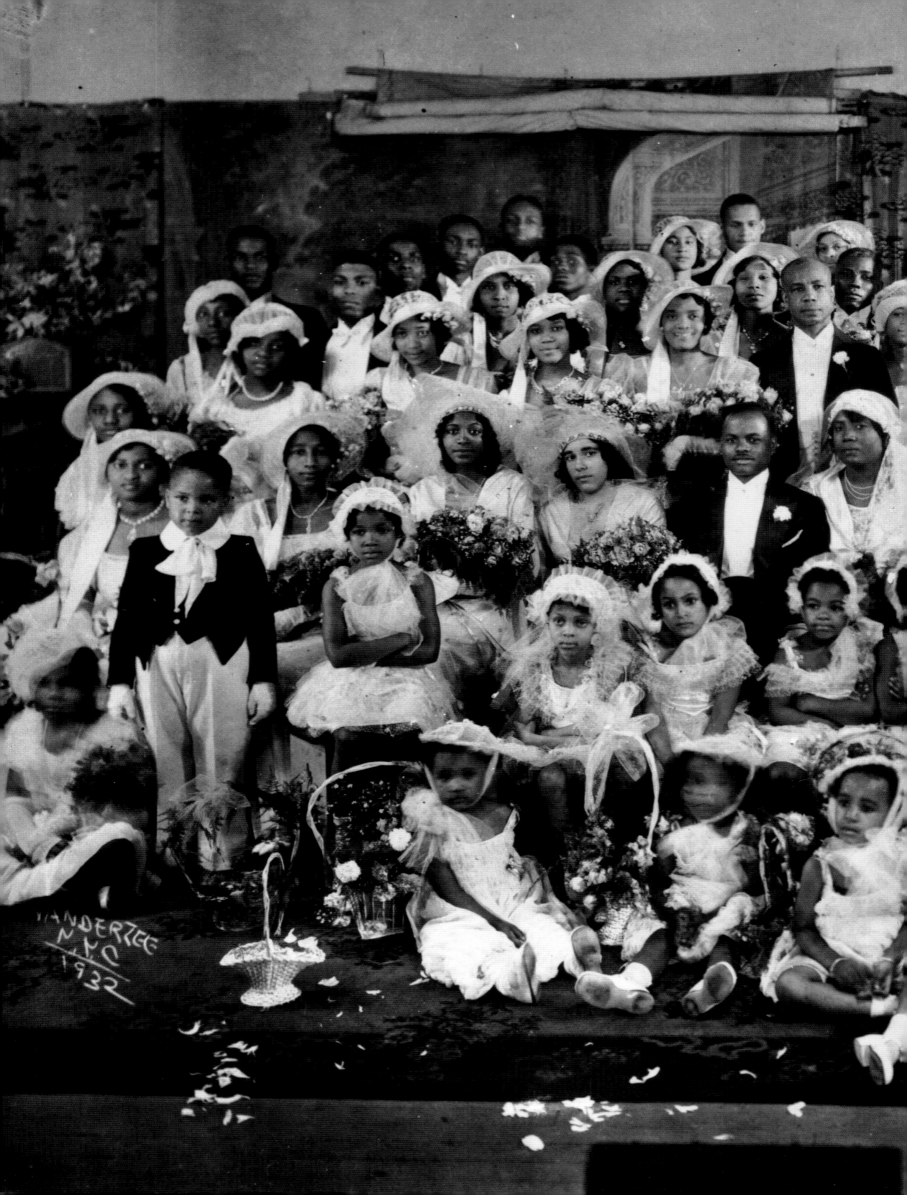

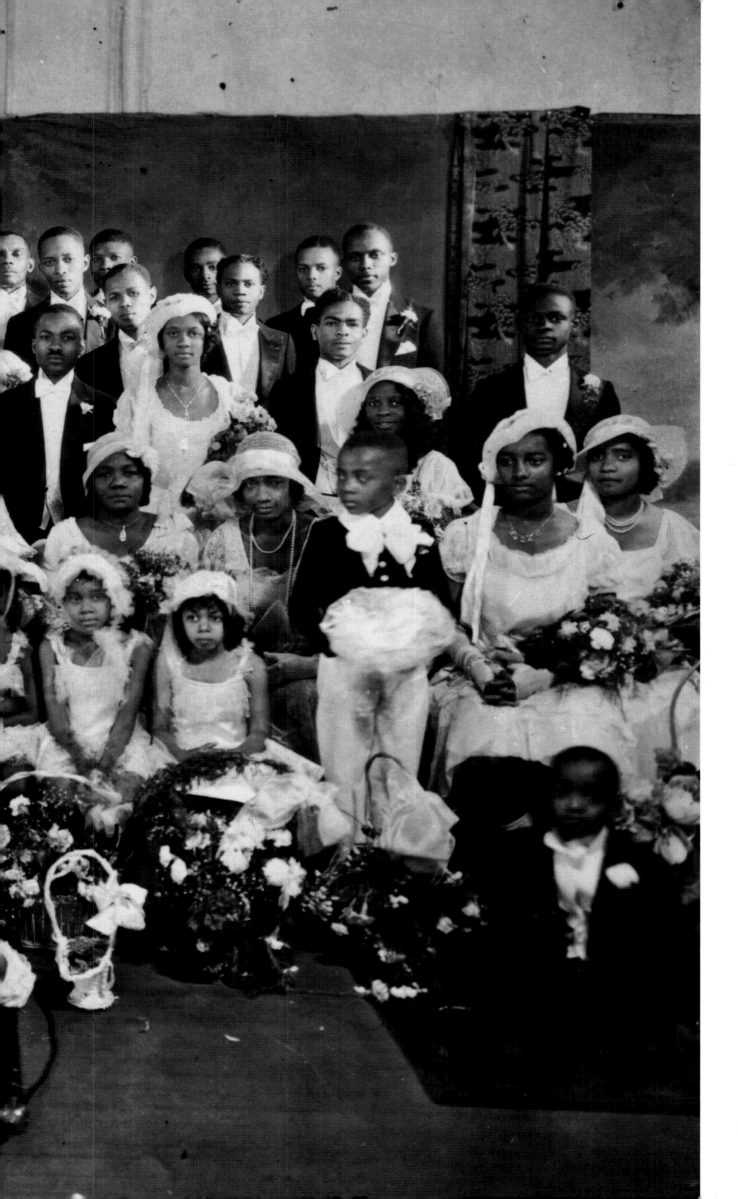

Wedding party, 1932.

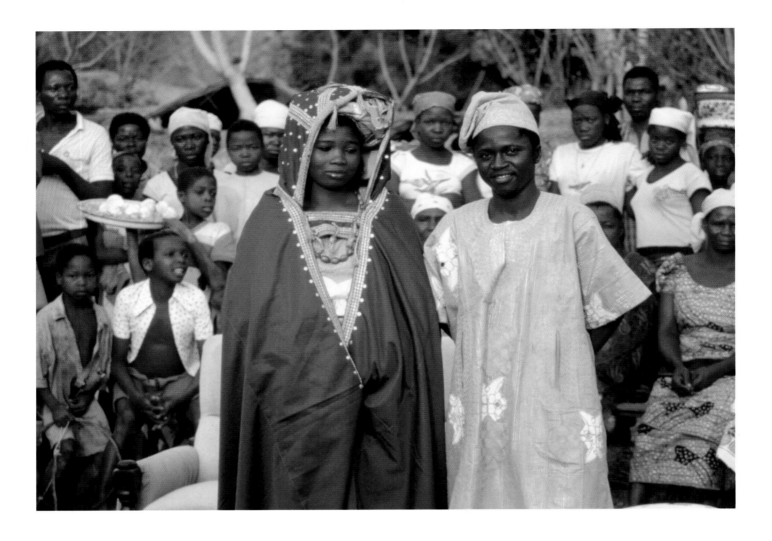

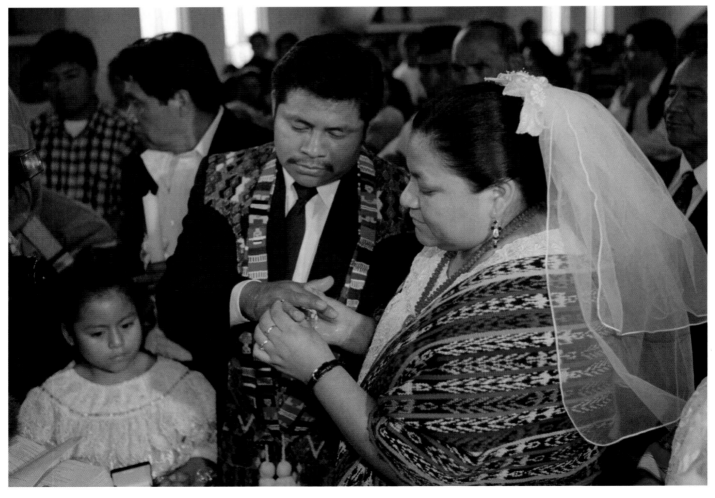

TOP: Wedding in Monkin, Nigeria, 1989.

BOTTOM: Rigoberta Menchu, Nobel Peace Prize winner, marries Angel Camile on January 17, 1998, in the village of San Pedro Jocopilas, Guatemala. Afterward Menchu, who was exiled in the 1980s for her activism in the Indian communities, announced her plans to return to reside officially in Guatemala.

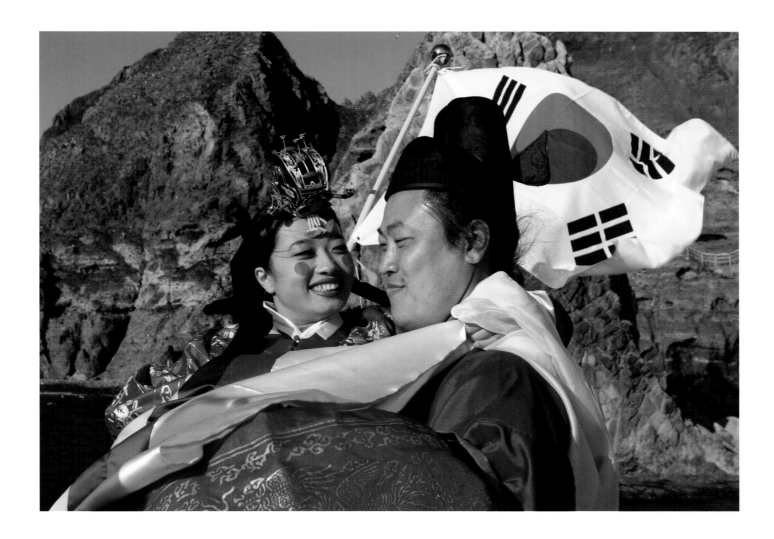

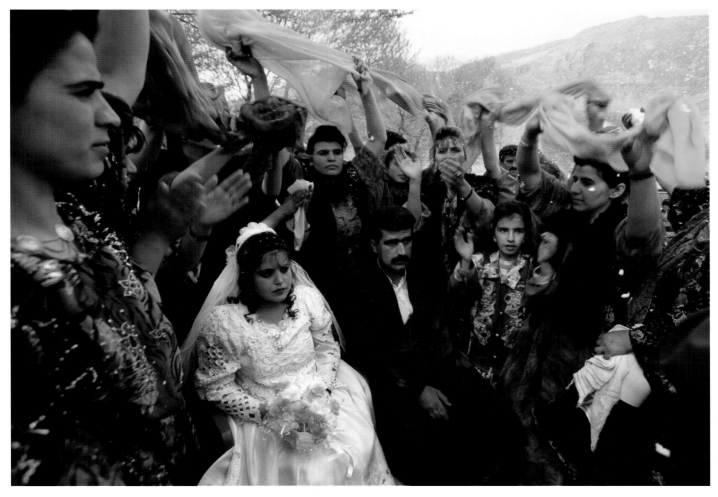

Top: A South Korean couple gets married on the Tokto islets off the Korean peninsula on April 23, 2005. It was the first-ever wedding on Tokto, organized to protest Japan's claim over the islets, which it calls "Takeshima."

Bottom: Celebration during a Kurdish wedding in Jundiyan, Iraq, 1999.

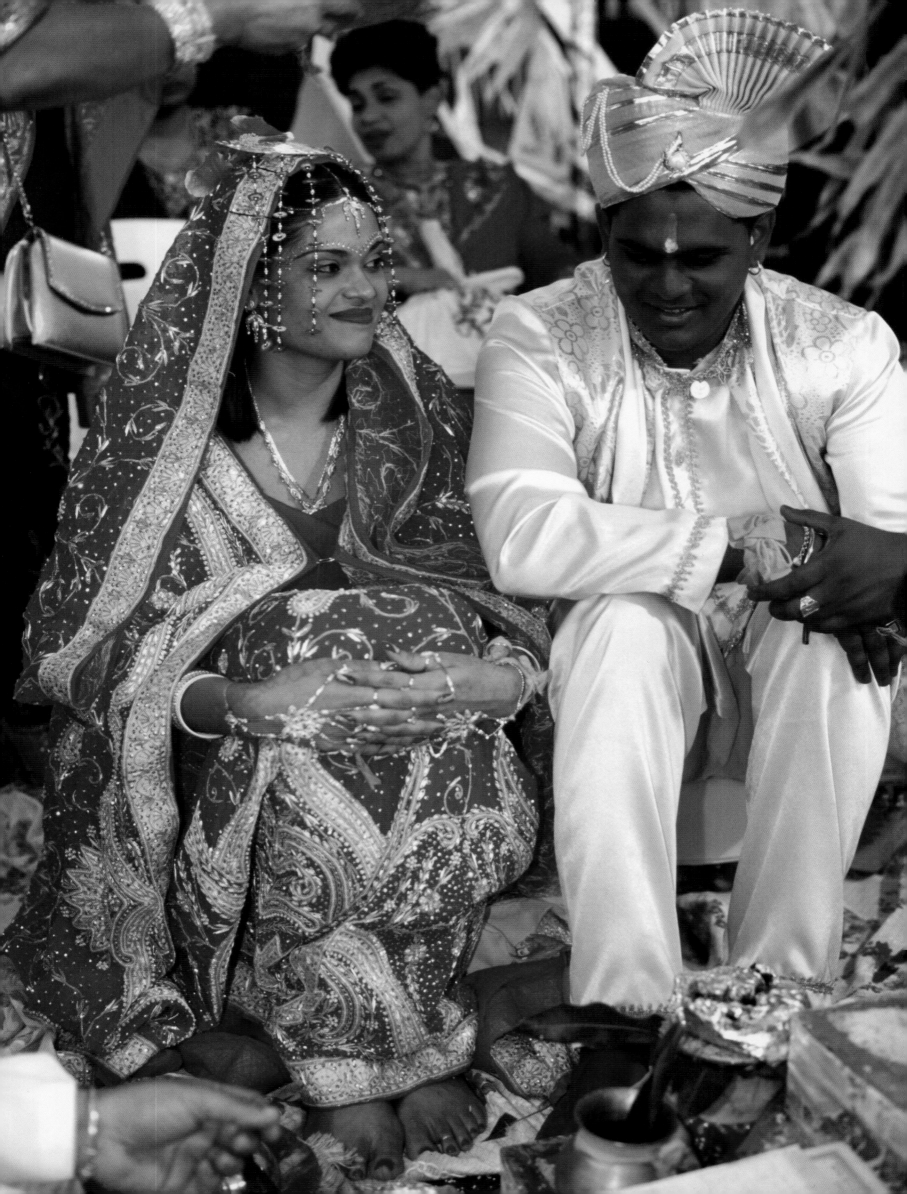

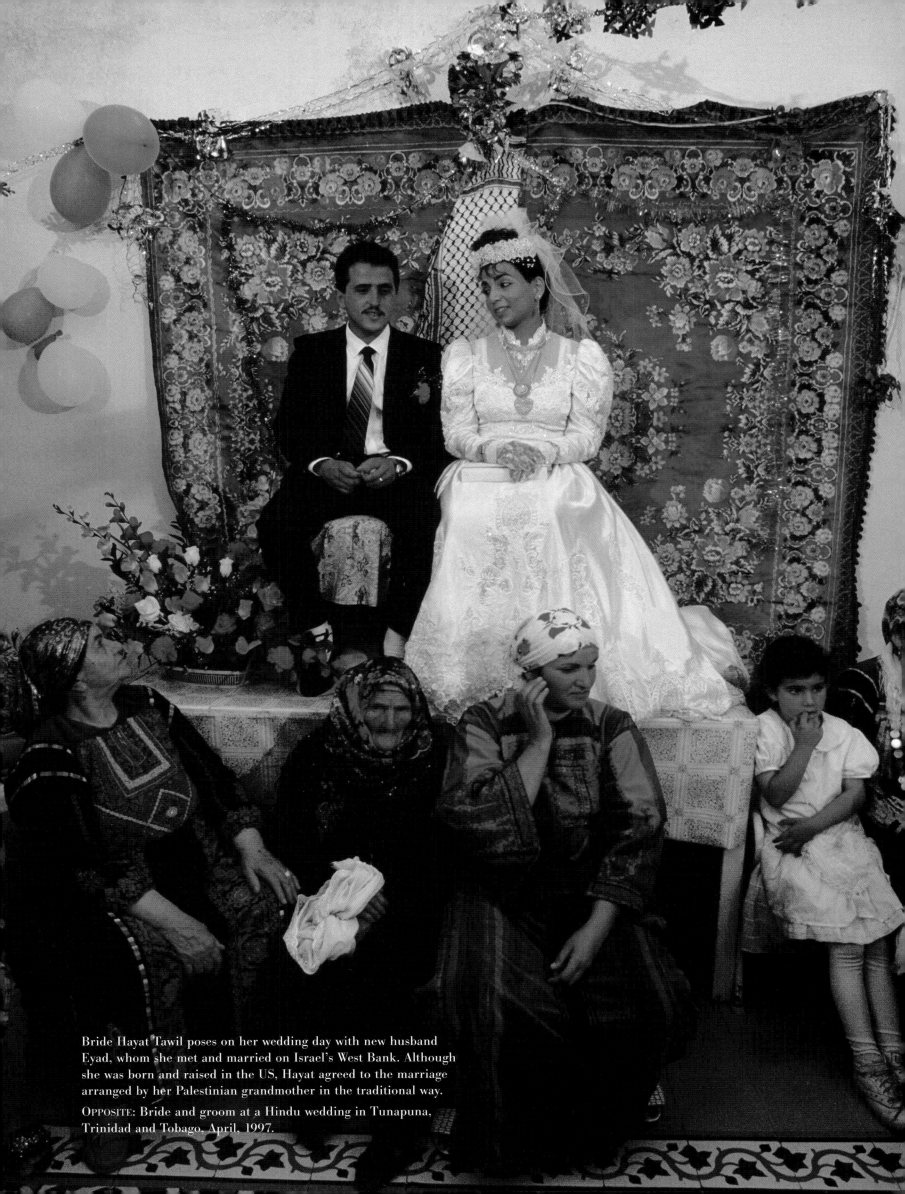

Bride Hayat Tawil poses on her wedding day with new husband
Eyad, whom she met and married on Israel's West Bank. Although
she was born and raised in the US, Hayat agreed to the marriage
arranged by her Palestinian grandmother in the traditional way.

OPPOSITE: Bride and groom at a Hindu wedding in Tunapuna,
Trinidad and Tobago, April, 1997.

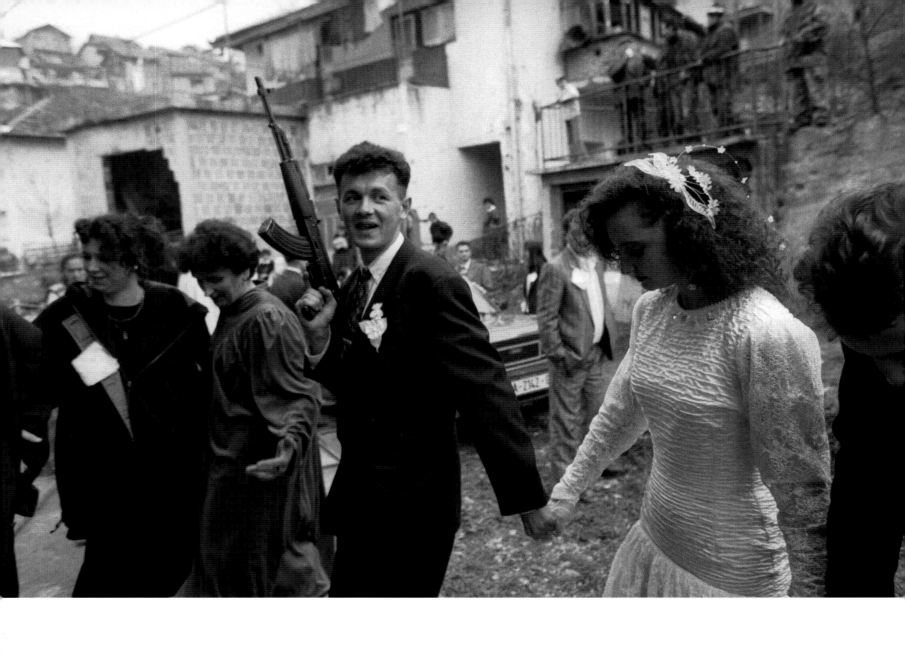

Newlyweds Esad Pitic and Senada Karcic walk to the reception after their wedding ceremony in Sarajevo, Bosnia and Herzegovina, circa 1995. Although the city is not under complete siege, Pitic still carries an assault rifle just in case.

OPPOSITE: An soldier's wedding in Israel, 1967.

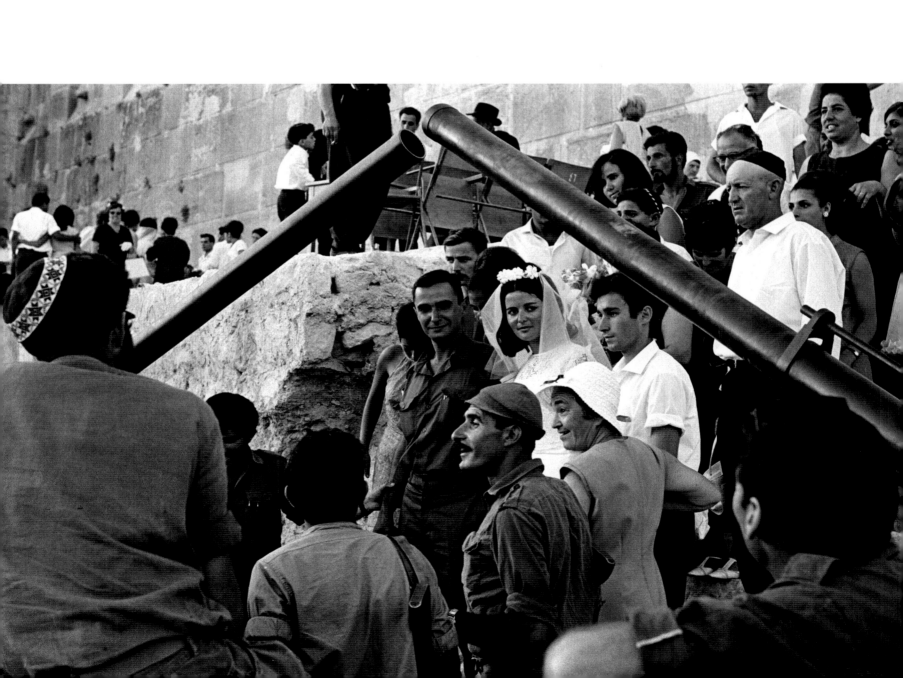

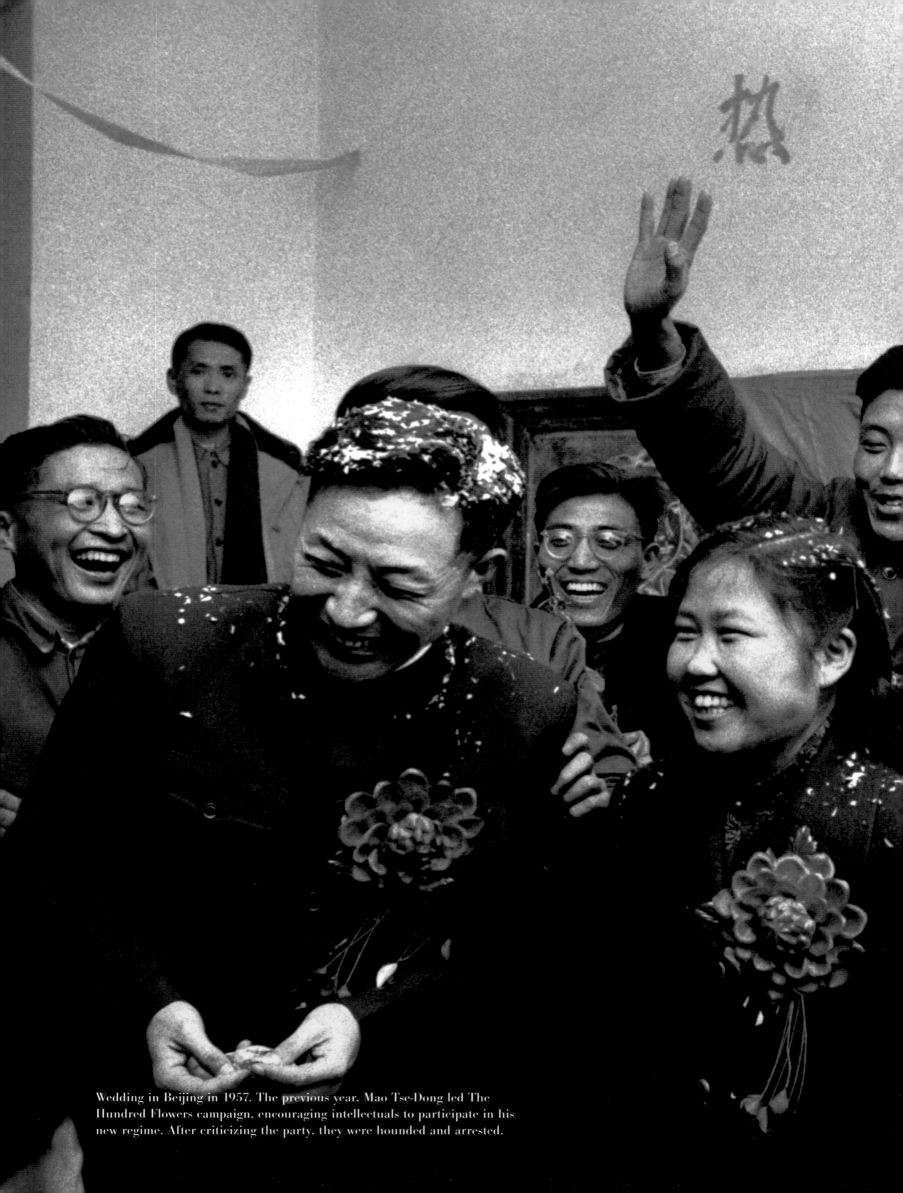

Wedding in Beijing in 1957. The previous year, Mao Tse-Dong led The Hundred Flowers campaign, encouraging intellectuals to participate in his new regime. After criticizing the party, they were hounded and arrested.

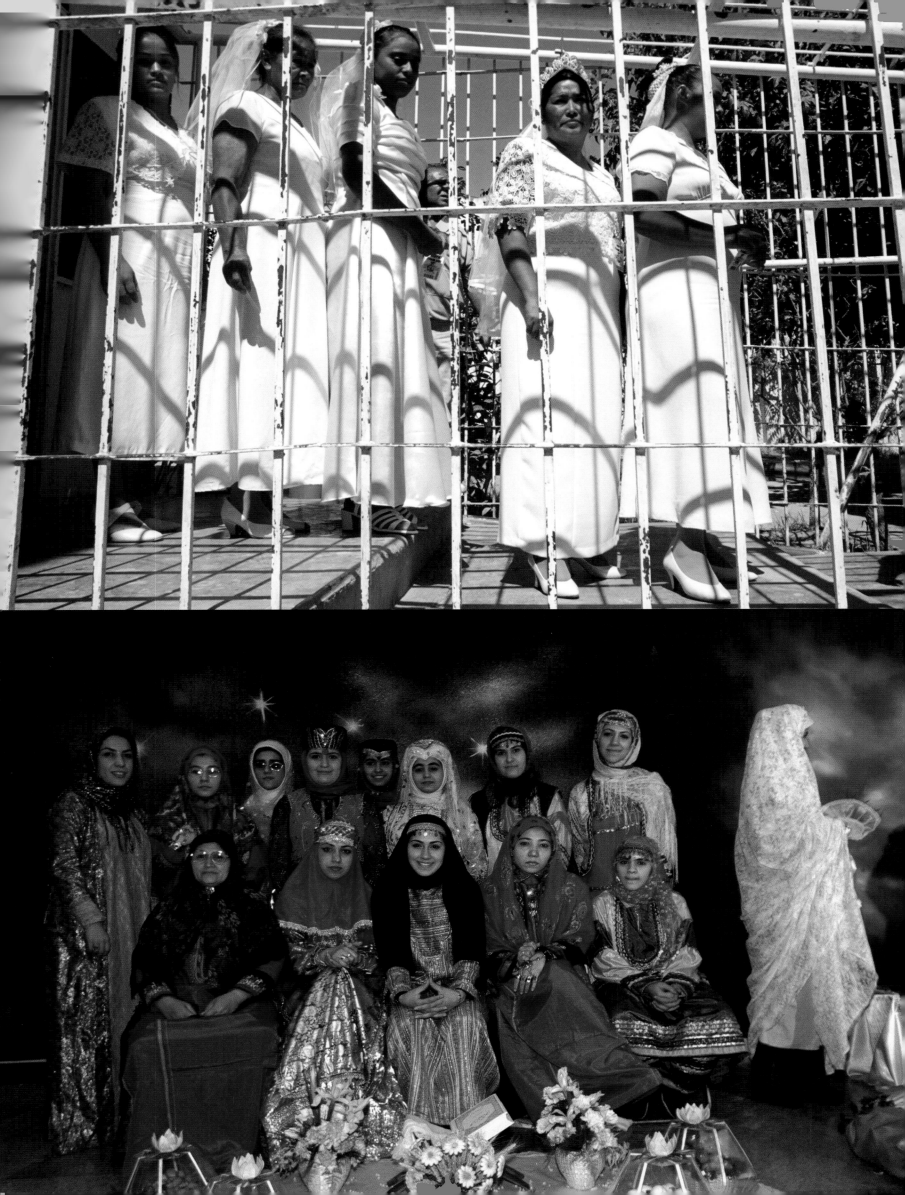

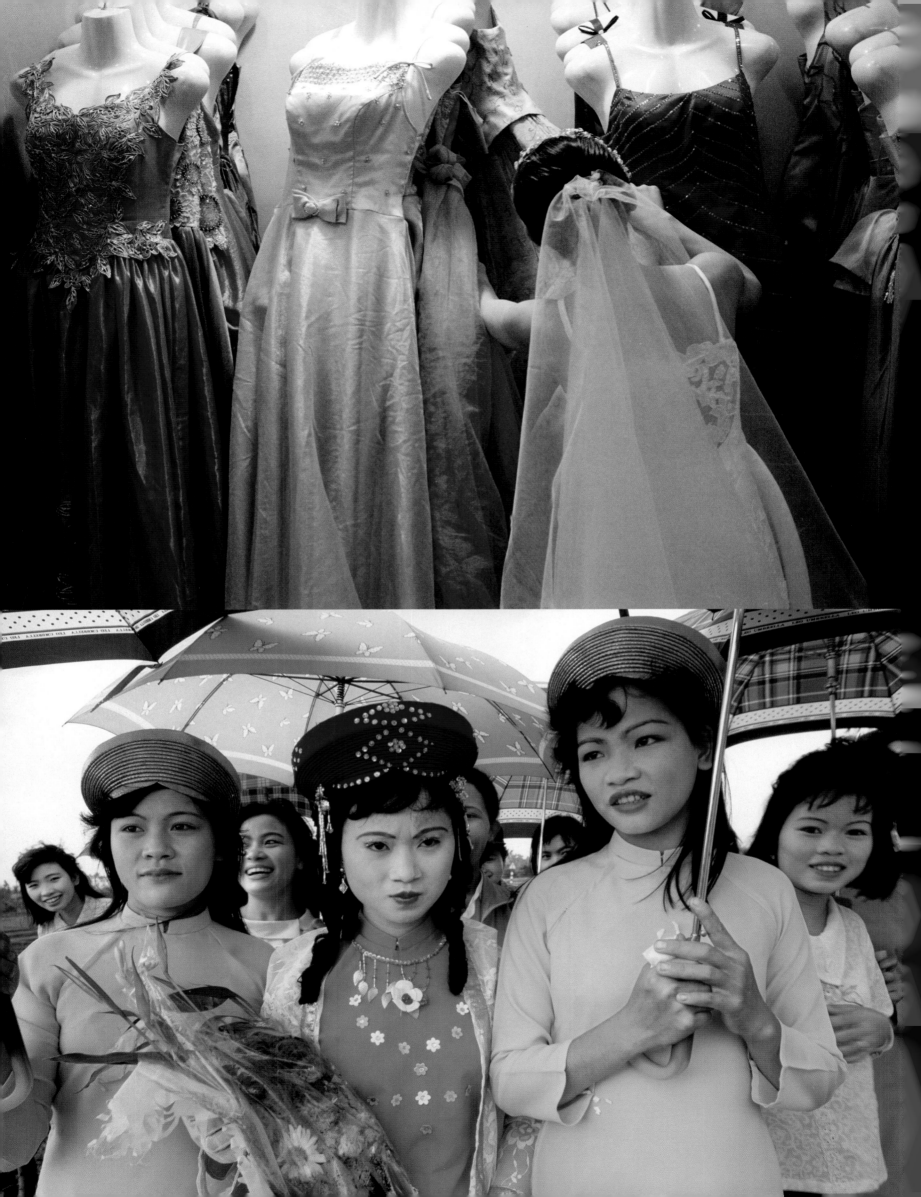

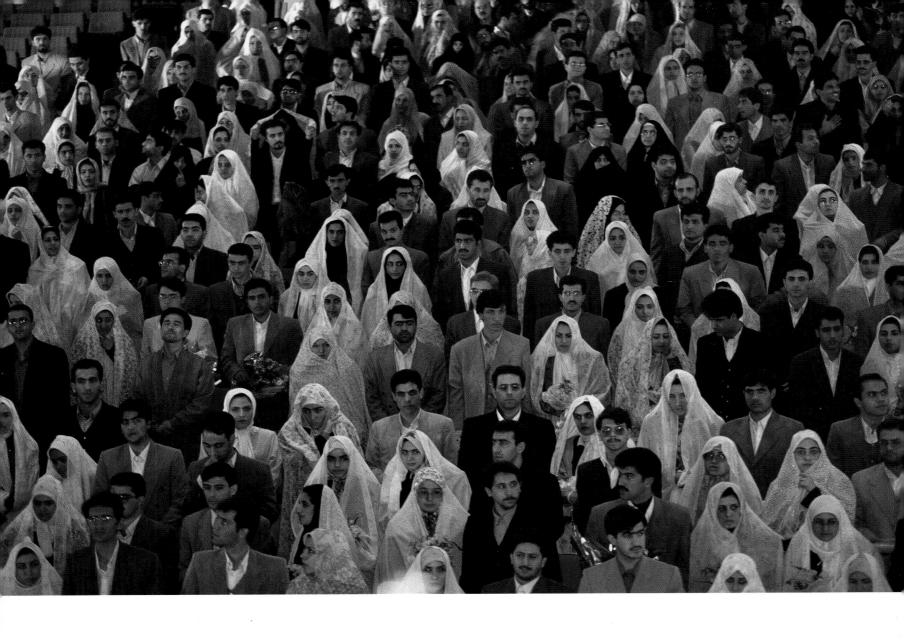

CLOCKWISE FROM ABOVE: Mass wedding in Tehran, Iran, 2001.
A wedding party of four generations in Okinawa, Japan, 1996.
Eighty-five couples release balloons during a mass wedding to mark
Valentine's Day in Hong Kong, 2006.

PREVIOUS PAGE, ABOVE LEFT: Brides file through a prison October 2, 2000 at Ciudad
Juarez, Mexico. Mexican law allows for inmates to marry inside prison walls. Five
couples, including one current inmate and four former inmates, were married by
their church pastor.

BELOW LEFT: Young women wear the tribal wedding gowns of the various provinces of
Iran during it's first-ever mass wedding, with 14,000 university student couples, in
Tehran, 2001. The ceremony was sponsored by the representatives of Iranian supreme
leader Ali Kamenei to save money for the newlyweds during an economic crisis.

PREVIOUS PAGE, ABOVE RIGHT: Wedding Studio's Paris Photo in Beijing, China.

BELOW RIGHT: A wedding procession south of Quang Tri, Vietnam, circa 1990.

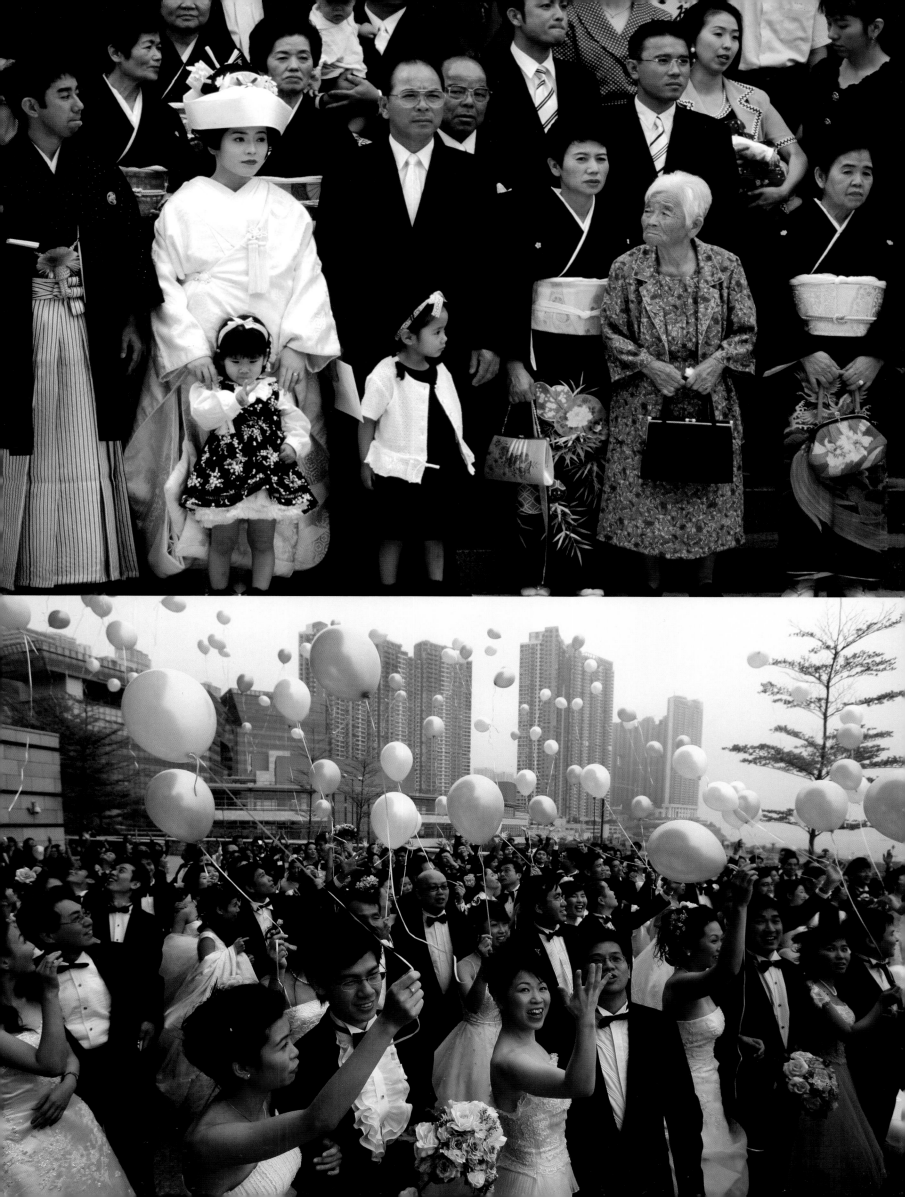

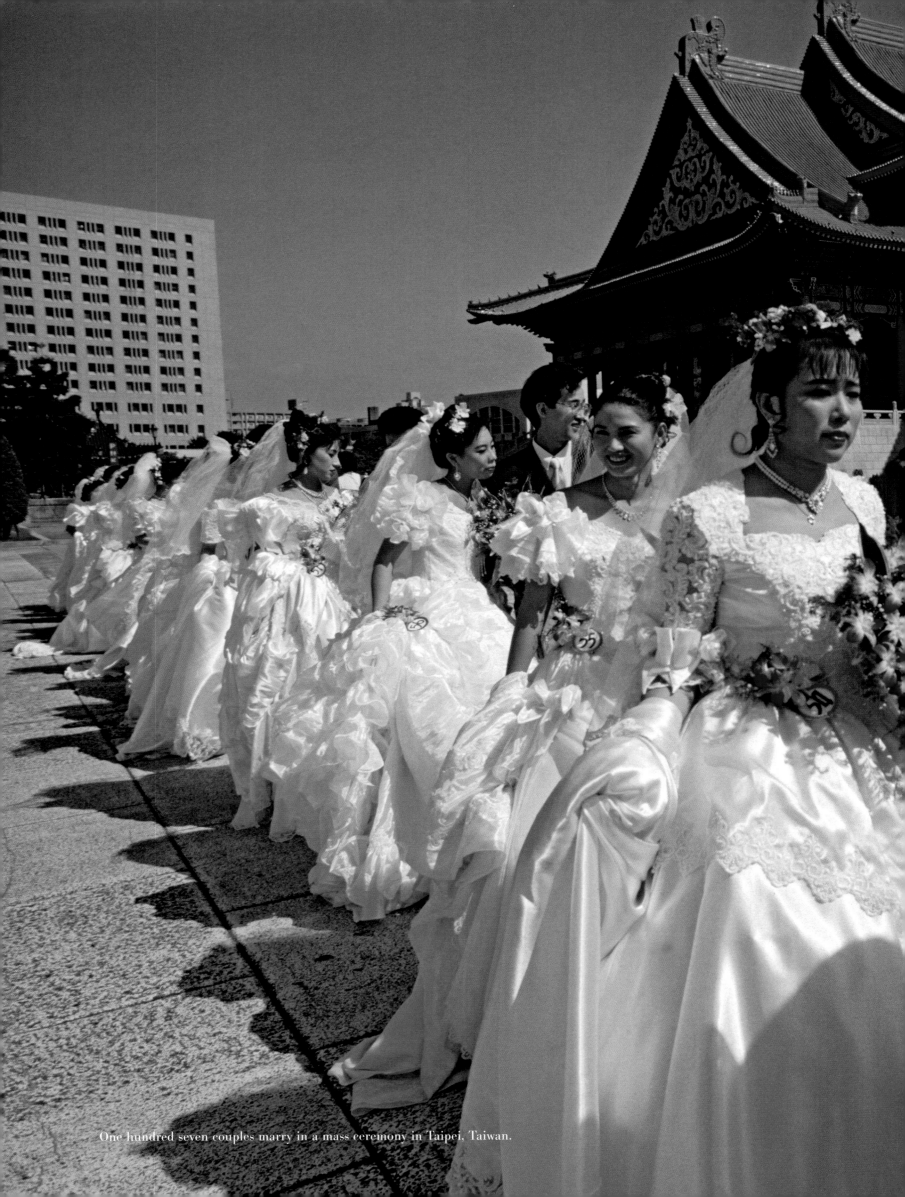

One hundred seven couples marry in a mass ceremony in Taipei, Taiwan.

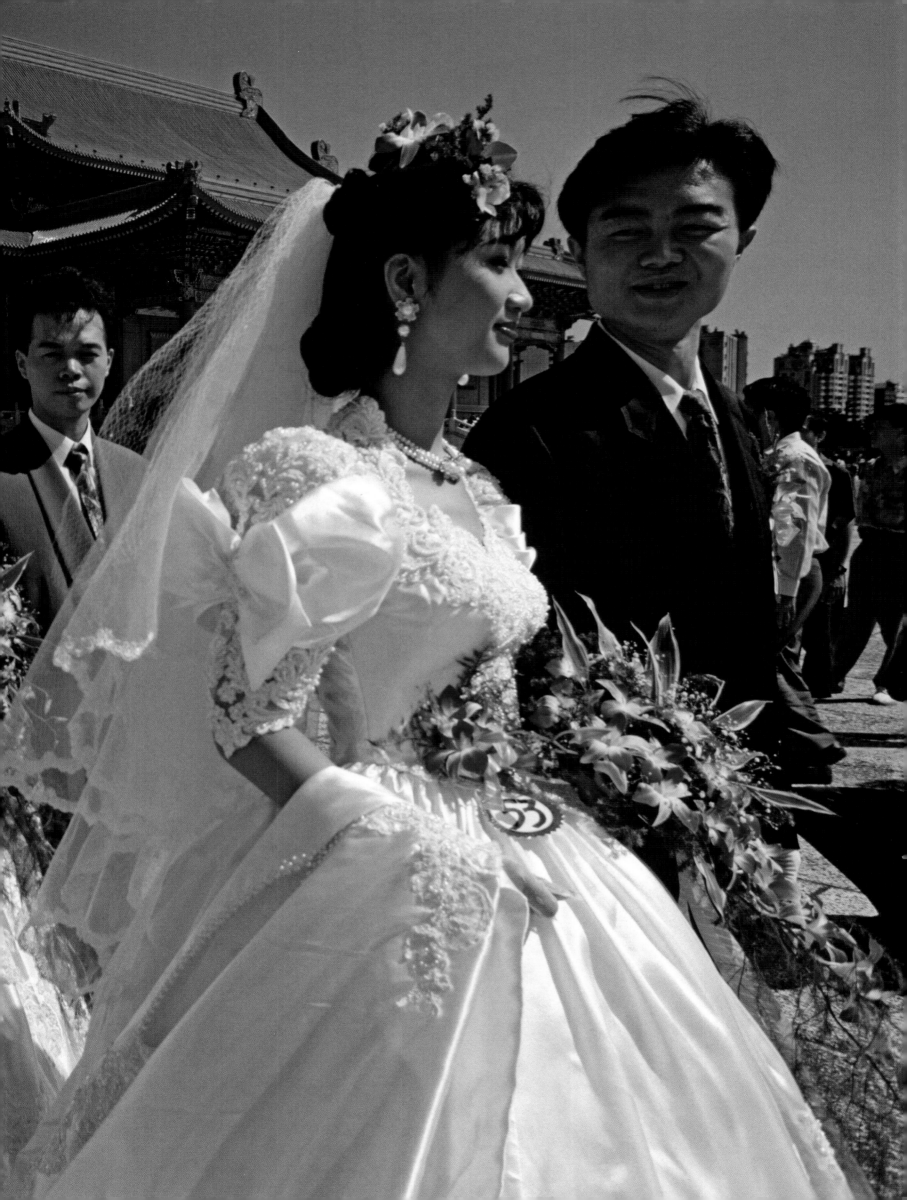

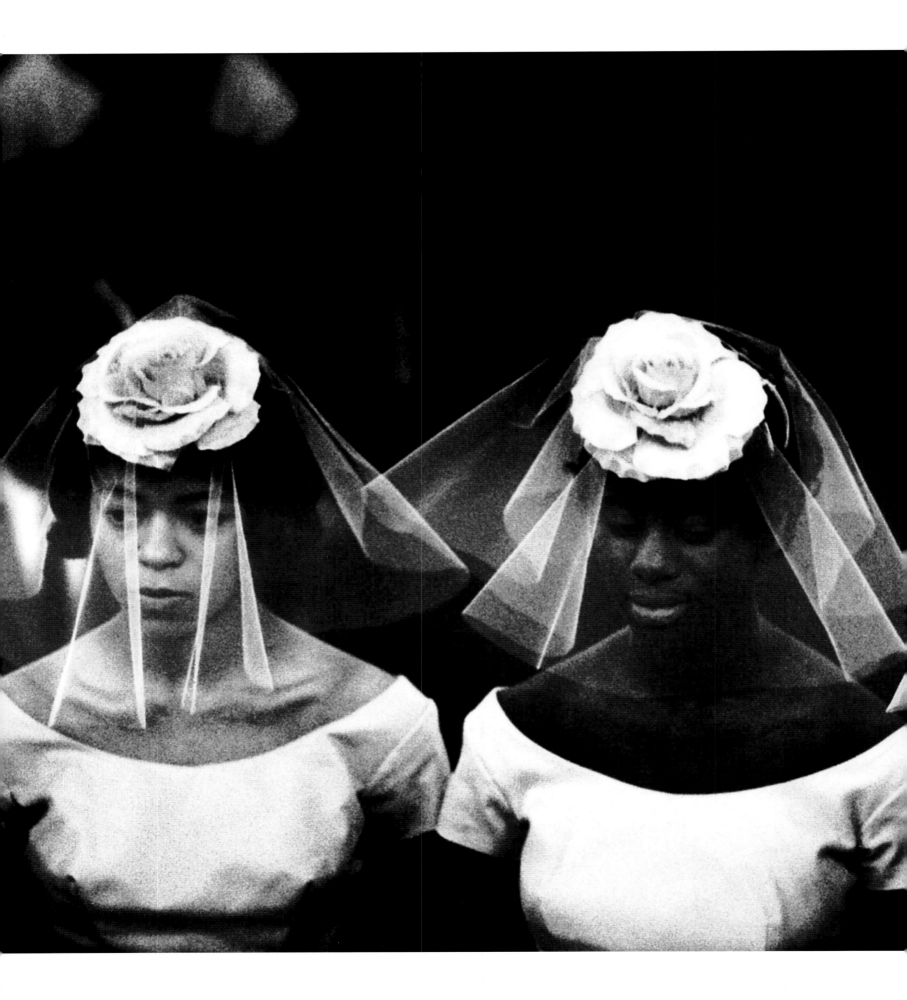

Bridesmaids at a wedding in Harlem, 1962.

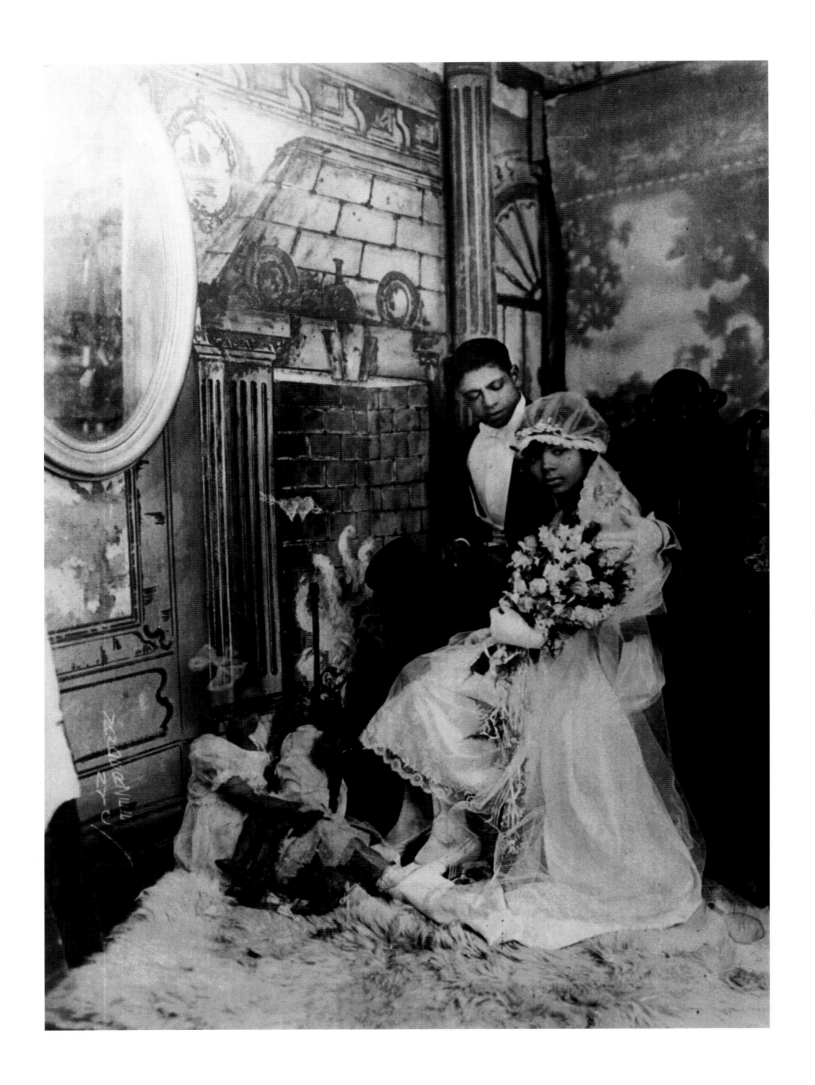

Wedding day portrait of bride and groom, called "Future Expectations, 1926."

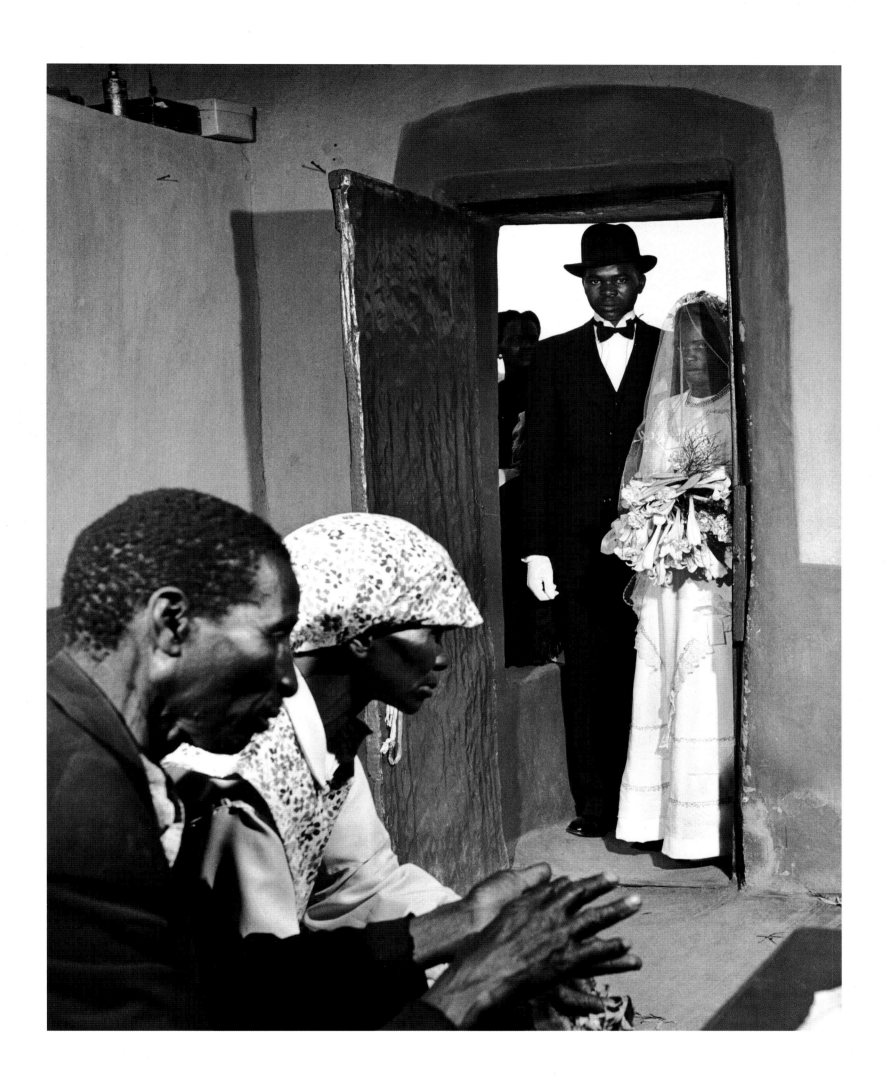

A Basuto bride comes home, South Africa, 1946.

Bride and groom in front of the Eiffel Tower.

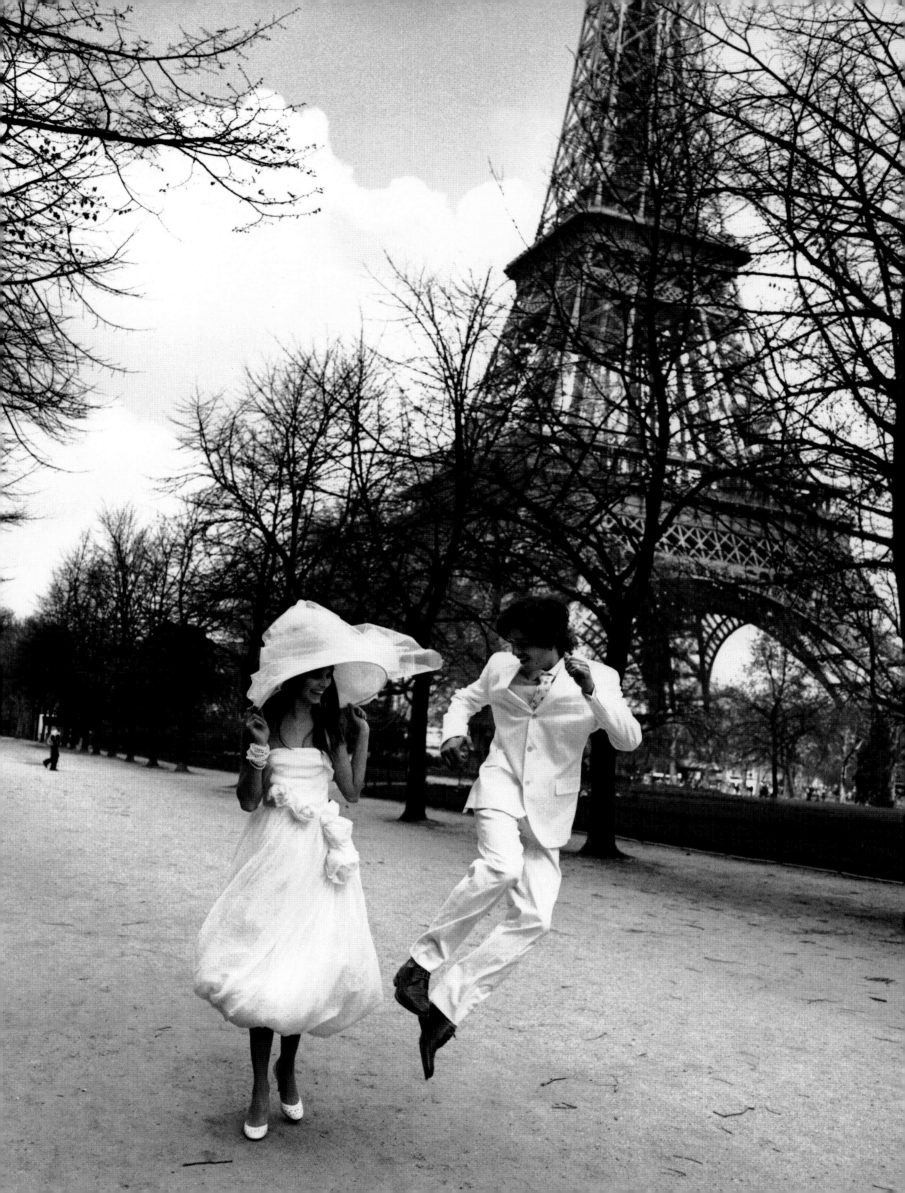

Celebrities

are fascinating by definition, but their marriages captivate millions round the globe. Why are we so obsessed with celebrity weddings? Is it the all-out glamour, watching two gorgeous, airbrushed people fall head over heels in love? Is it the carefully orchestrated hype and well-placed quotes that paint the perfect picture of a storybook romance? Or is it that we're living out our romantic fantasies, imagining ourselves with unlimited budgets, over-the-top celebrations, and the white knights of the movies waiting for us at the altar? Because no matter how many celebrity marriages fail spectacularly we still want to believe in true love, especially the fairy tale love of real life princesses or our celluloid heroes.

Celebrity weddings, whether cloaked in secrecy or deliciously over the top, are simply mesmerizing. Great beauty, great wealth, and fame, paired with romance, form a fascinating combination that is hard to resist. It's often the very qualities that make someone a star that make them so alluring to watch when they get married—the need for attention, the larger-than-life personality, and the obsession with doing everything in grand fashion. When two stars get together, the joining (and possible clashing) of two great egos is twice the fun.

It's the great celebrity love stories that captivate us with their drama and passion relentlessly documented in photographs and magazines. We now know how many of this past century's great romances end, which makes the photos of their wedding day all the more intriguing—the picture of Diana Spencer in her elaborate gown about to marry a man who would break her heart is tragic now, where it once was the stuff of fairy tales. Hollywood's golden couple, Paul Newman and Joanne Woodward, married in Las Vegas without a lot of hype and fanfare and their wedding photo shows them utterly entranced by each other. It's a breathtaking picture of a private moment and a glimpse into a profound love that has endured.

Audrey Hepburn wears the wedding gown designed by Zoe Fontana of Rome for her marriage to James Hanson. September 23, 1952, Rome, Italy.

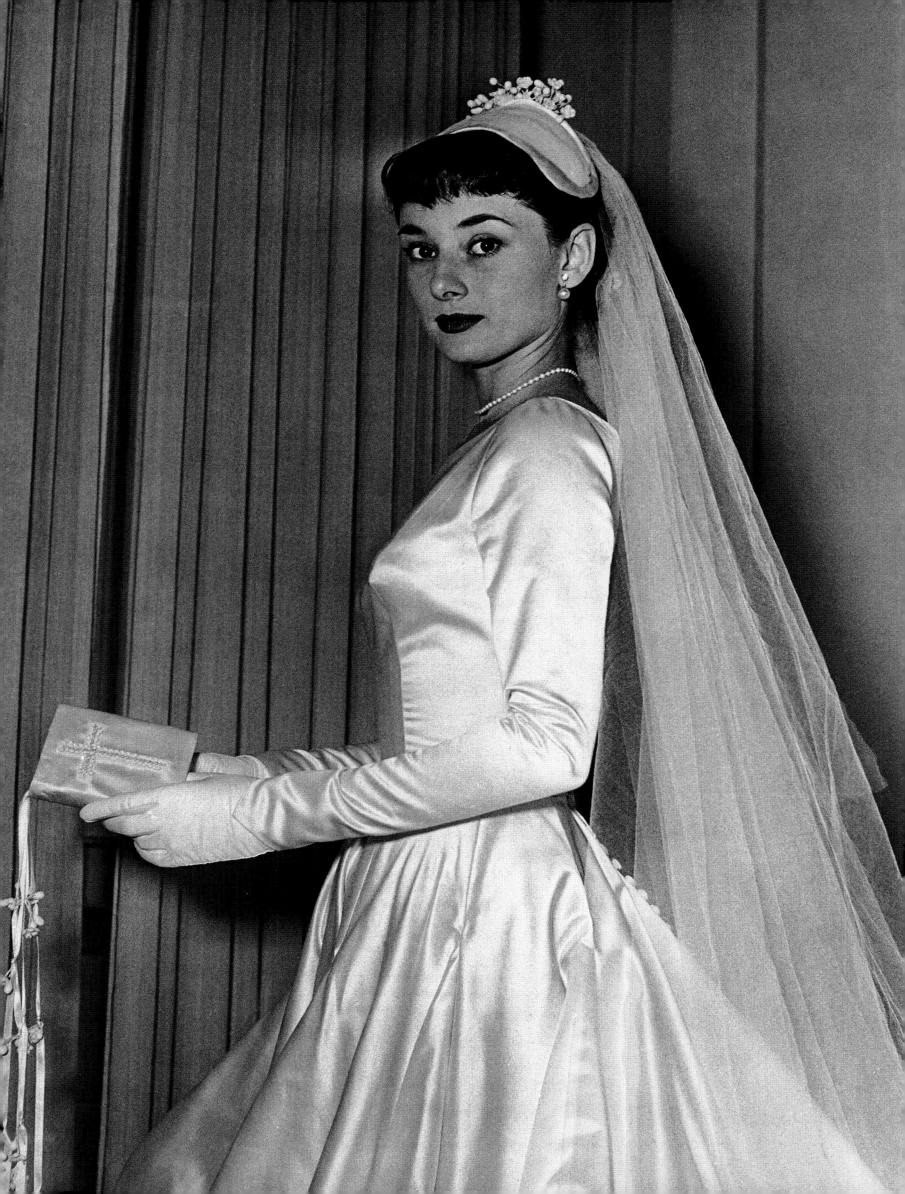

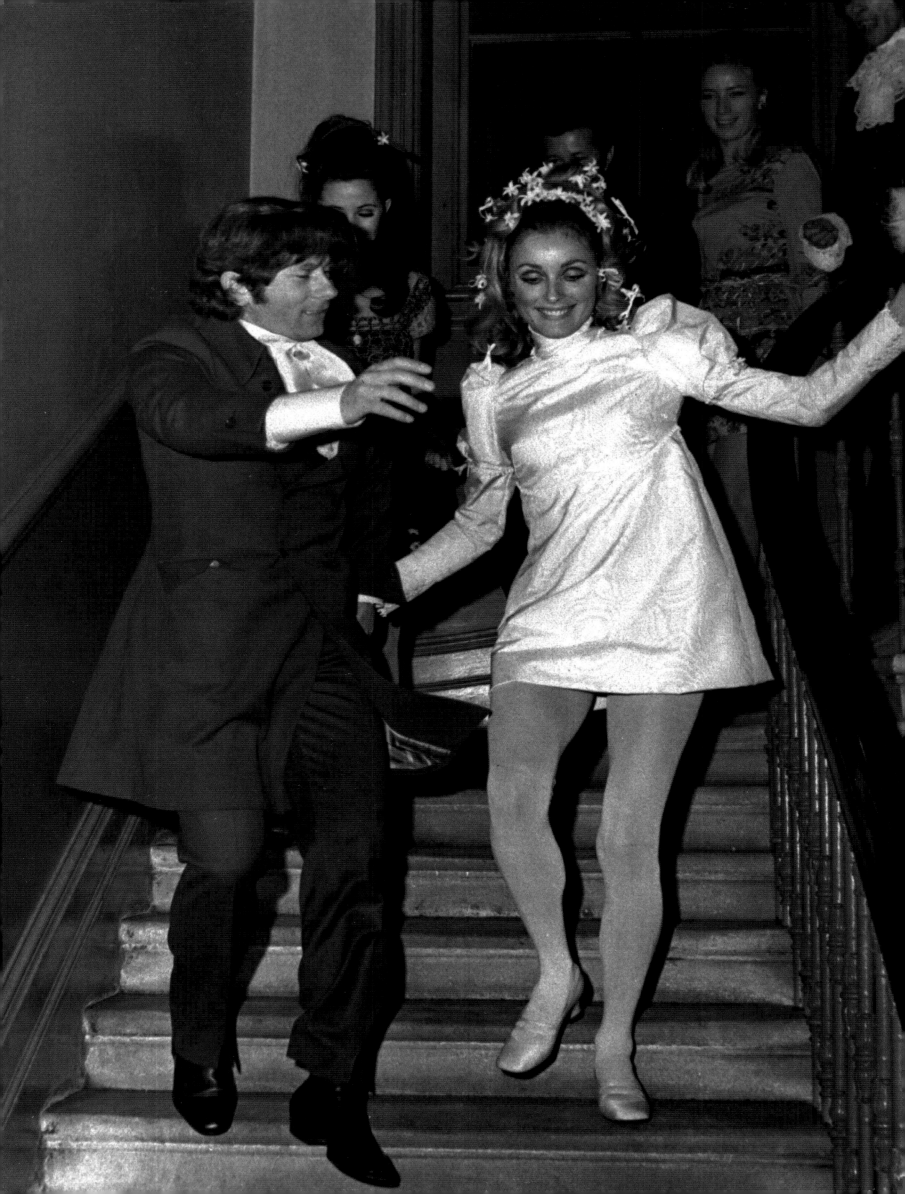

Actress Sharon Tate and director Roman Polanski
after their wedding in London, January, 1968.

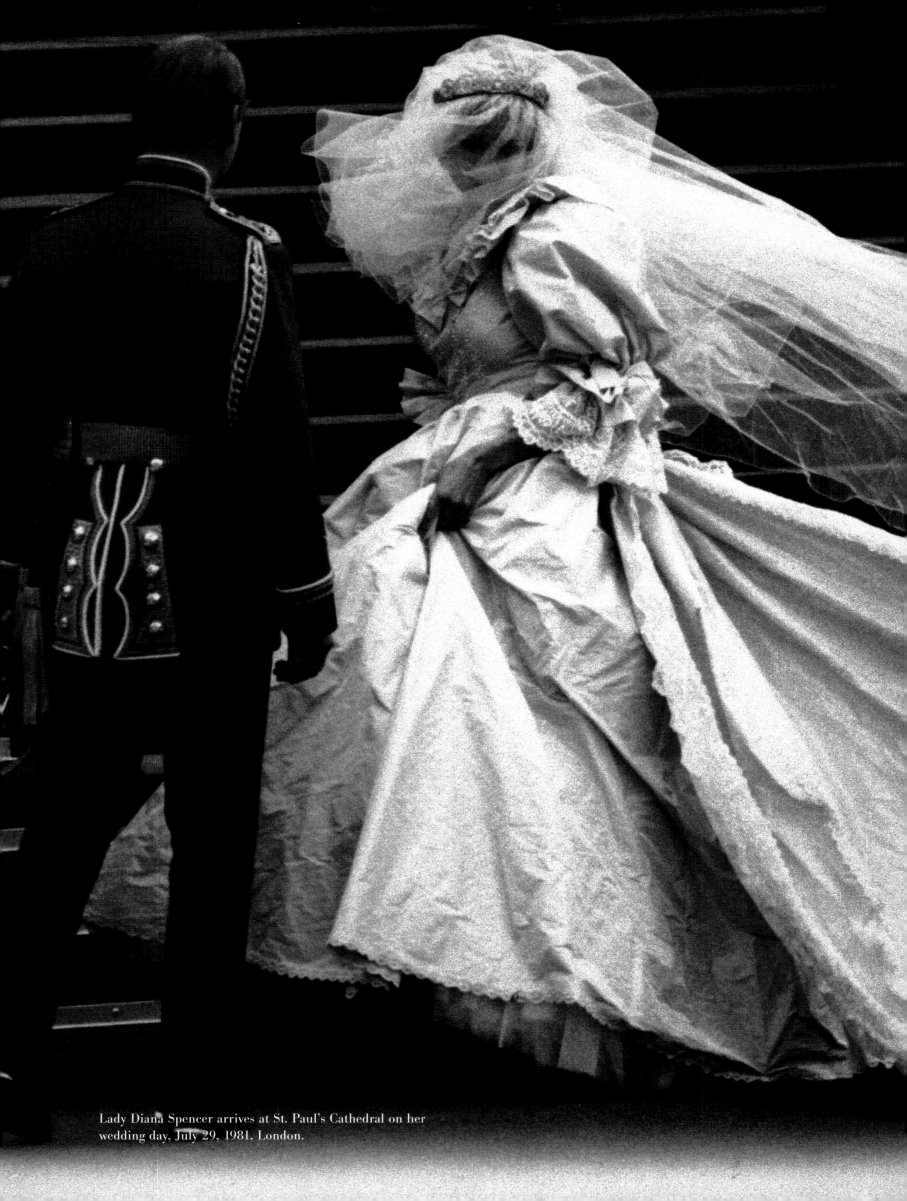

Lady Diana Spencer arrives at St. Paul's Cathedral on her
wedding day, July 29, 1981, London.

93

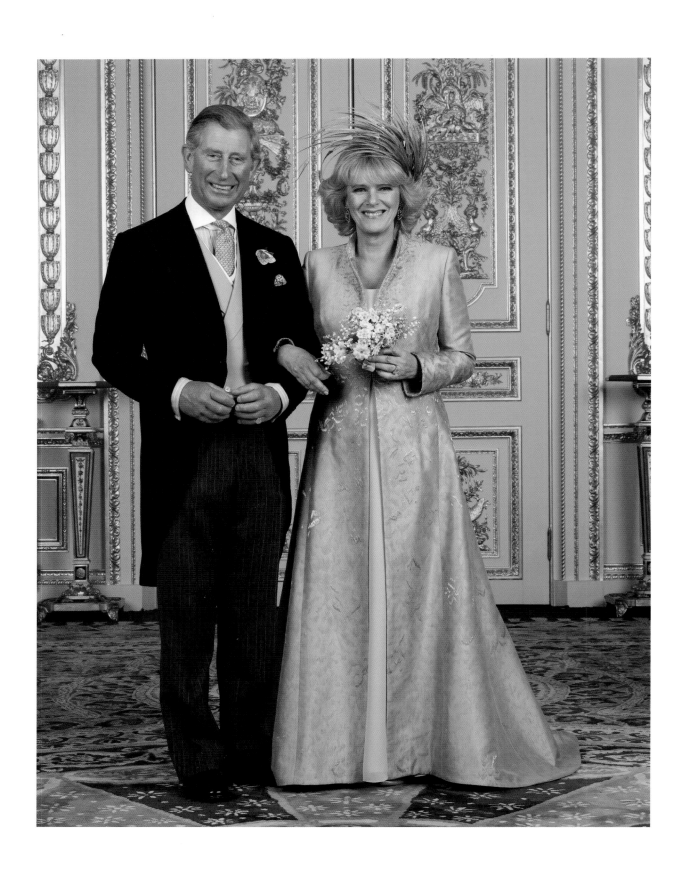

Prince Charles and his new bride Camilla, Duchess of Cornwall,
pose for their official photograph in the White Drawing Room at
Windsor Castle following their marriage, April 9, 2005.

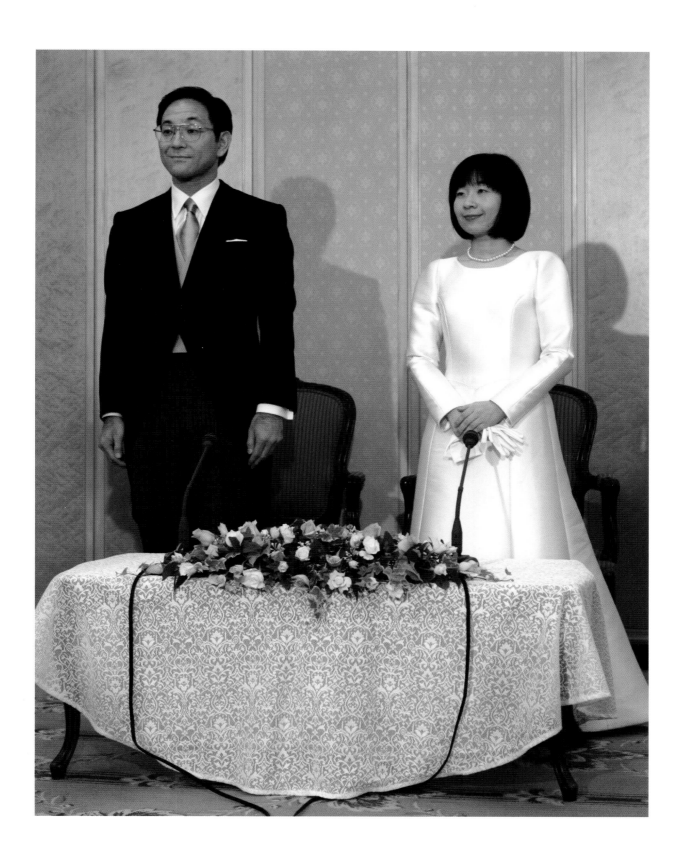

Princess Sayako Kuroda and her husband Yoshiki Kuroda attend a press conference following their wedding ceremony, November 15, 2005. Kurado, the emperor's only daughter, married a commoner at age 36, losing her status in the world's oldest monarchy, Japan.

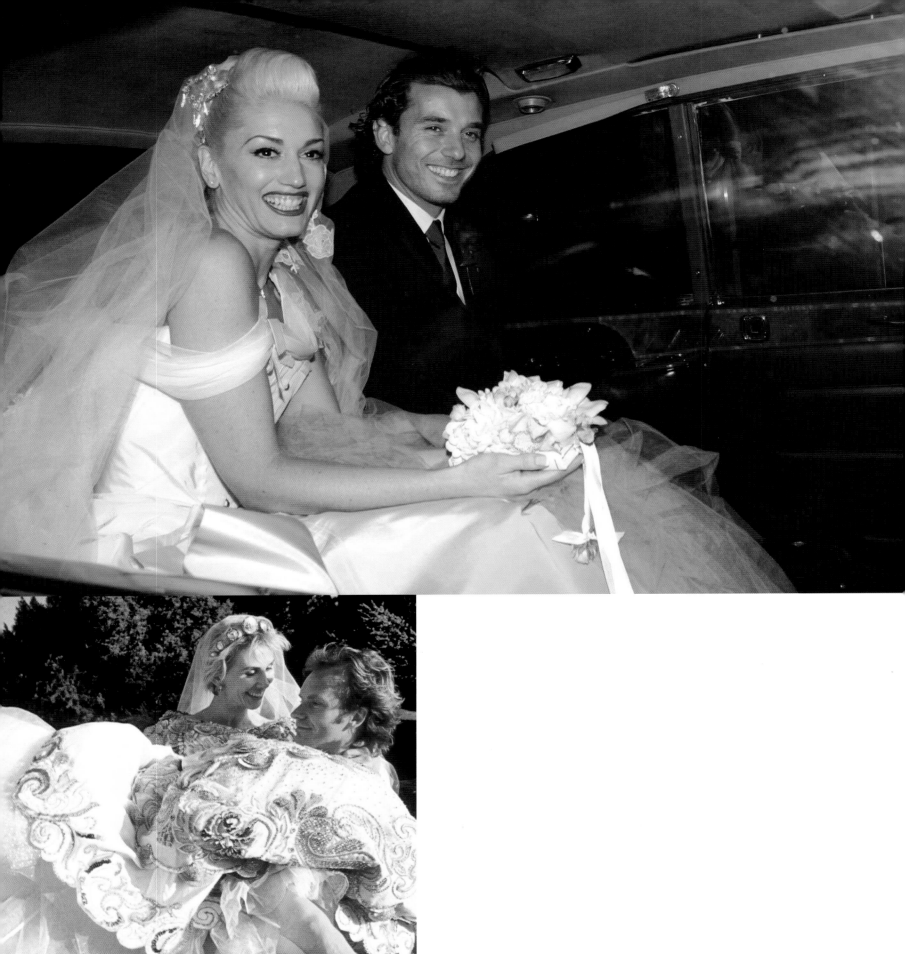

TOP: Gwen Stefani and Gavin Rossdale in London, September 14, 2002.

LEFT: Sting and Trudie Styler in Great Durnford, Wiltshire, England, 1992.

OPPOSITE, CLOCKWISE FROM TOP:
Elton John and David Furnish at their civil partnership ceremony, Guildhall, Windsor, England, on December 21, 2005.

Actress Tammy Lynn Michaels and Melissa Etheridge following their wedding, September 20, 2003, Malibu, California.

Mariah Carey arrives at her Halloween party at Cain, October 31, 2004, New York City.

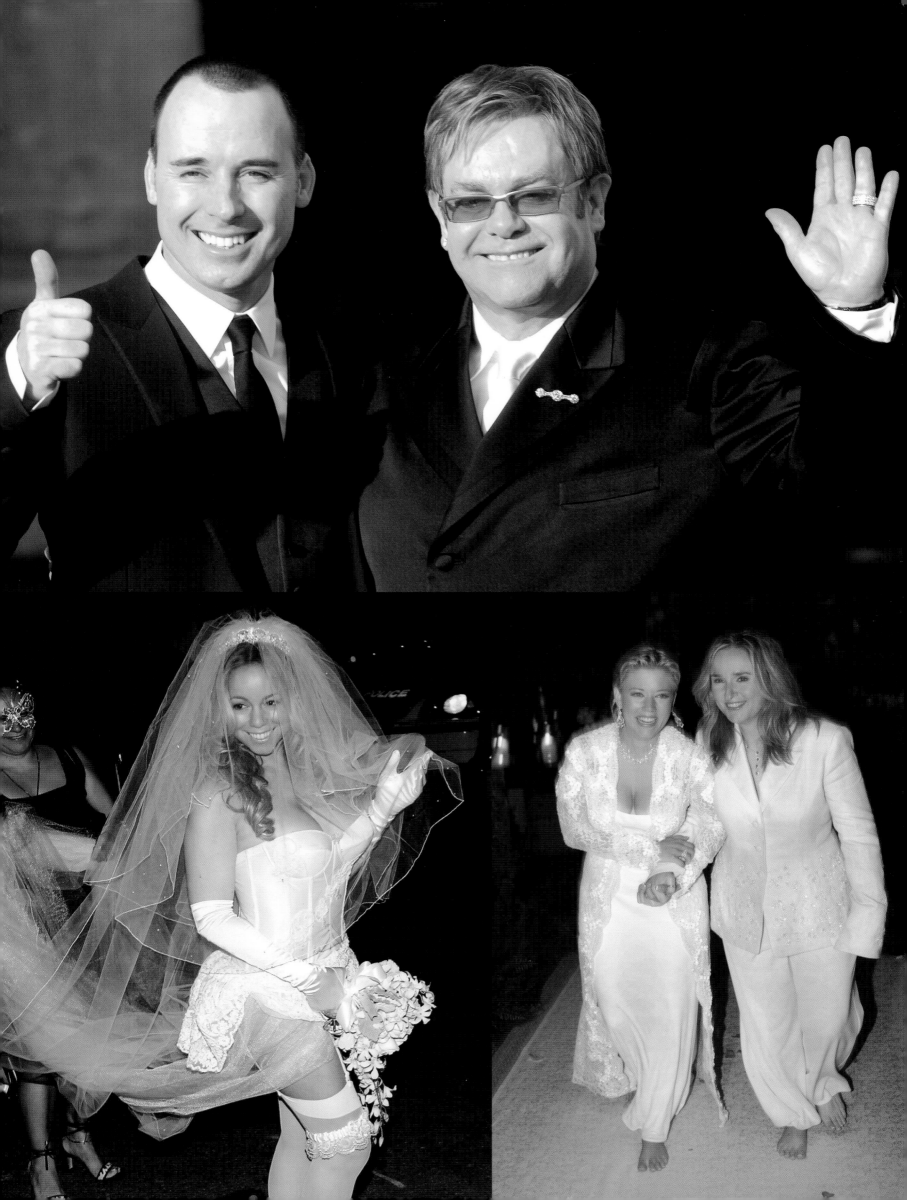

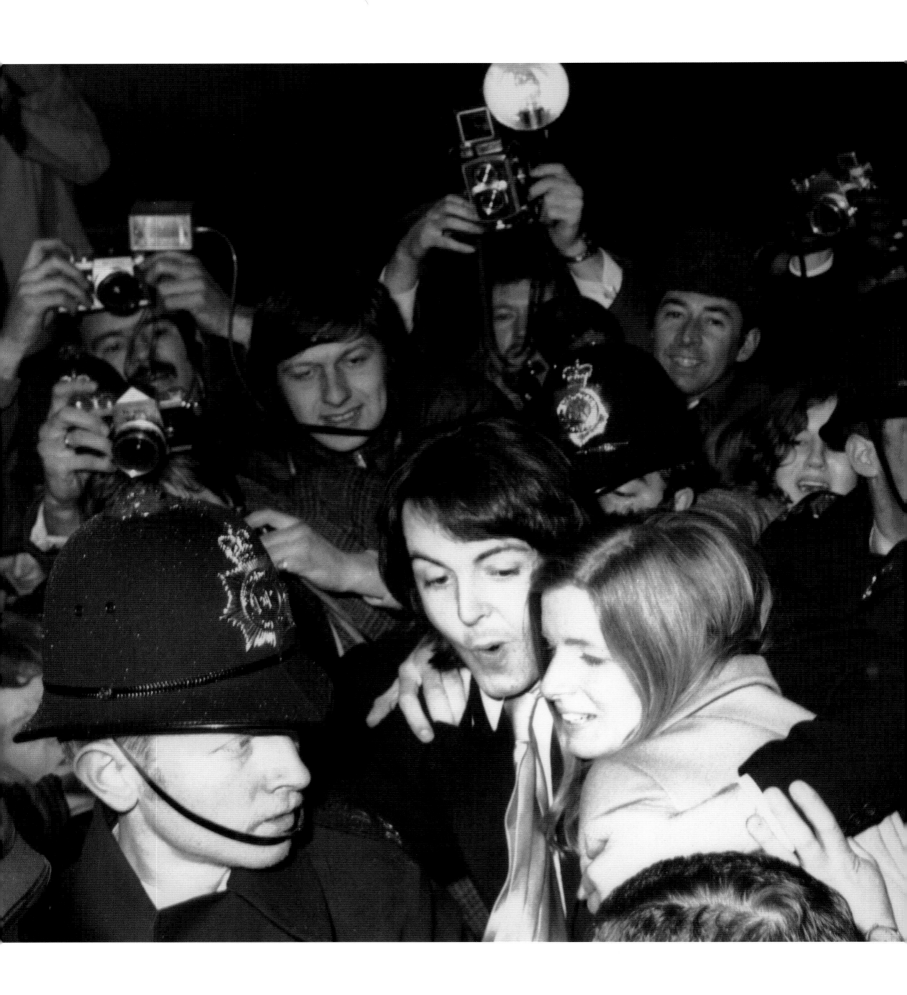

Paul McCartney and his wife Linda as they struggle through the crowds gathered
outside Marylebone Register Office, where they have just married, March 12, 1969.

OPPOSITE: John Lennon and Yoko Ono, after their wedding at
the Rock of Gibraltar on March 20, 1969.

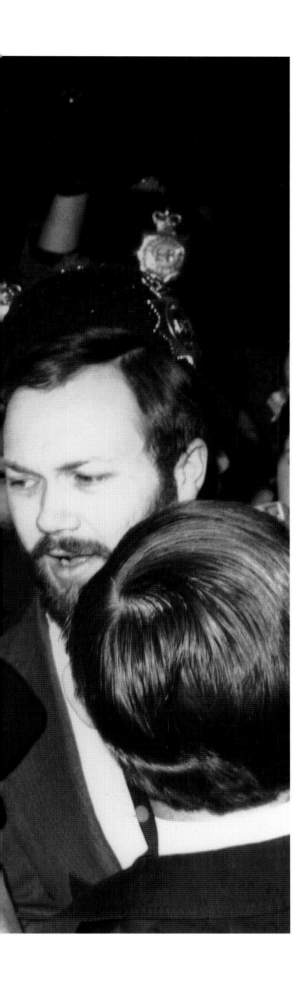
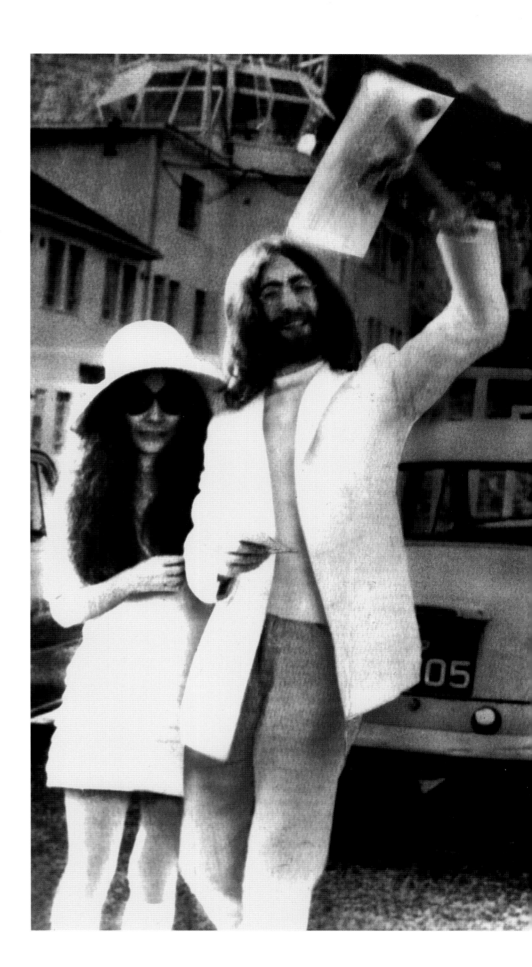

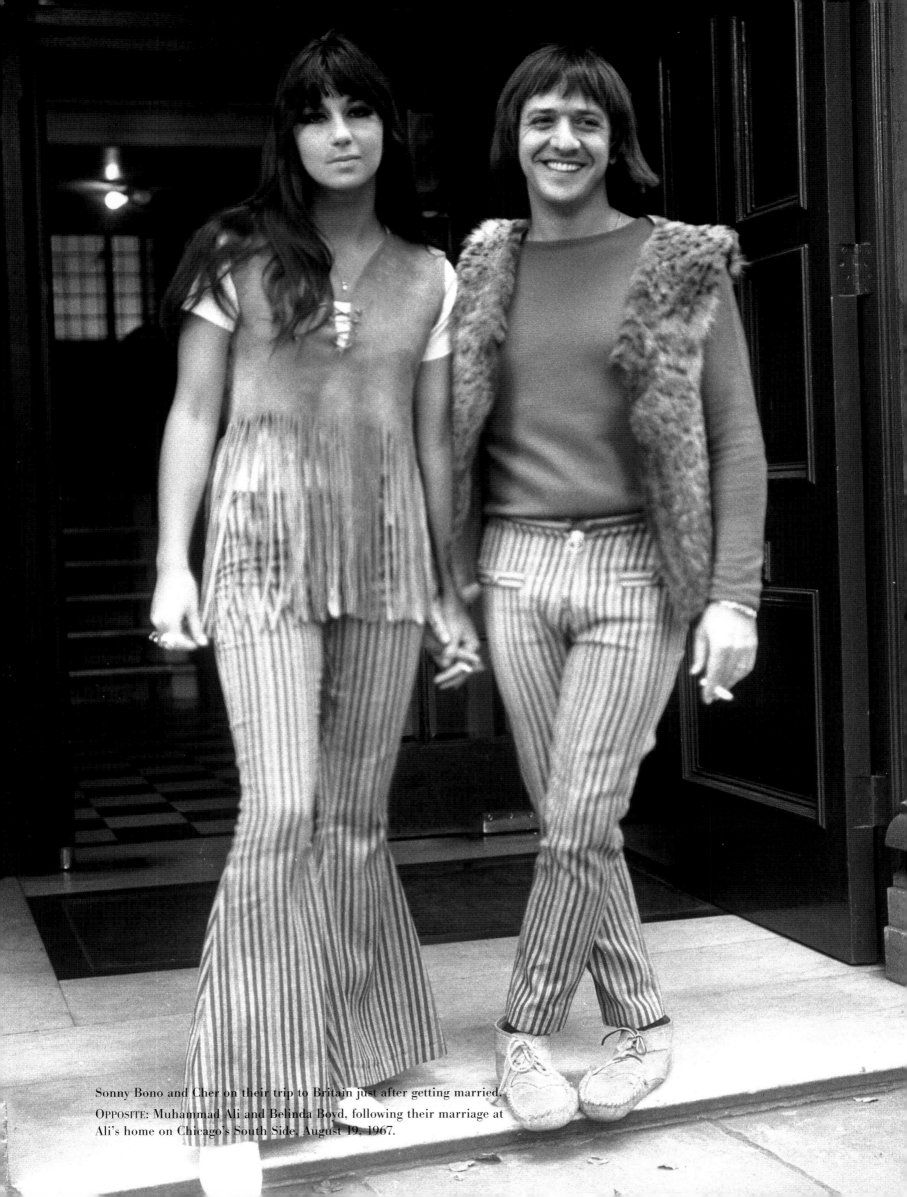

Sonny Bono and Cher on their trip to Britain just after getting married.

OPPOSITE: Muhammad Ali and Belinda Boyd, following their marriage at Ali's home on Chicago's South Side, August 19, 1967.

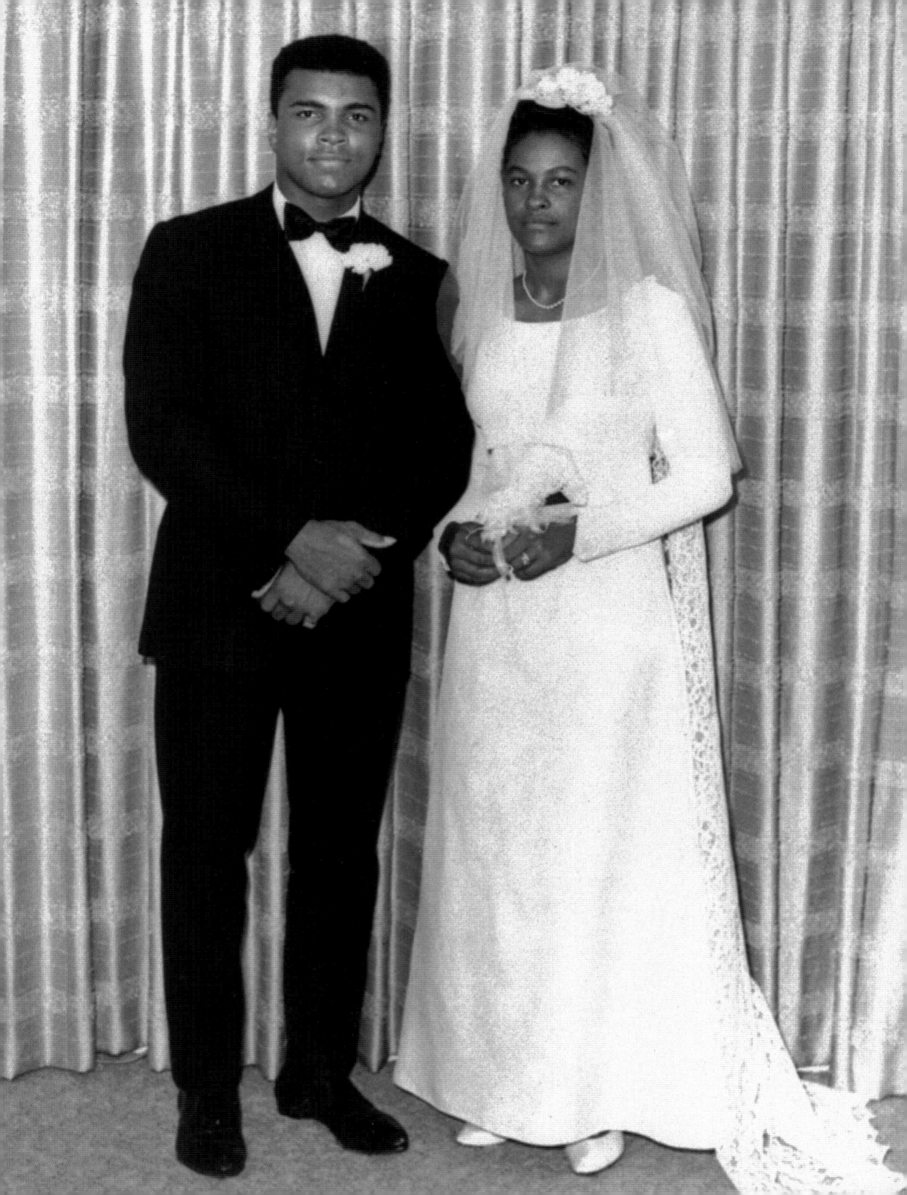

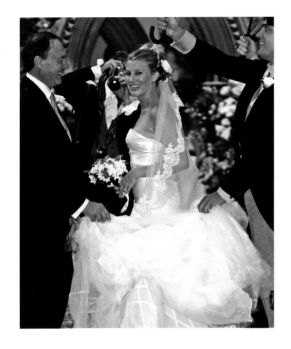
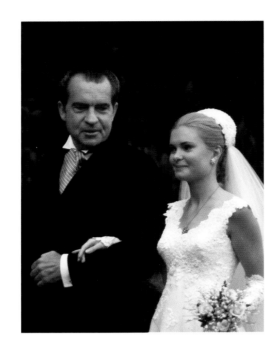
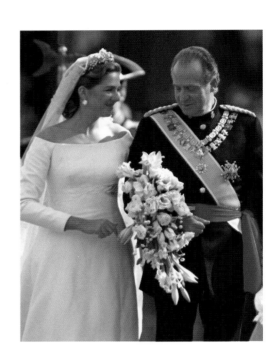
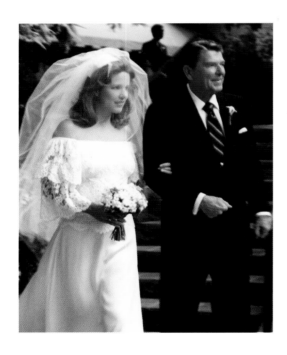
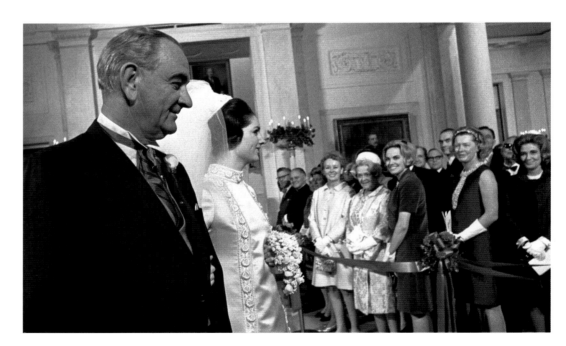

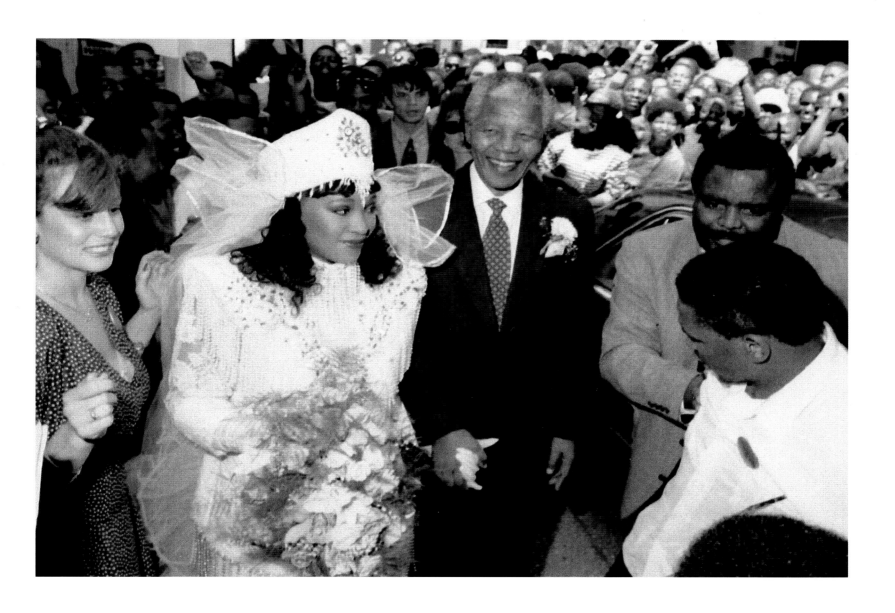

African National Congress leader Nelson Mandela and his daughter Zindzi,
before her marriage to Zweli Hlongwane in downtown Johannesburg, South
Africa, October 24, 1992.

OPPOSITE, CLOCKWISE FROM TOP LEFT:
Tom Parker Bowles and Sara Buys' wedding at St. Nicholas Church,
Rotherfield Greys, England, on September 10, 2005.
President Richard Nixon escorts his daughter Tricia down the aisle at the
White House, Washington DC, June 12, 1971.
King Juan Carlos leads his daughter into the Santa Eulalia Cathedral,
Barcelona, Spain, October 4, 1997.
President Johnson and his daughter Lynda file past guests on the way to
the East Room. Washington DC, December 9, 1967.
President Ronald Reagan escorts his daughter Patti, August 14, 1984.

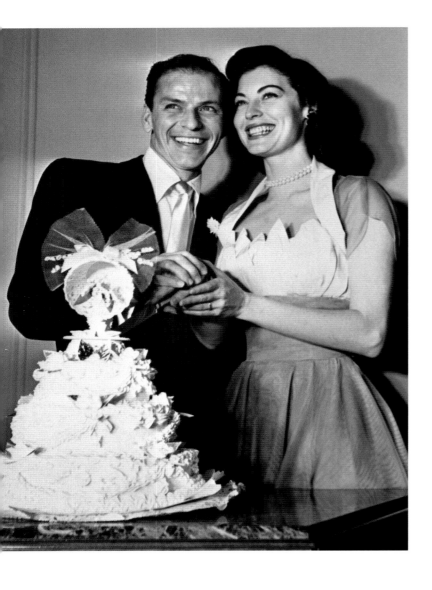 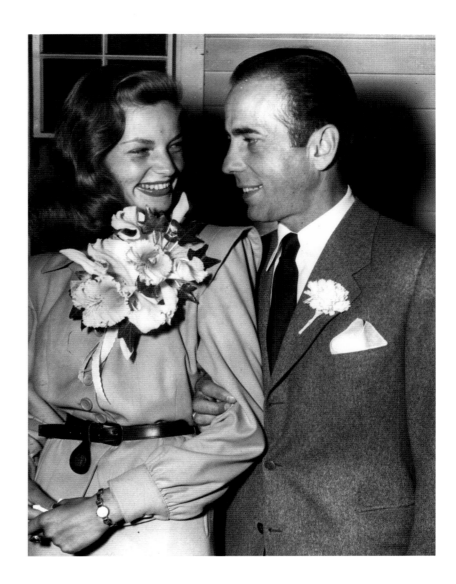

LEFT TO RIGHT:
Frank Sinatra and Ava Gardner cut their wedding cake in Philadelphia,
Pennsylvania, November 7, 1951, after a ceremony in a friend's home.
Bogey weds Baby on May 5, 1945, in Cleveland, Ohio.
Joe DiMaggio and Marilyn Monroe kiss at their wedding, San Francisco, California, January 1, 1954.
Joanne Woodward and Paul Newman on their wedding day, Las Vegas, February 2, 1958.

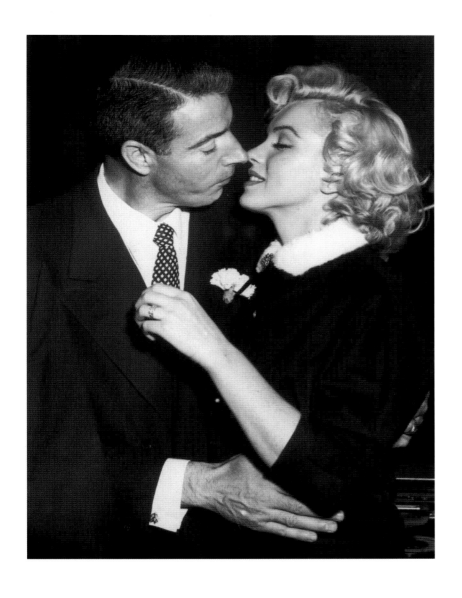
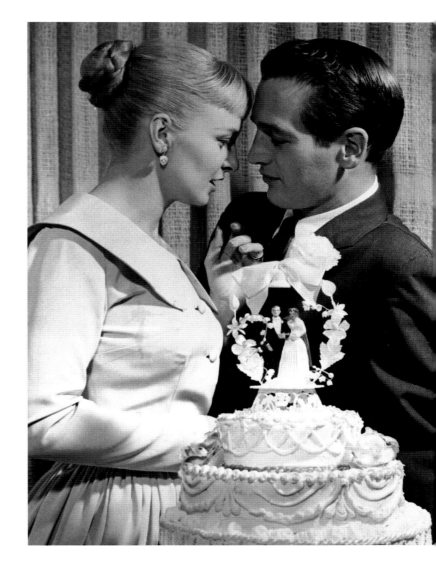

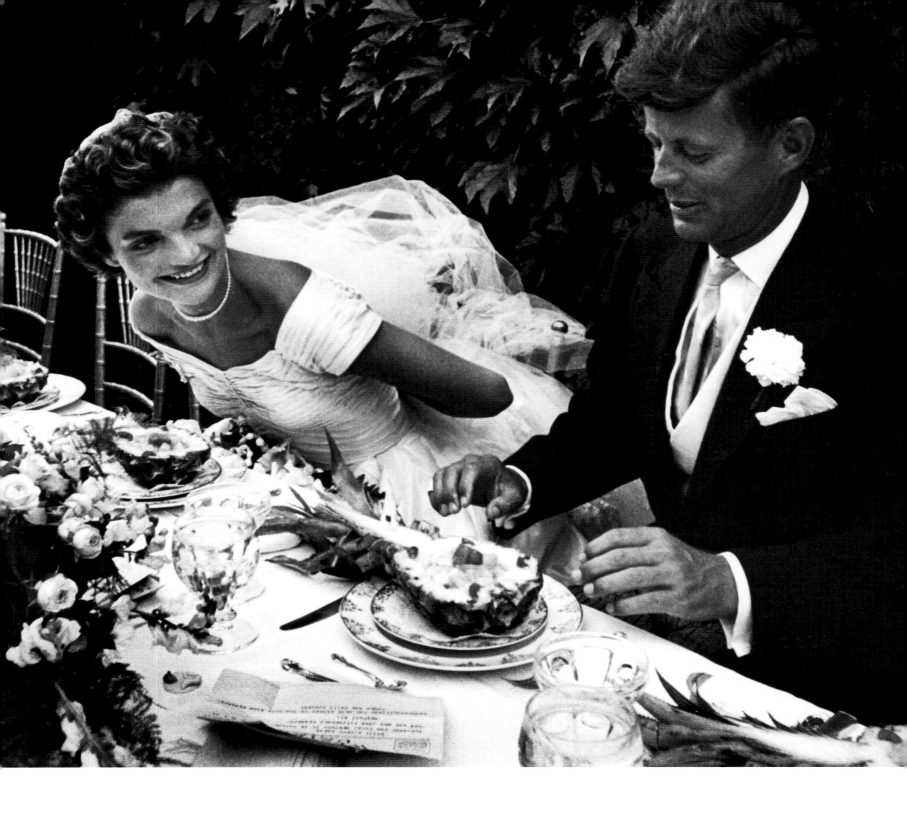

John and and Jackie Kennedy enjoying dinner at their outdoor wedding celebration. Newport, Rhode Island, January 1, 1953.

OPPOSITE LEFT: John F. Kennedy Jr. and Carolyn Bessette's private ceremony on a Georgia barrier island. September 23, 1996.

OPPOSITE TOP RIGHT: Senator Ted Kennedy and his niece Caroline at her wedding to Edward Schlossberg at Our Lady of Victory Church in Centerville, Massachusetts, July 19, 1986.

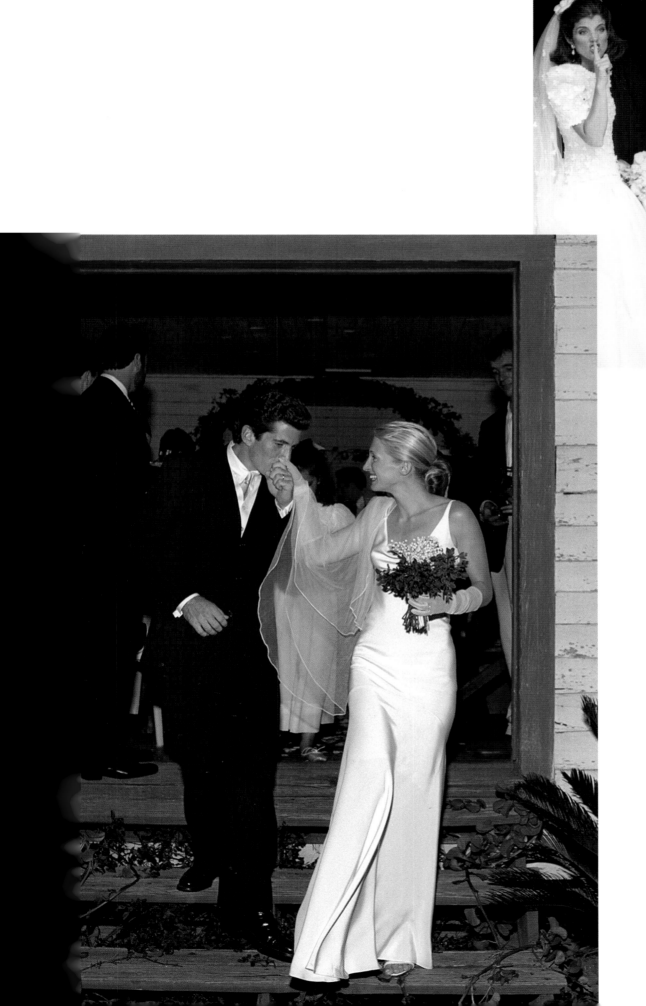
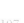

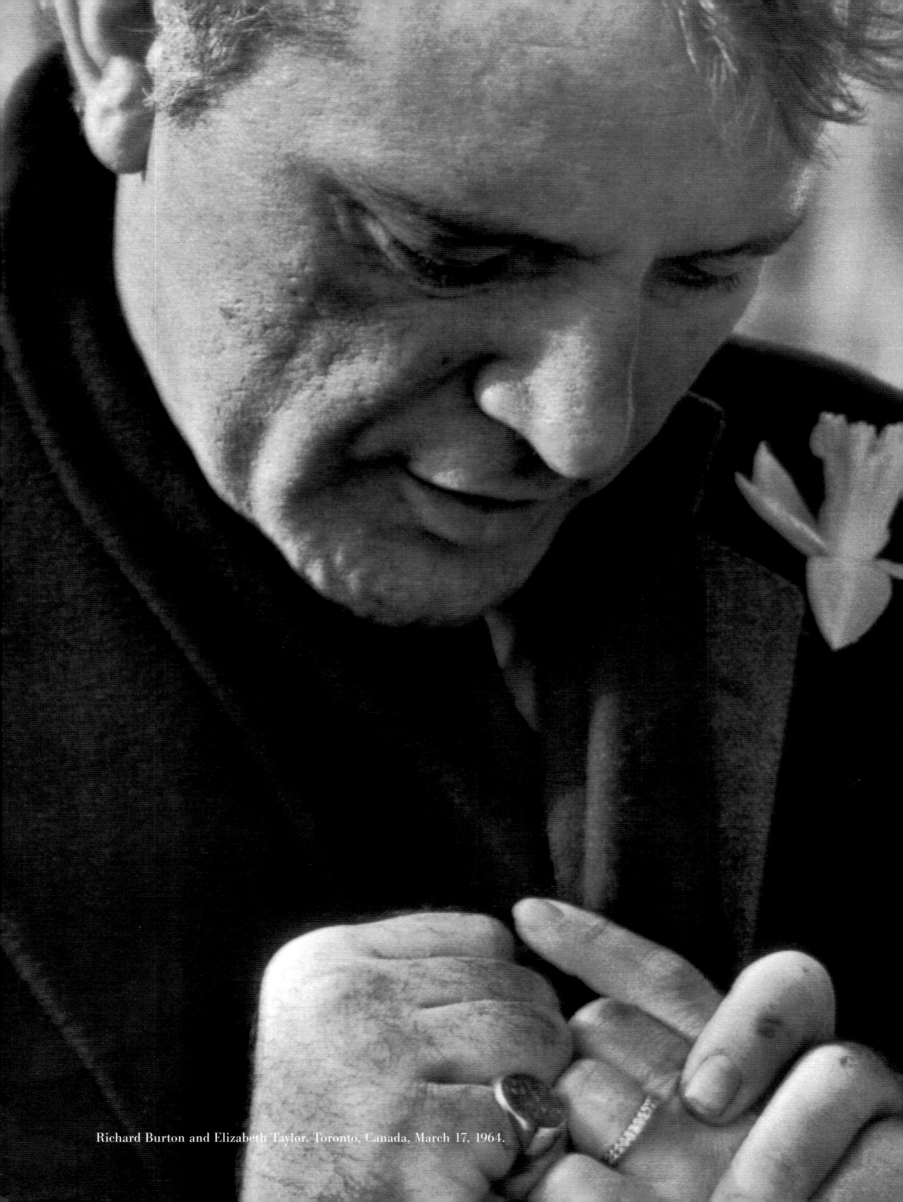

Richard Burton and Elizabeth Taylor. Toronto, Canada, March 17, 1964.

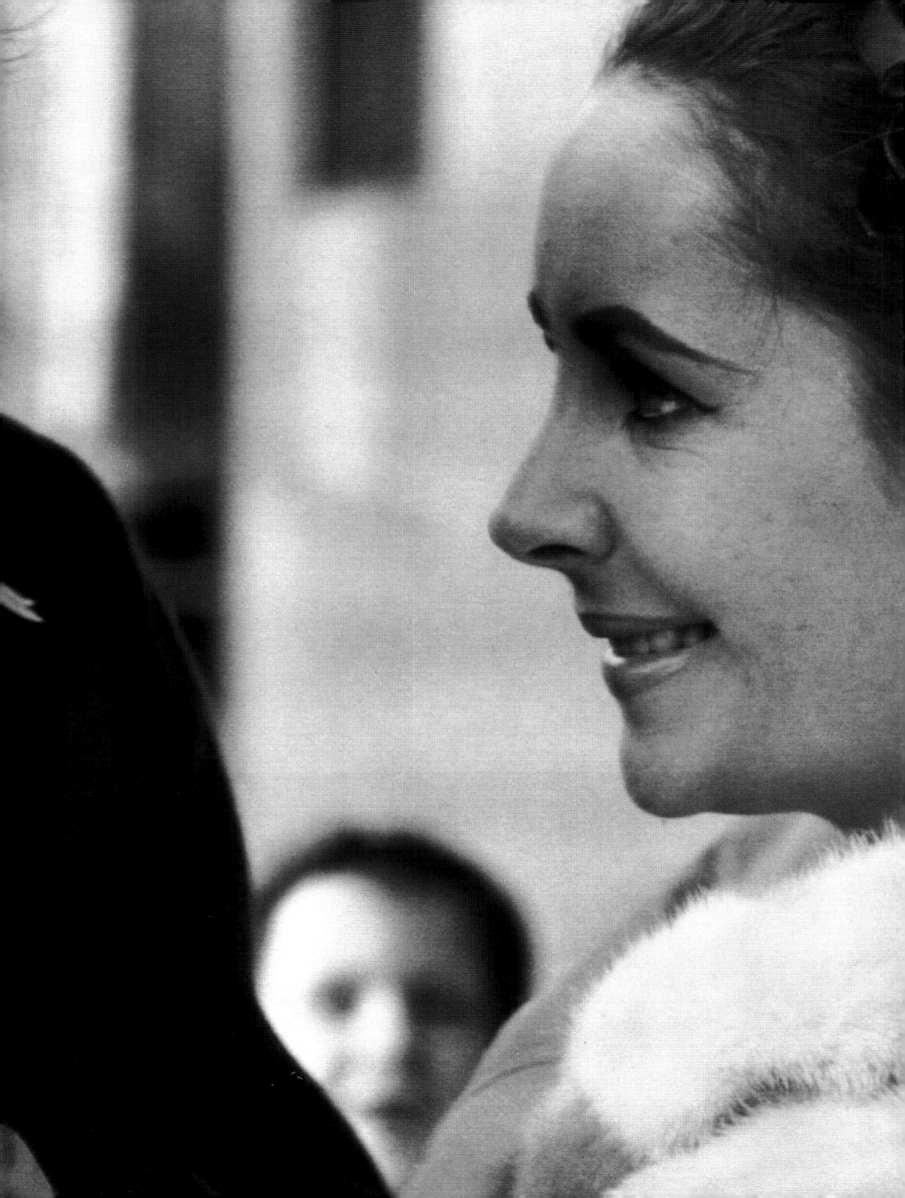

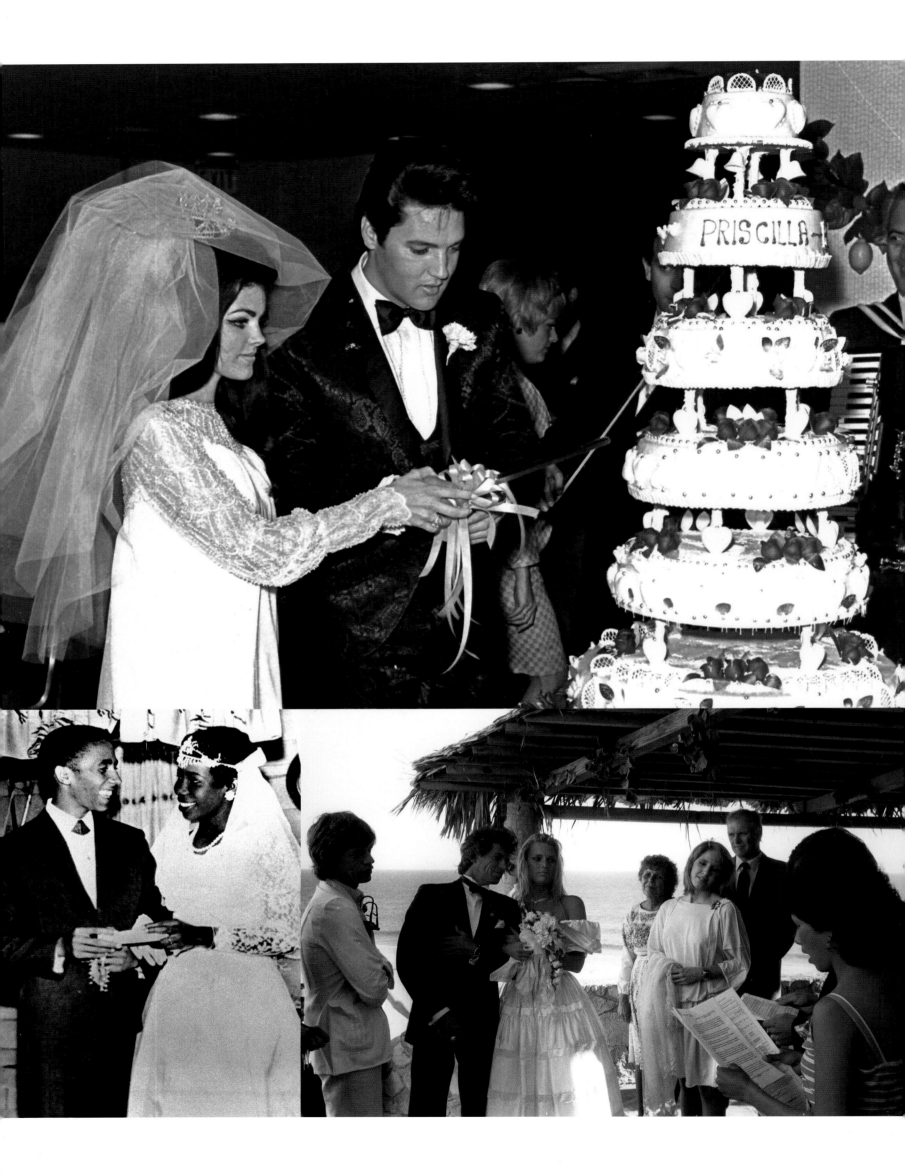

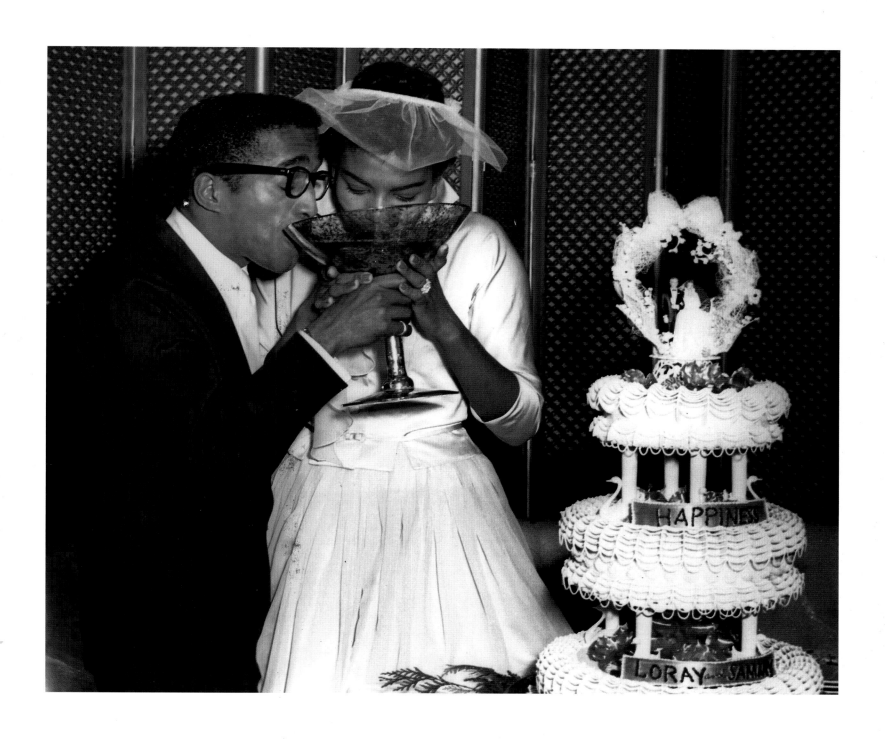

Sammy Davis Jr. weds Loray White, January 1, 1958.

Opposite, clockwise from top: Elvis and Priscilla Presley
in the Aladdin Hotel and Casino, Las Vegas, 1967.
Keith Richards and Patti Hansen in Cabo San Lucas, Baja California.
Bob Marley and Judy Mowatt, 1969.

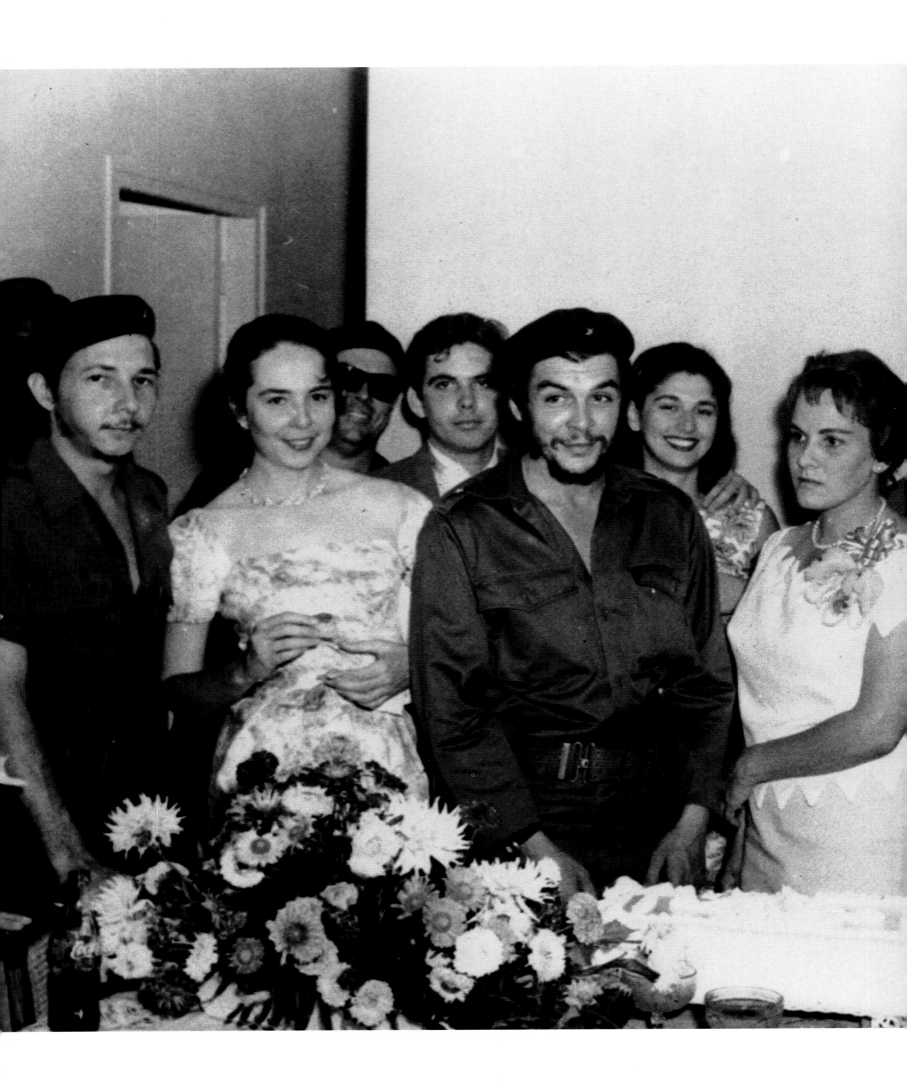

Major Ernesto "Che" Guevara and his bride Aleida stand before the wedding cake following their marriage at a civil ceremony at La Cabana military fortress, March 23, 1959. Major Raul Castro, commander in chief of the armed forces and brother of Fidel Castro, is at left.

Grace Kelly prays during her wedding to
Prince Rainier of Monaco on April 20, 1956.

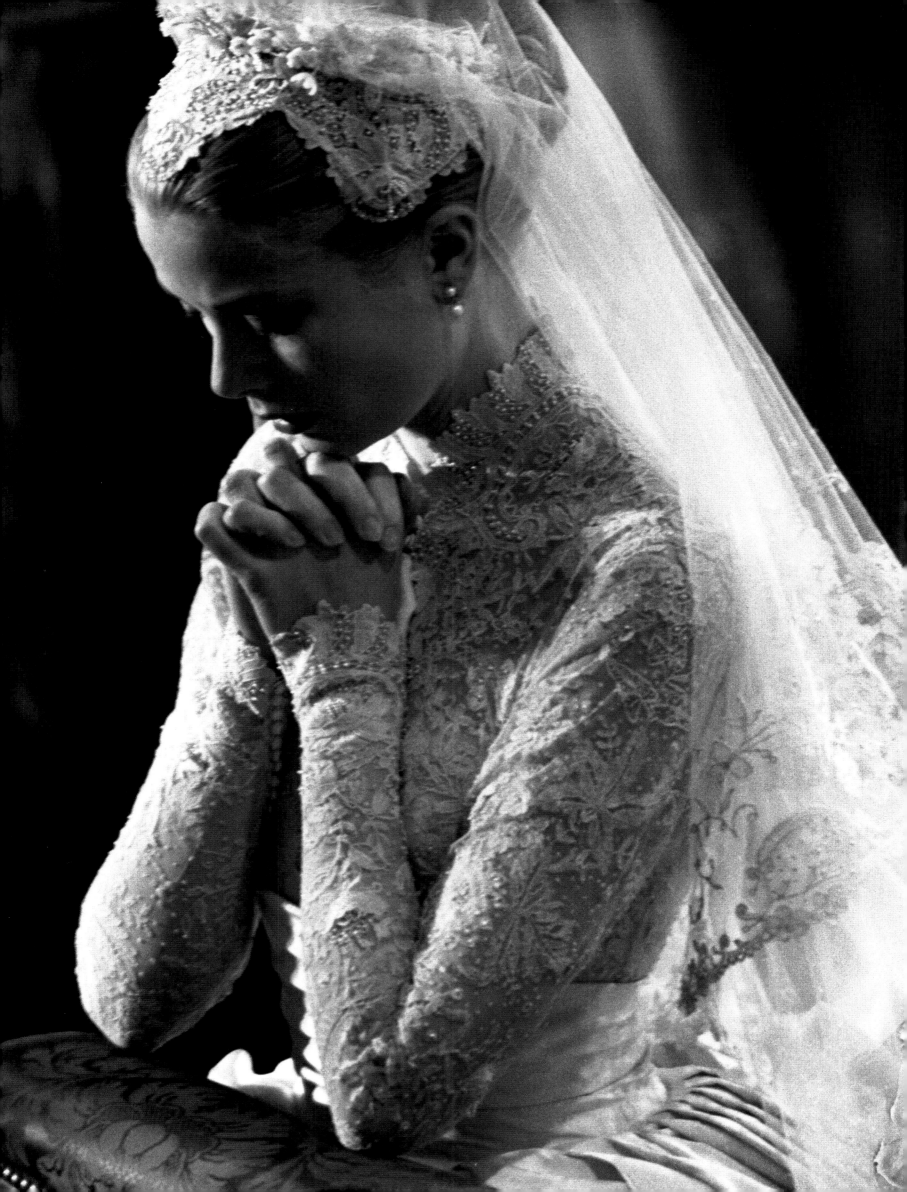

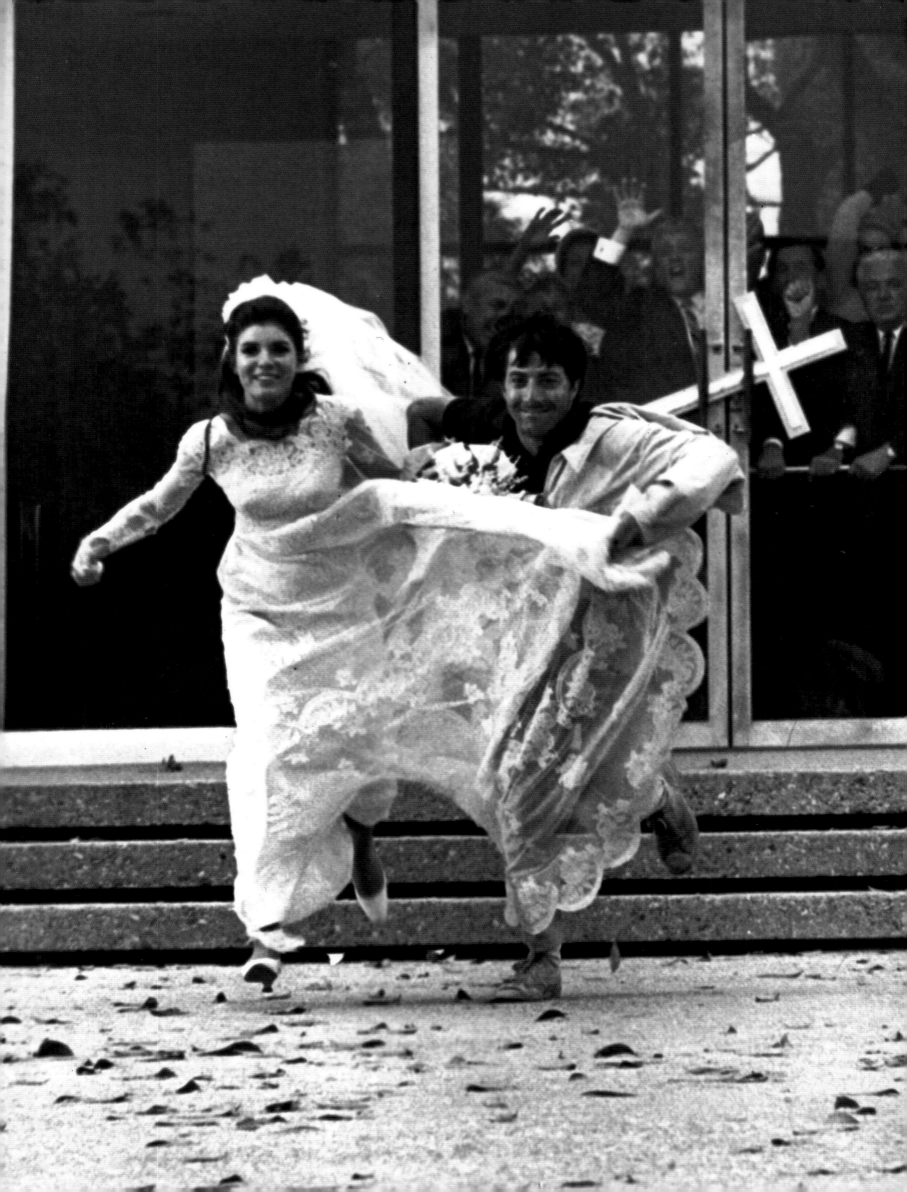

Dustin Hoffman and Katharine Ross in *The Graduate*, 1967.

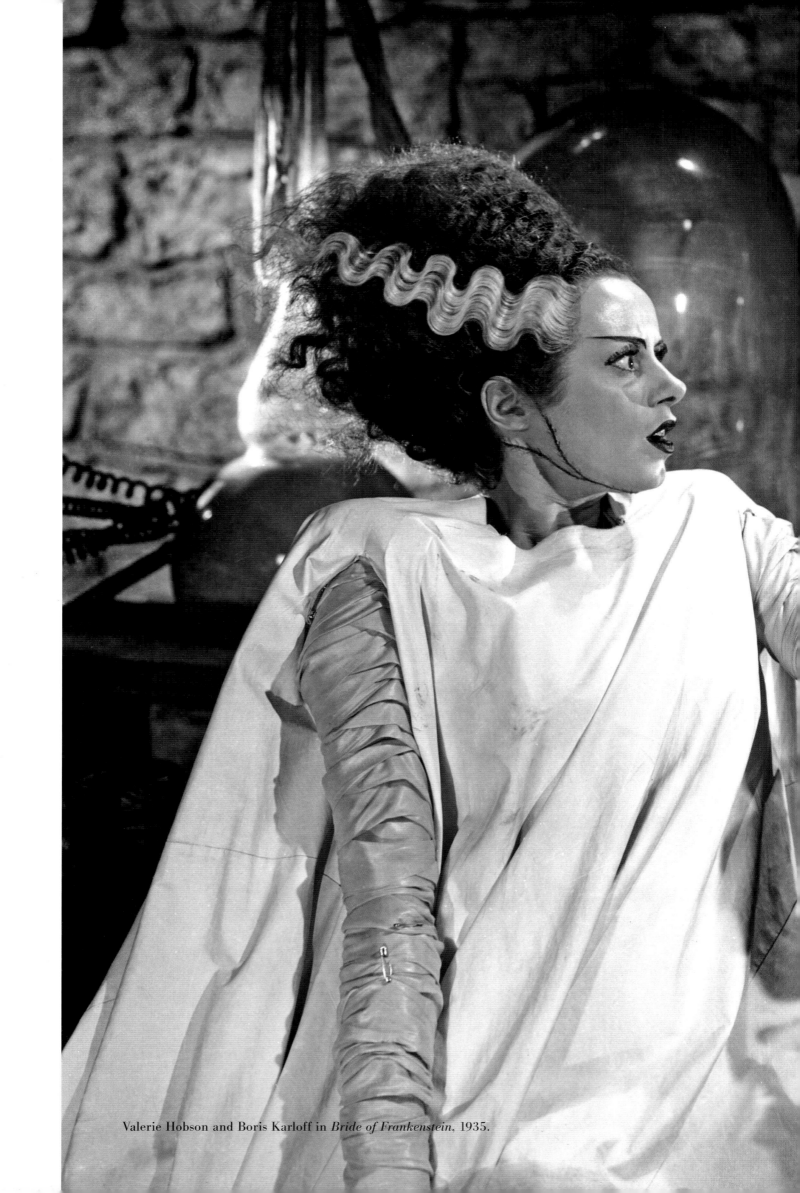

Valerie Hobson and Boris Karloff in *Bride of Frankenstein*, 1935.

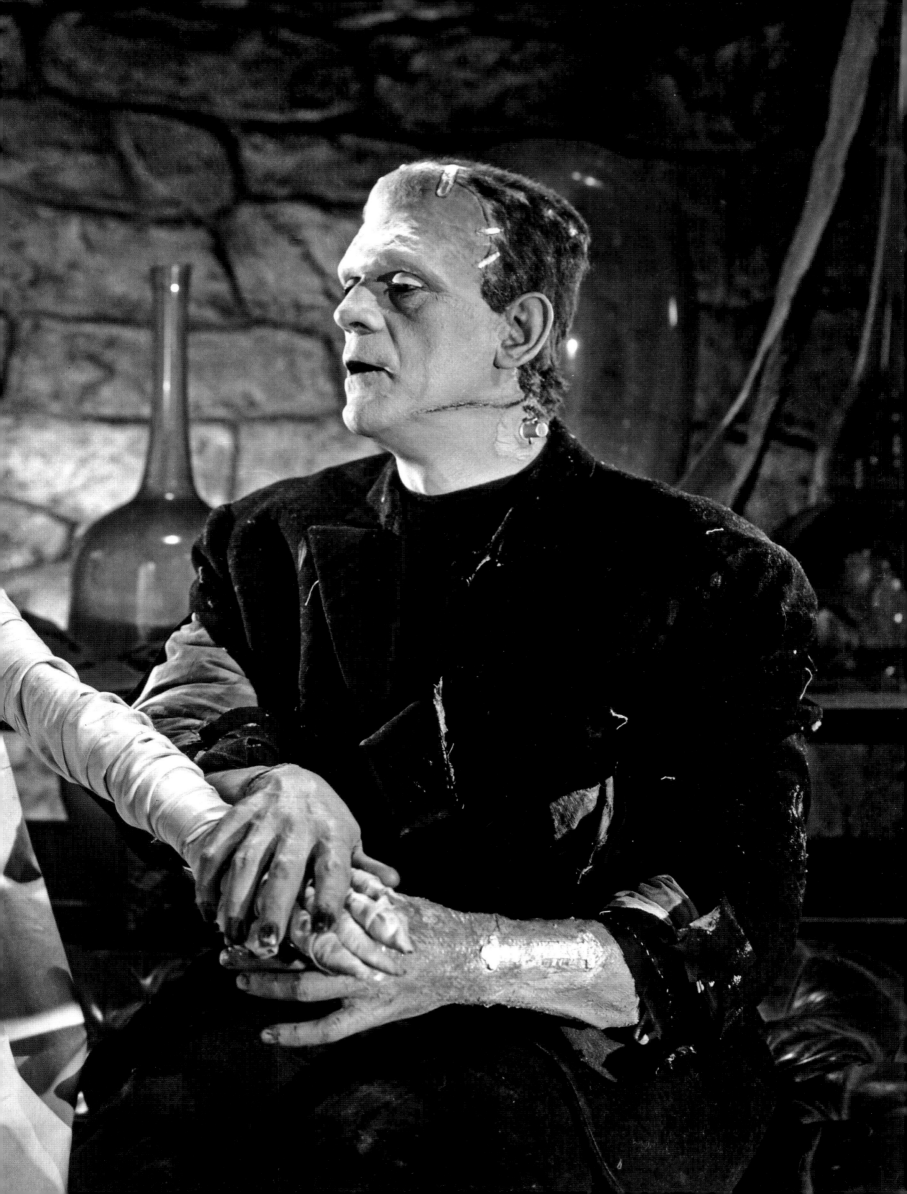

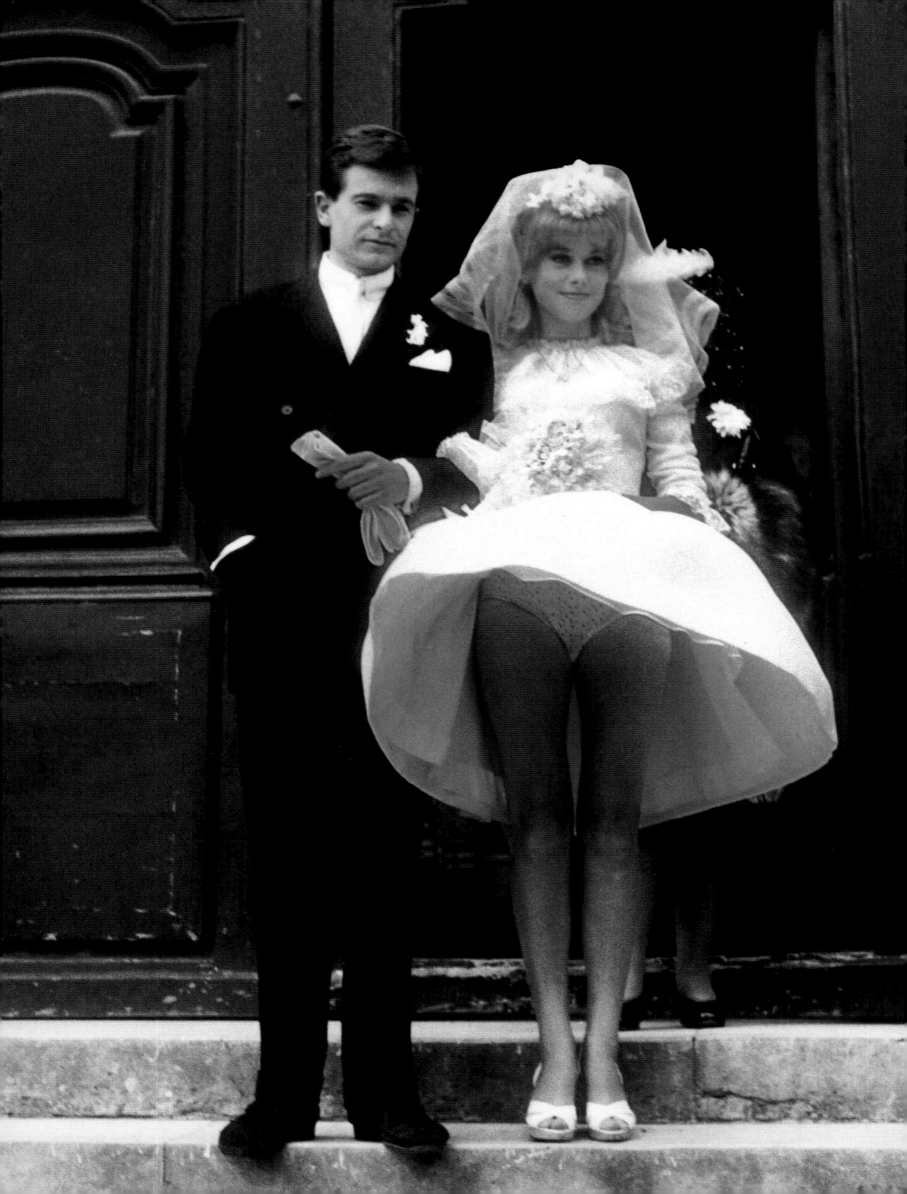

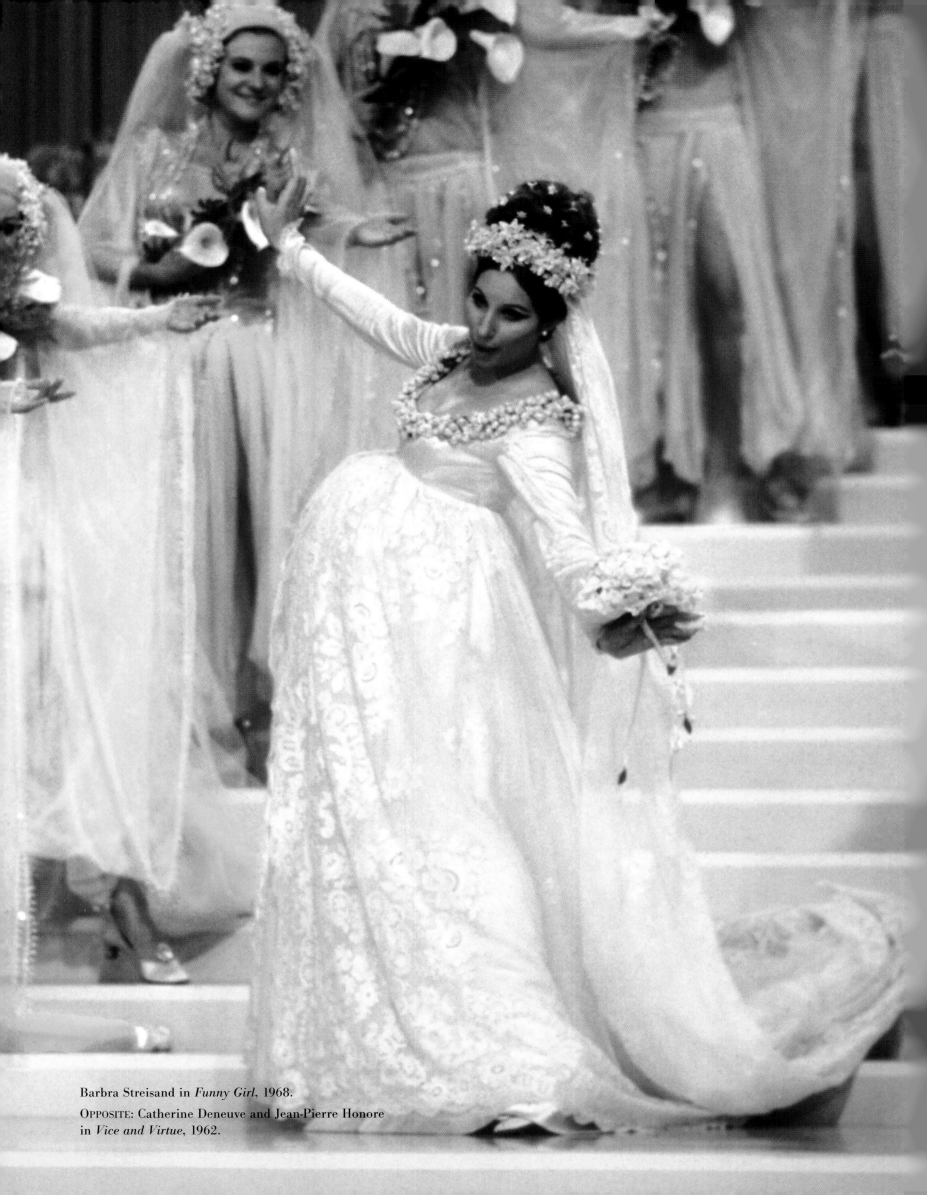

Barbra Streisand in *Funny Girl*, 1968.

OPPOSITE: Catherine Deneuve and Jean-Pierre Honore
in *Vice and Virtue*, 1962.

Spectacular

weddings push the envelope of fantasy, fun, daring, and conventional expectations. And if weddings set the tone of the marriage, why not start off with a sense of humor? A few lighthearted brides and grooms choose to abandon the traditional rules and regulations, preferring instead to take their vows to new heights, speeds, or terrains. And more often than not, an unconventional wedding is one that doesn't take itself too seriously, choosing humor and laughter as one of the keys to a good marriage. These free spirits are bonded and liberated by creating their own unique take on "I do."

For those who want to break the mold, their weddings have to be a reflection of them, their passions and personalities. While following tradition speaks volumes for some couples, it's not a personal enough process for others. To bring themselves into the ceremony, bold brides and grooms prefer to get married doing something they love. Two trapeze artists might say their vows while balancing on a high wire or a nudist couple may keep it basic and get married in the buff.

For some couples, taking the plunge into commitment requires a similarly dramatic spectacle. Whether it's getting married atop a mountain and skiing down together or diving into the ocean and having their wedding underwater, it's not enough for some people to simply say "I do." They are inspired to go to great lengths to ensure that their nuptials are as grand as their love. These spectacular weddings are symbolic of the unpredictable journey a couple takes on the literal roller coaster ride of marriage with all its peaks and valleys, twists and turns. And if you start your life together on a roller coaster maybe you're more prepared for the exciting ride ahead?

Preparing for a wedding in the air, August 2, 1996.

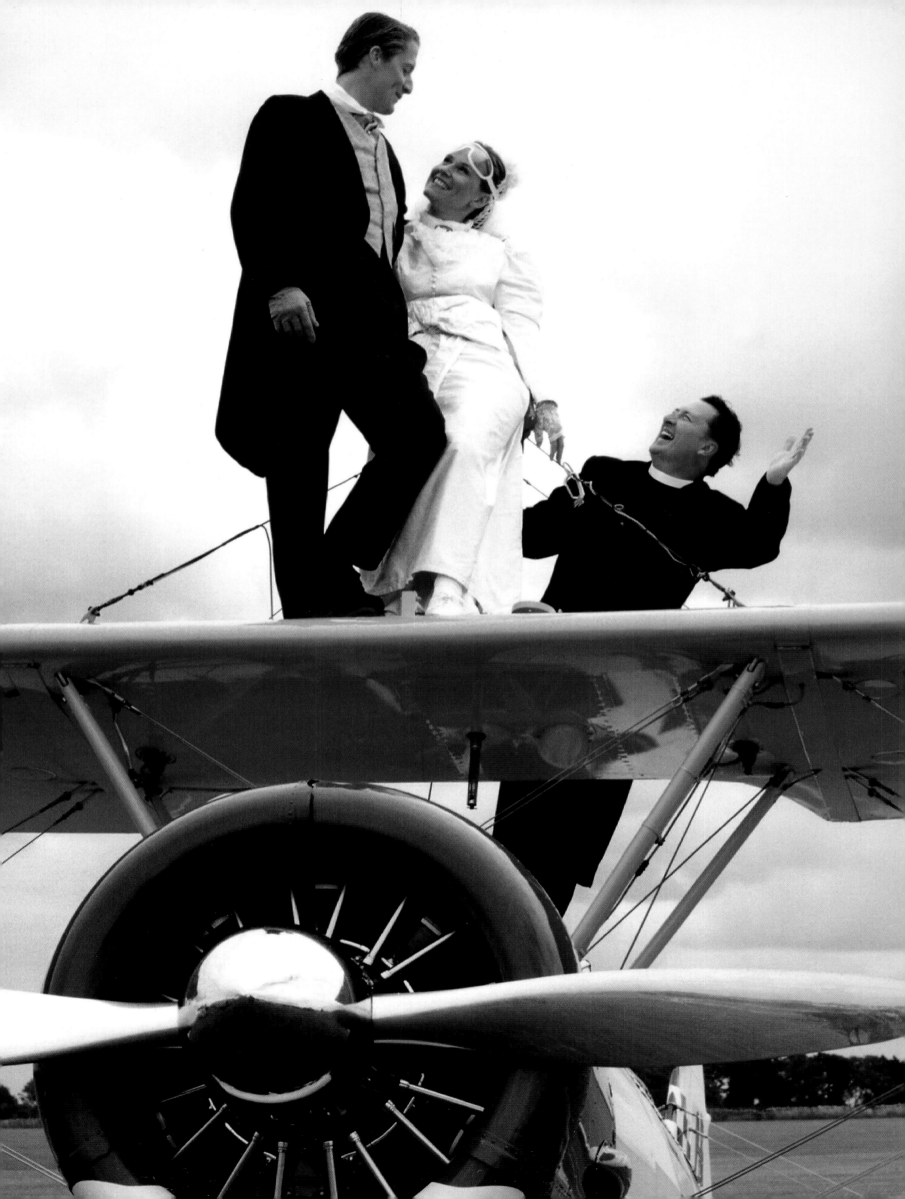

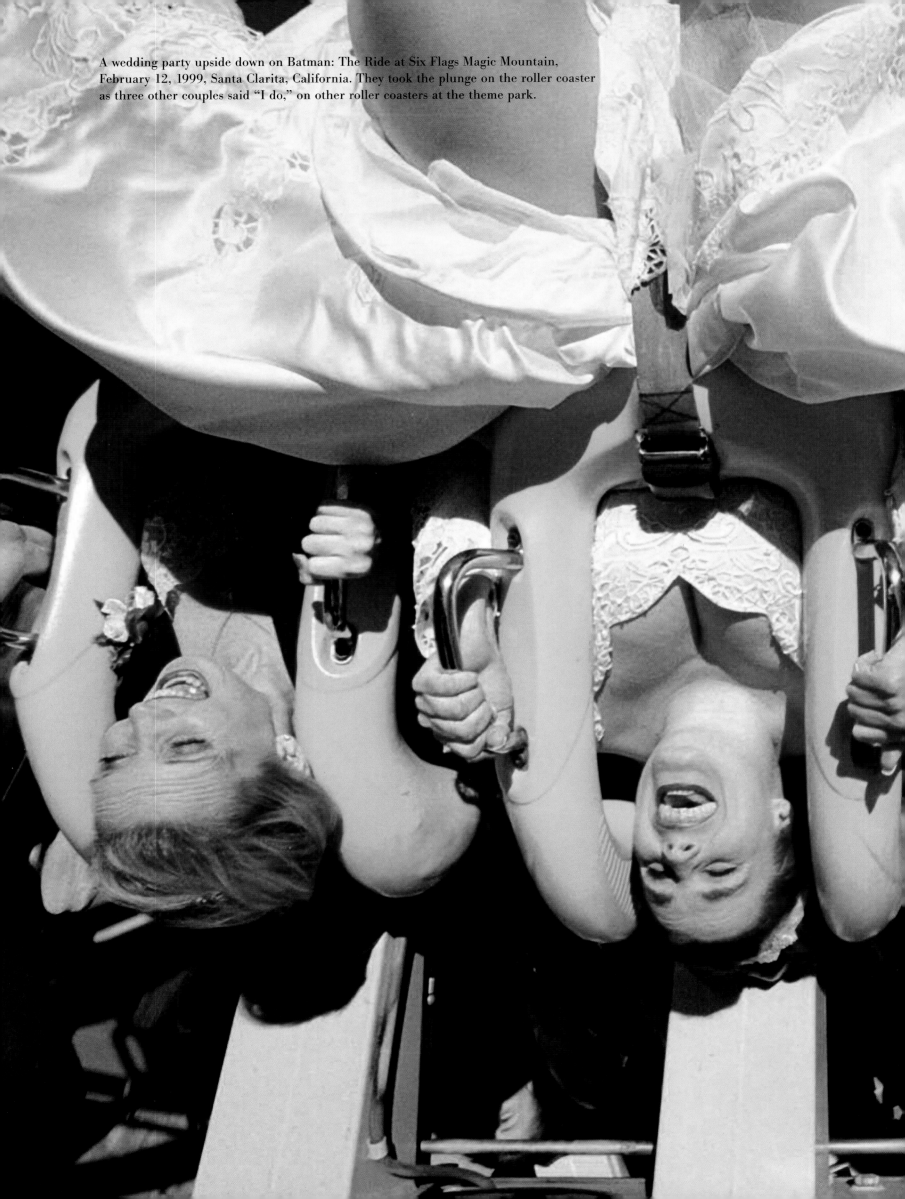

A wedding party upside down on Batman: The Ride at Six Flags Magic Mountain, February 12, 1999, Santa Clarita, California. They took the plunge on the roller coaster as three other couples said "I do," on other roller coasters at the theme park.

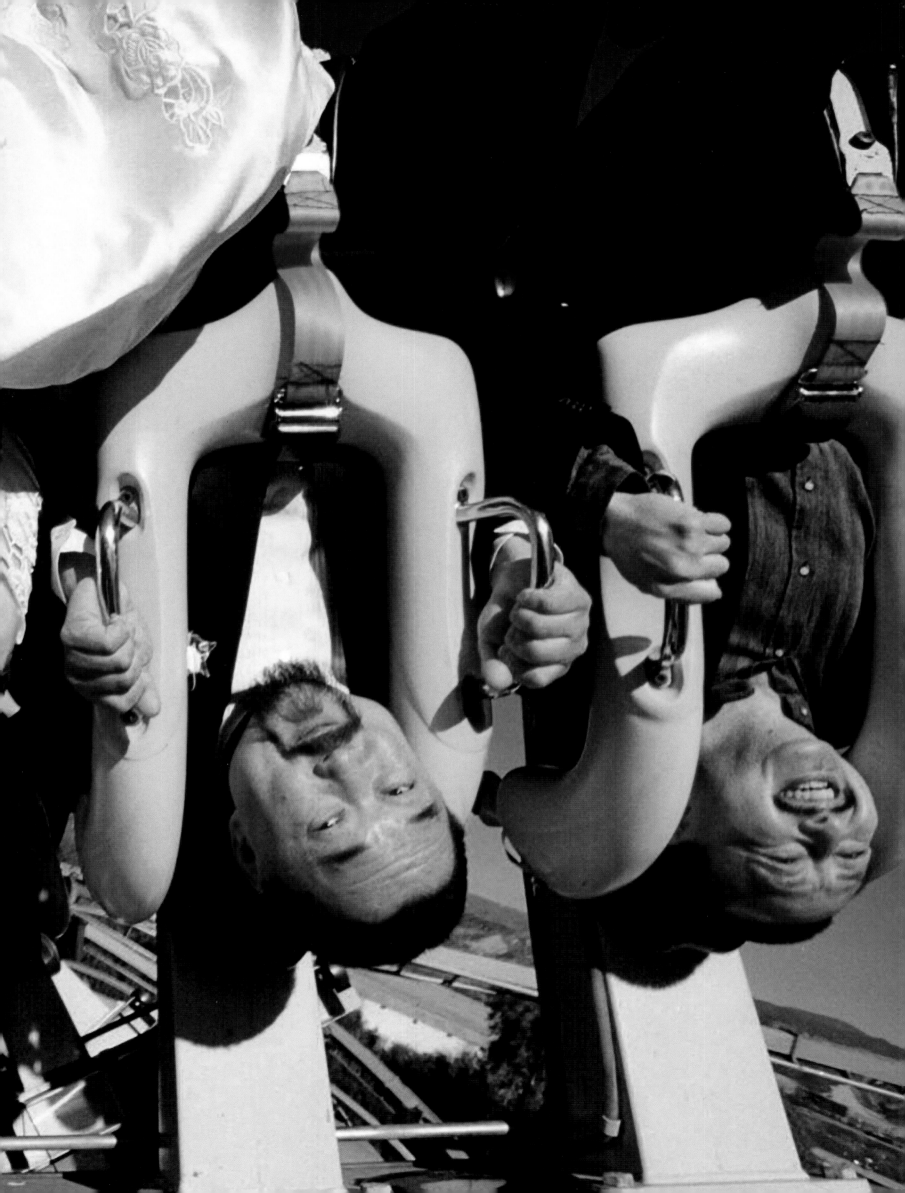

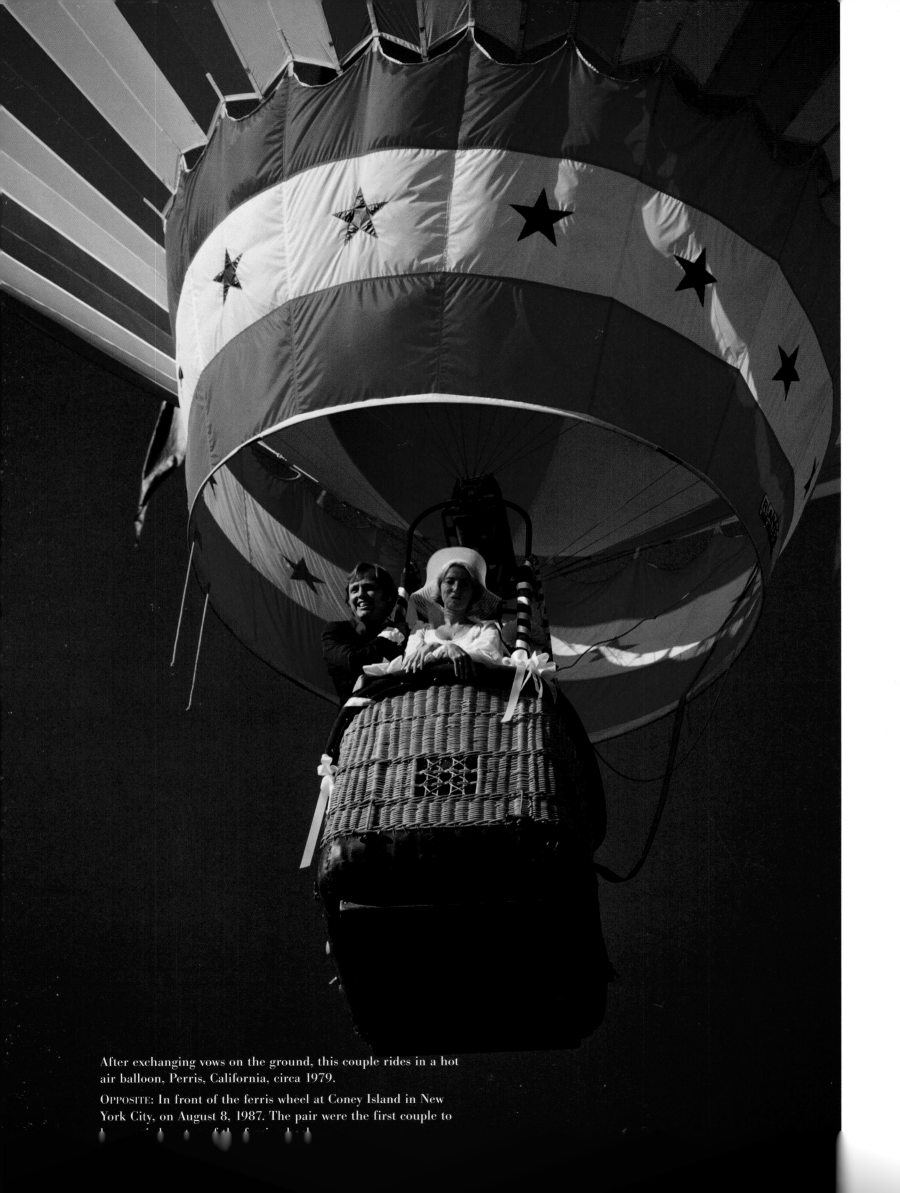

After exchanging vows on the ground, this couple rides in a hot air balloon, Perris, California, circa 1979.

OPPOSITE: In front of the ferris wheel at Coney Island in New York City, on August 8, 1987. The pair were the first couple to

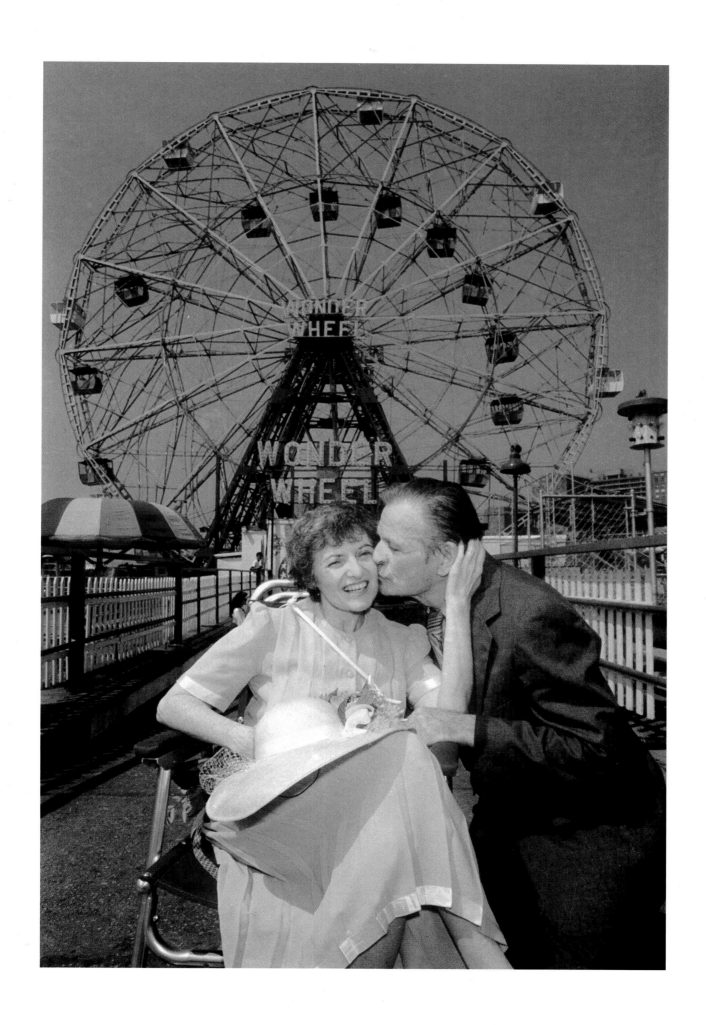

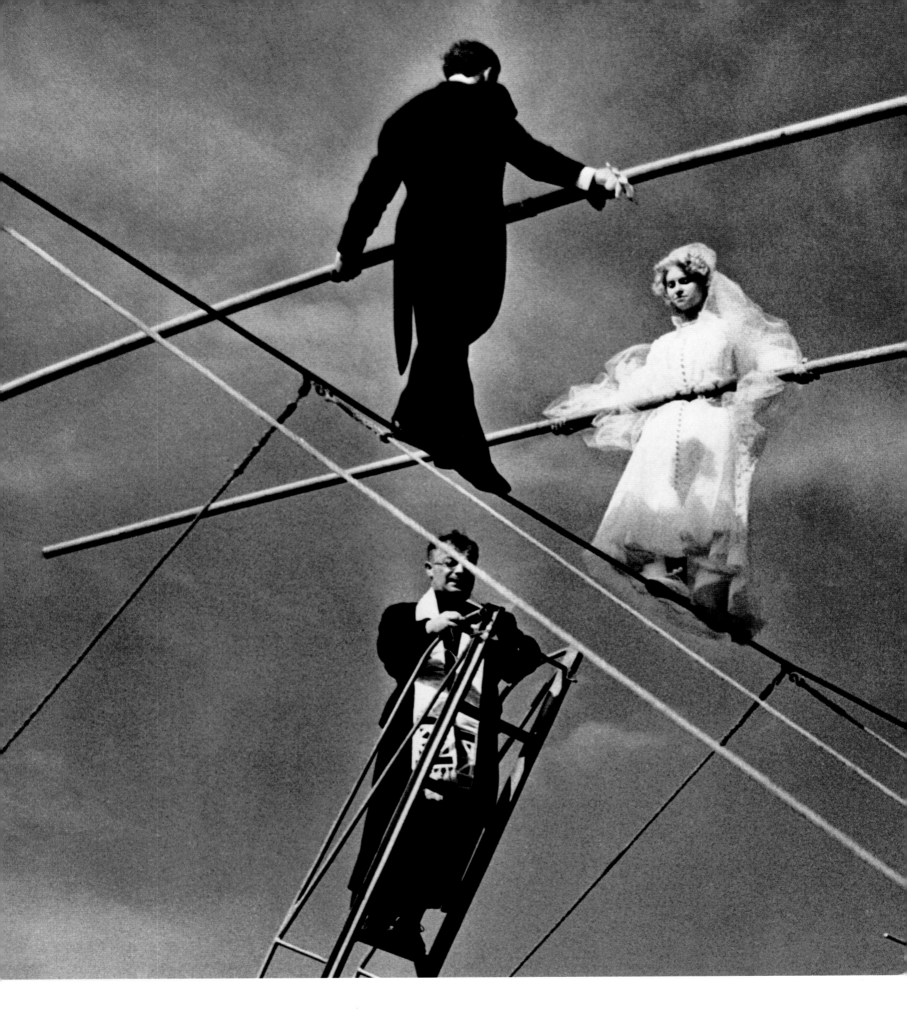

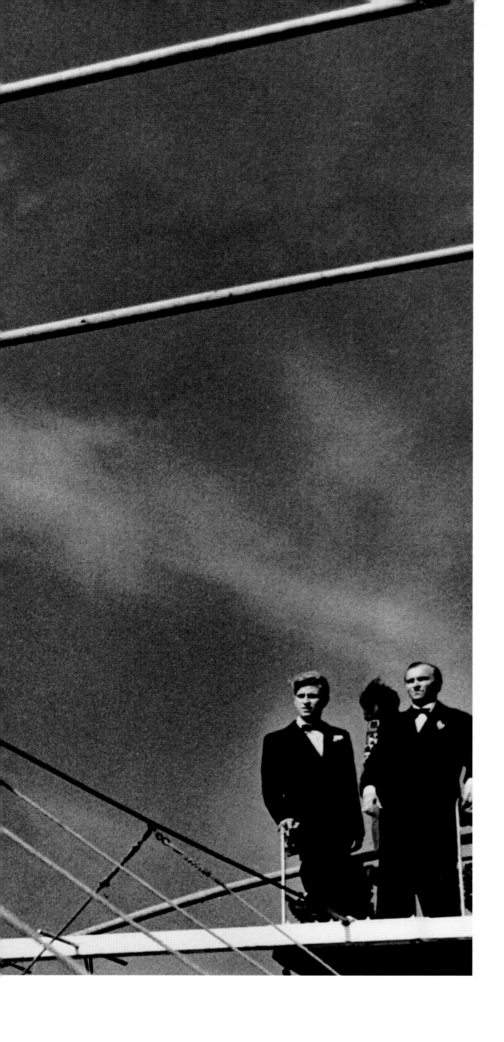

Marrying on a high wire, Toulouse, France,
May 25, 1954. They were 60 feet above a crowd
of 20,000 when they were blessed by Abbe
Simon, well known for his dives into the Seine
in aid of church restoration funds.

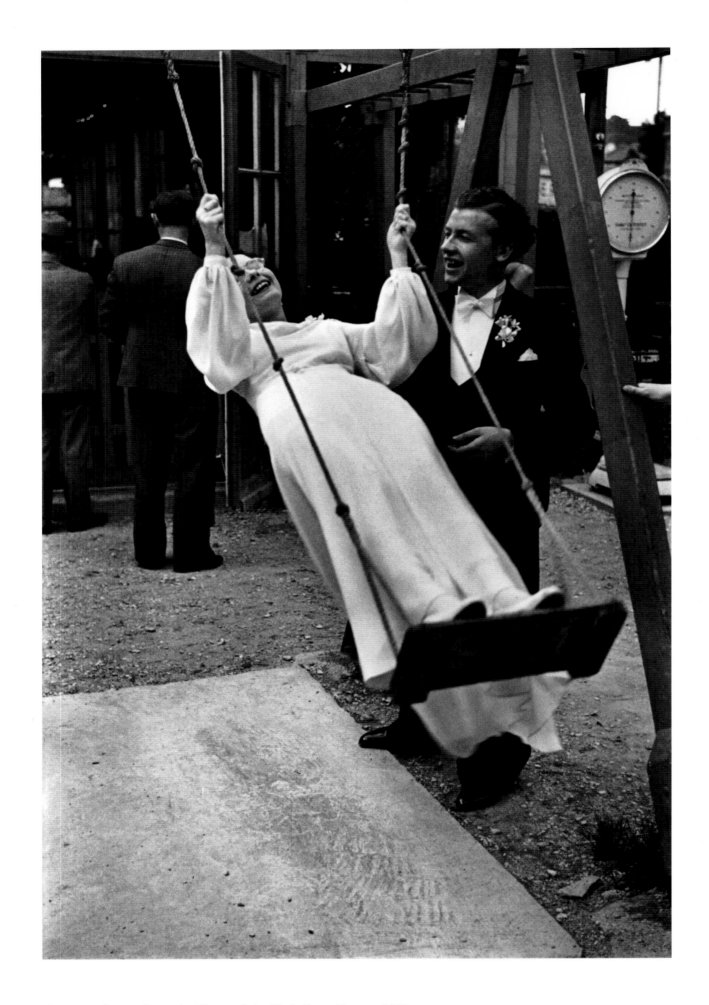

At an outdoor café on the Marne. Joinville-le-Pont, France, 1938.

OPPOSITE: Newlyweds skate their first dance as man and wife after their wedding in Twin Lakes, Wisconsin on July 14, 1962.

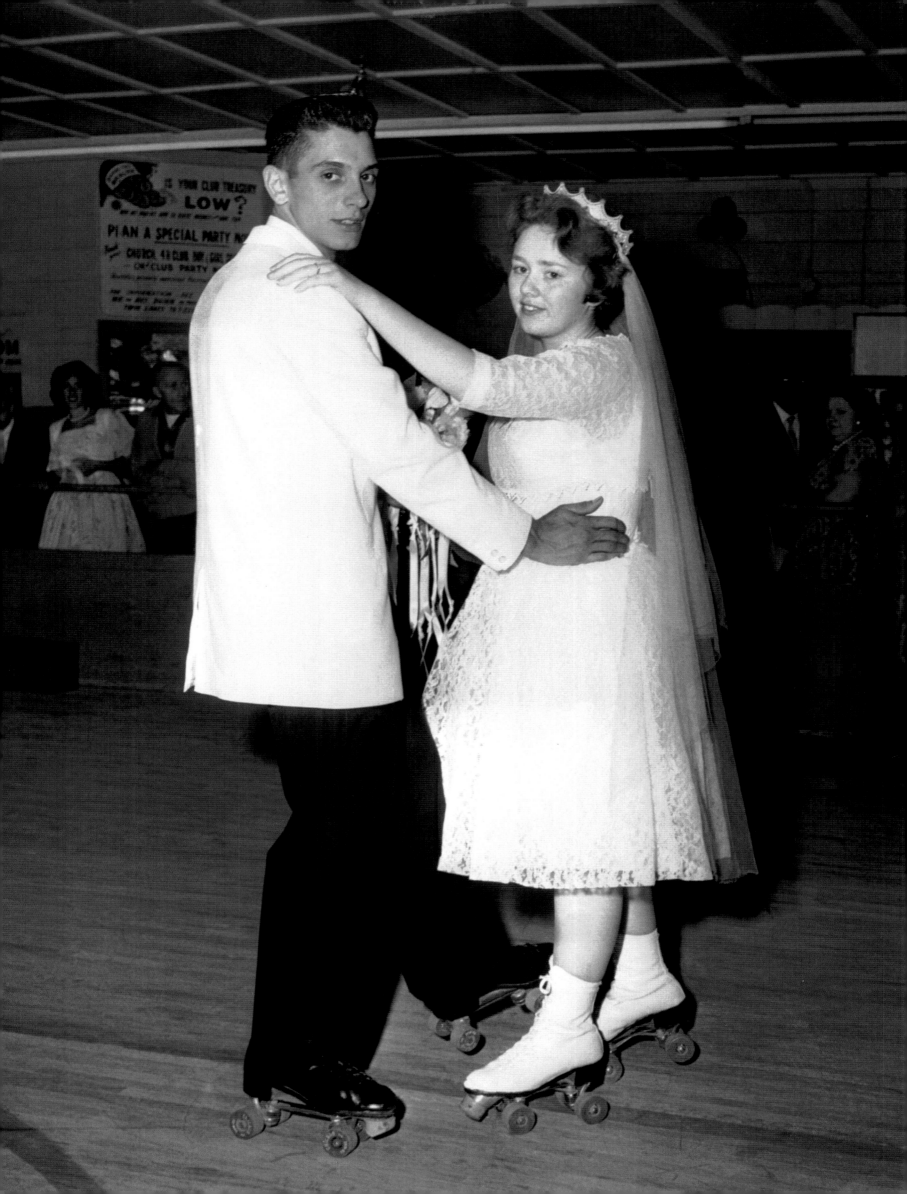

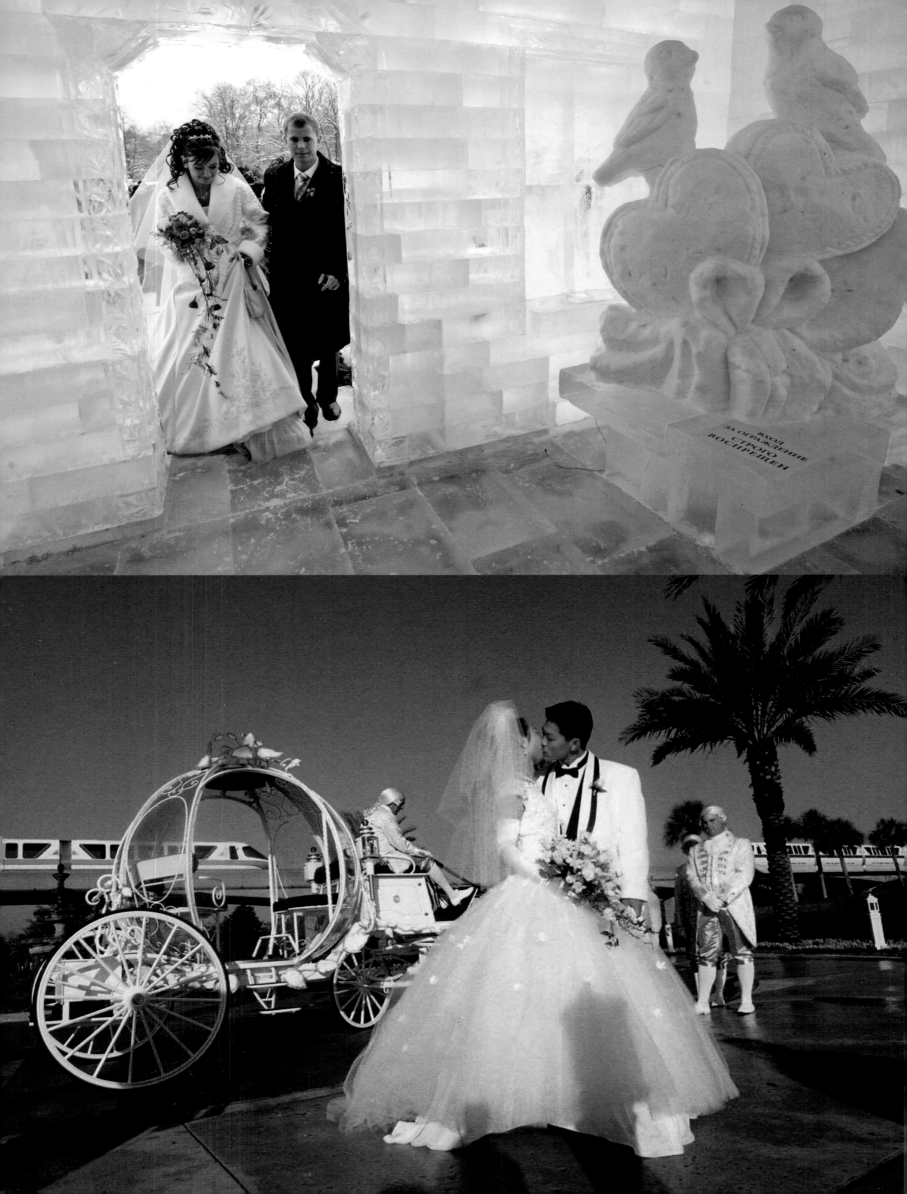

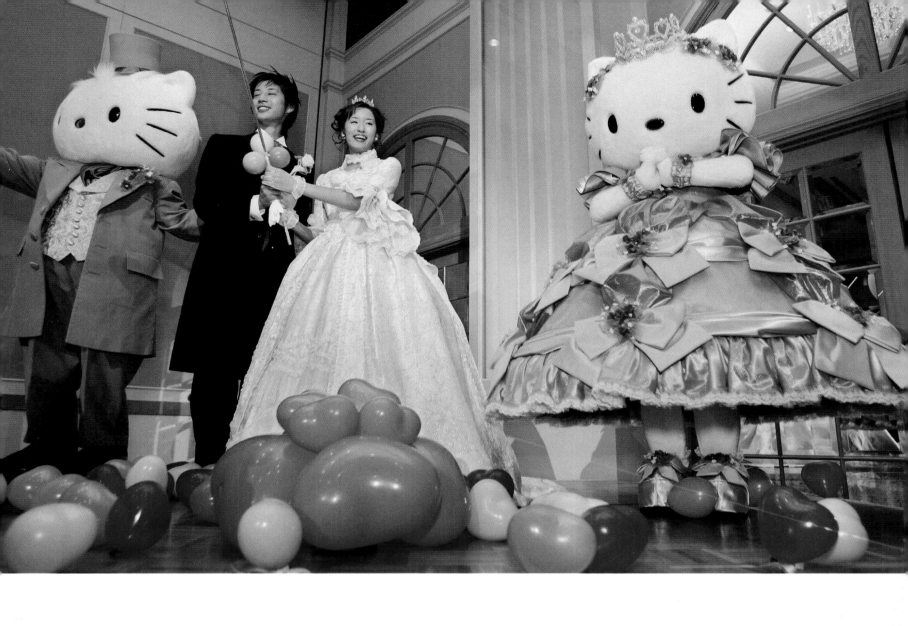

Hello Kitty and her boyfriend Dear Daniel congratulate a bride and a groom at Dai-Ichi Hotel, Tokyo, Japan, on October 21, 2005.

OPPOSITE ABOVE: A newly wedded couple, Olga and Andrei Khorkhorev, enter a replica of Empress Anna Ioannovna's Ice Palace to celebrate their wedding in St. Petersburg, Russia, February 14, 2006.

BELOW: Before boarding Cinderella's Glass Coach, after getting married at Disney World's Wedding Pavilion, February 12, 1997, in Lake Buena Vista, Florida.

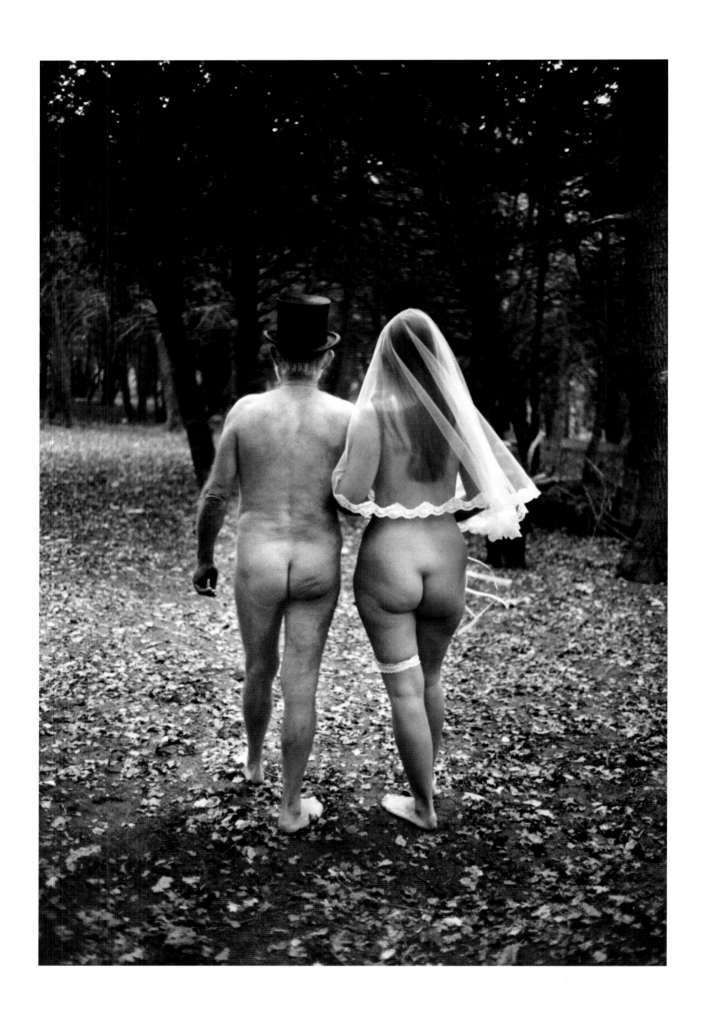

Kent, England, 1984.

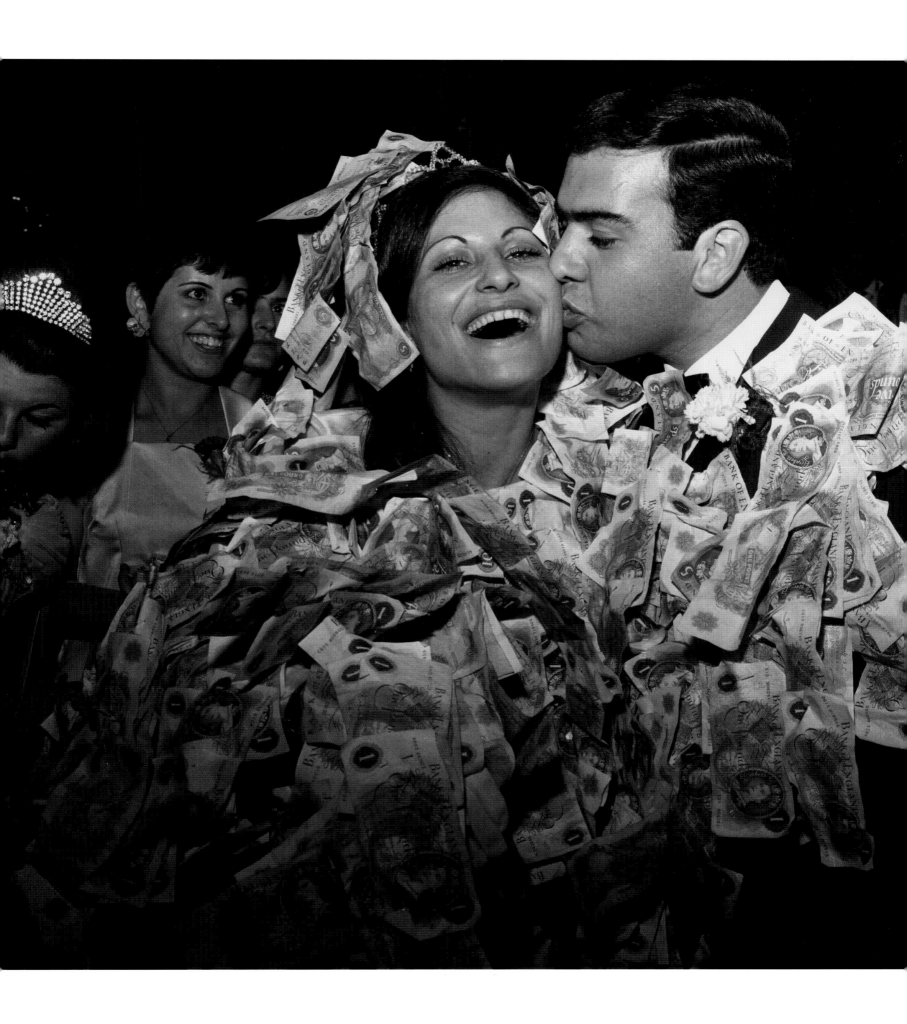

A traditional Cypriot wedding, August 6, 1967.

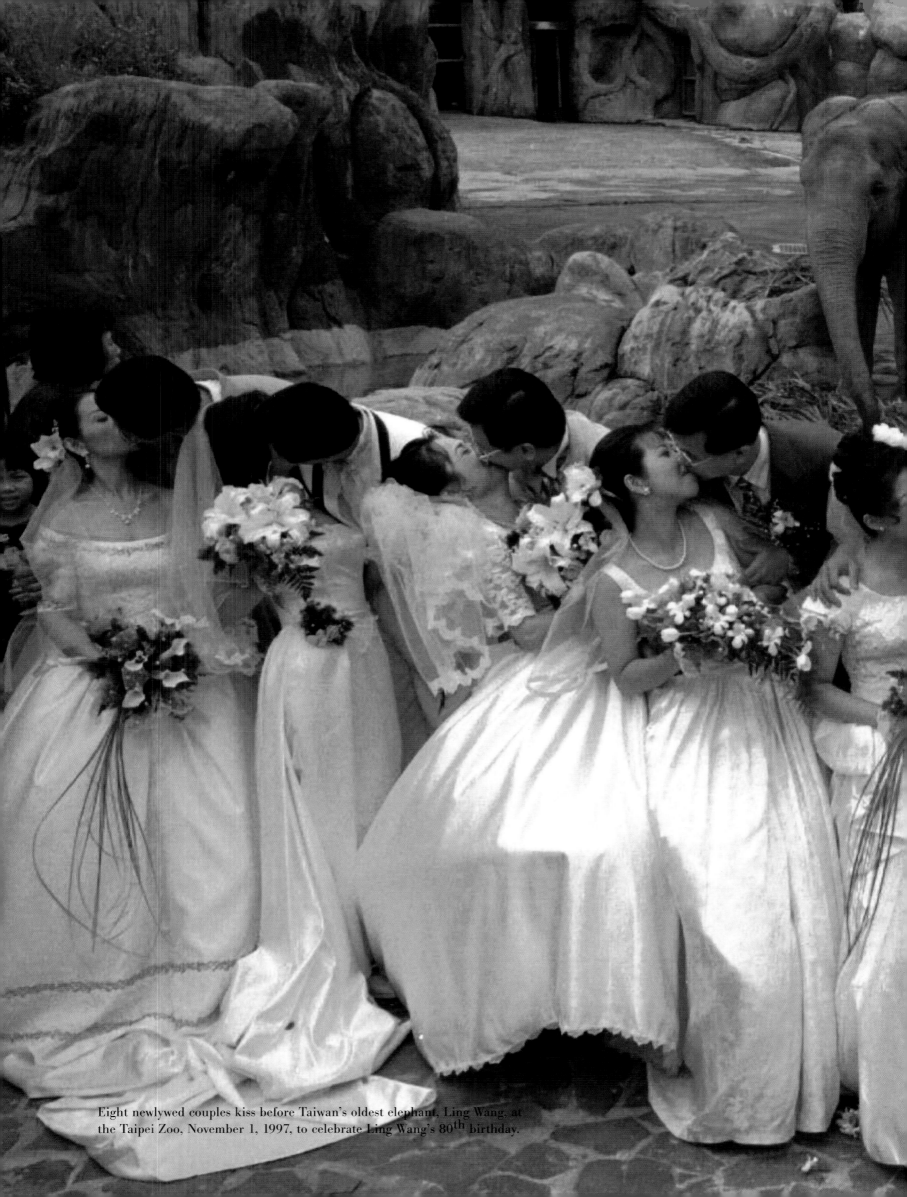

Eight newlywed couples kiss before Taiwan's oldest elephant, Ling Wang, at the Taipei Zoo, November 1, 1997, to celebrate Ling Wang's 80th birthday.

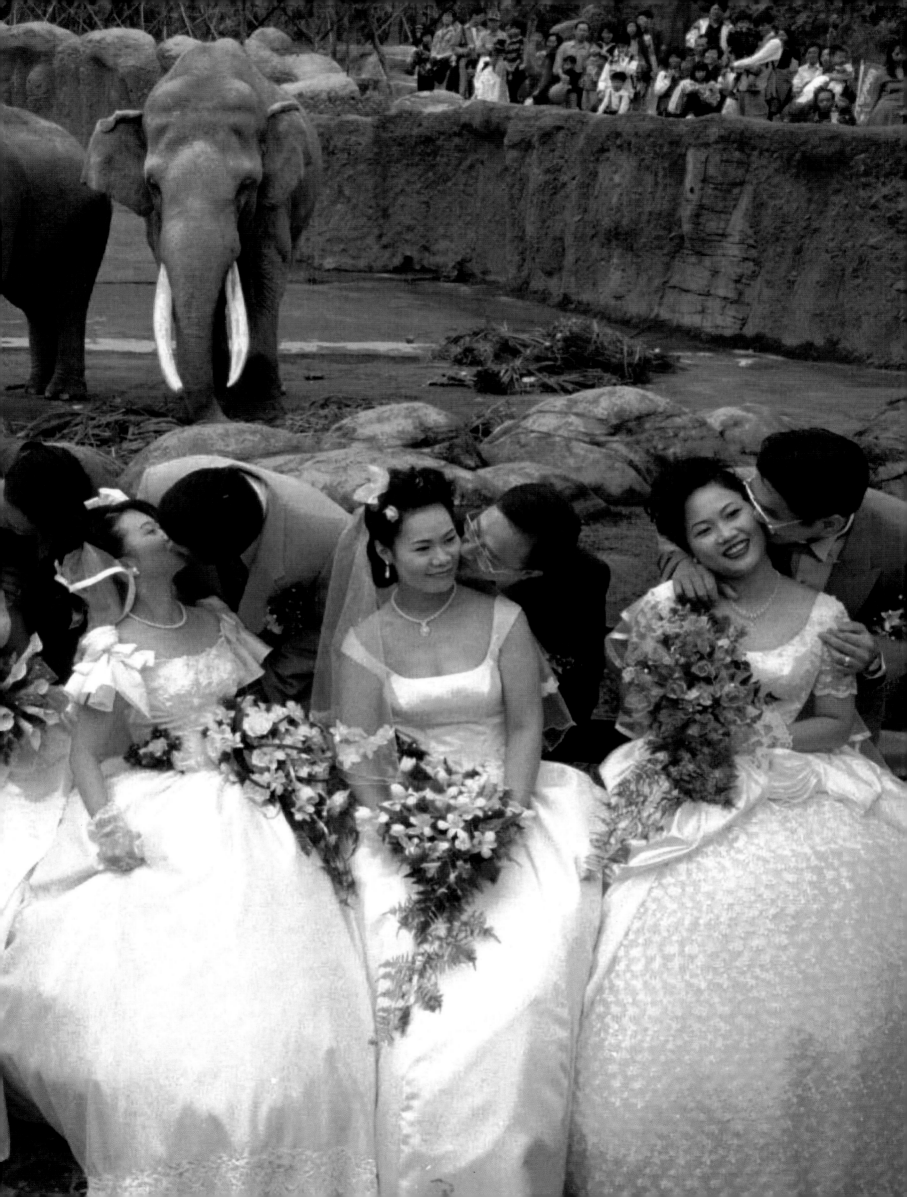

Happily ever after is what inspires

weddings to begin with. Whether someone marries for love, security, duty, or even money, they all hope that marriage will be the key to their happiness. That hope unites all couples no matter what their background, circumstance, race, or culture. On the day of their wedding, whether they're getting married in city hall or before 300 guests in Paris, whether their marriage has been arranged since their birth or it was decided two weeks before, there is certainty that their love will have a happy ending.

The secret to a successful wedding isn't the dress or the flowers—it's the belief in happy endings. And when you find someone who believes in the same possibilities, it seems all the more real and a lasting marriage becomes not a fairy tale but a completely attainable dream. That's why we love weddings, why we cry when we see the bride, smile when they kiss, laugh at their excitement, dance for joy, put on our finest clothes, and mortgage the house—it's all because we believe in happily ever after.

France, 1976.

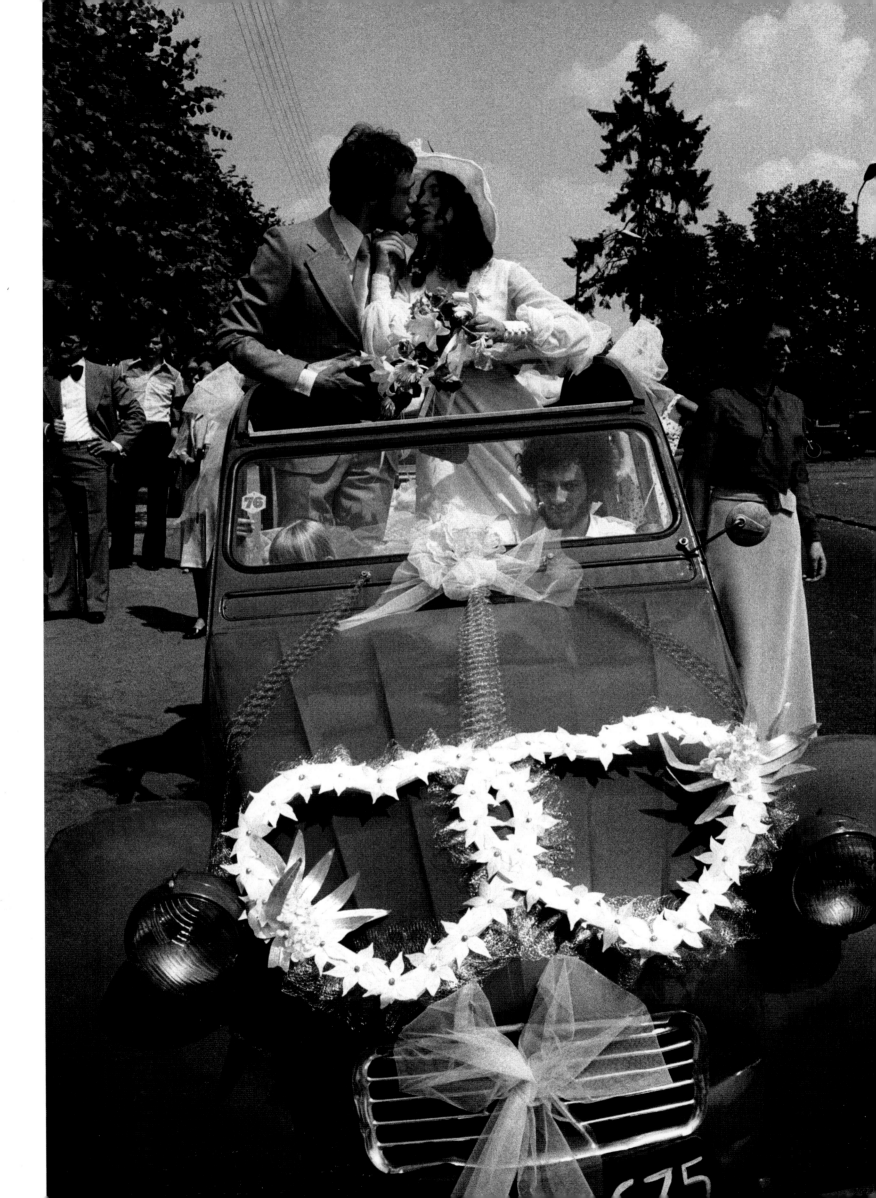

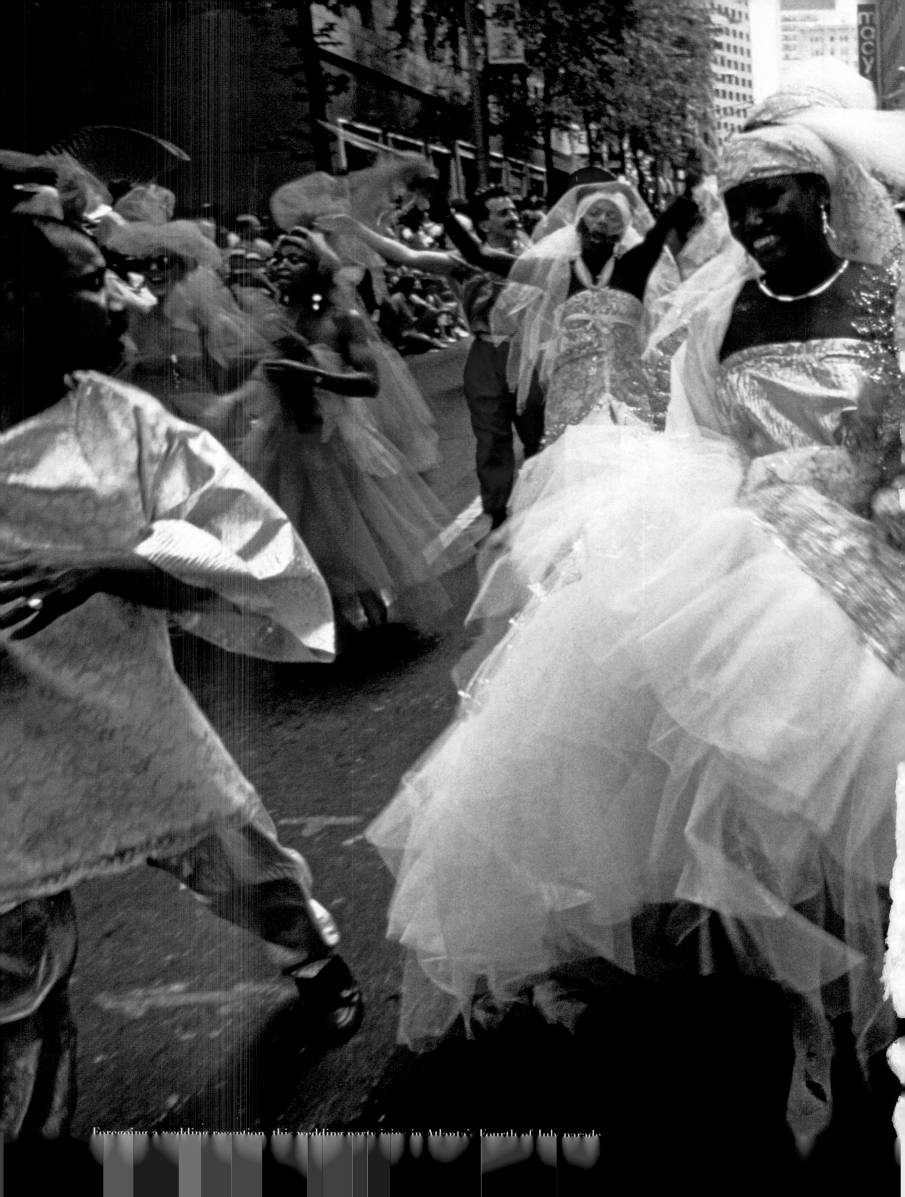

Foregoing a wedding reception, this wedding party joins in Atlanta's Fourth of July parade.

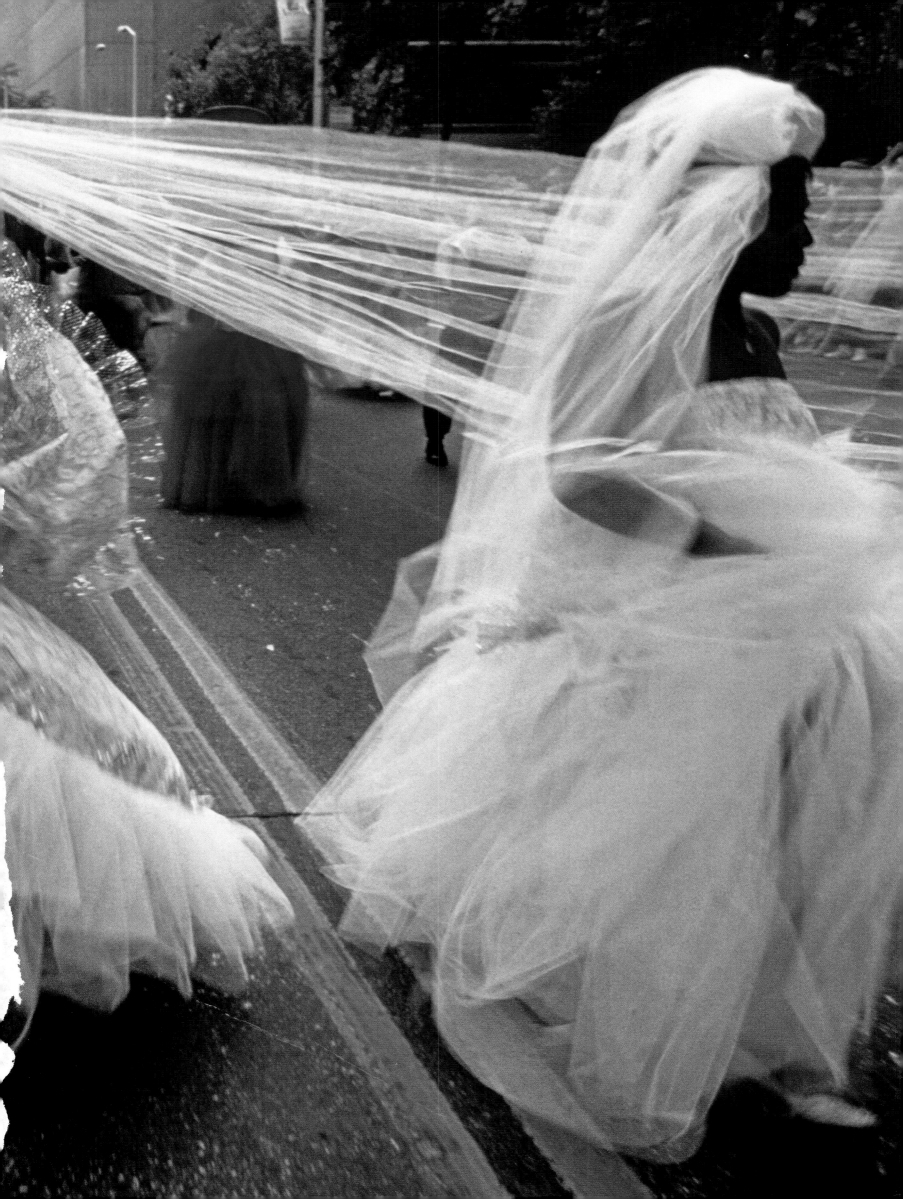

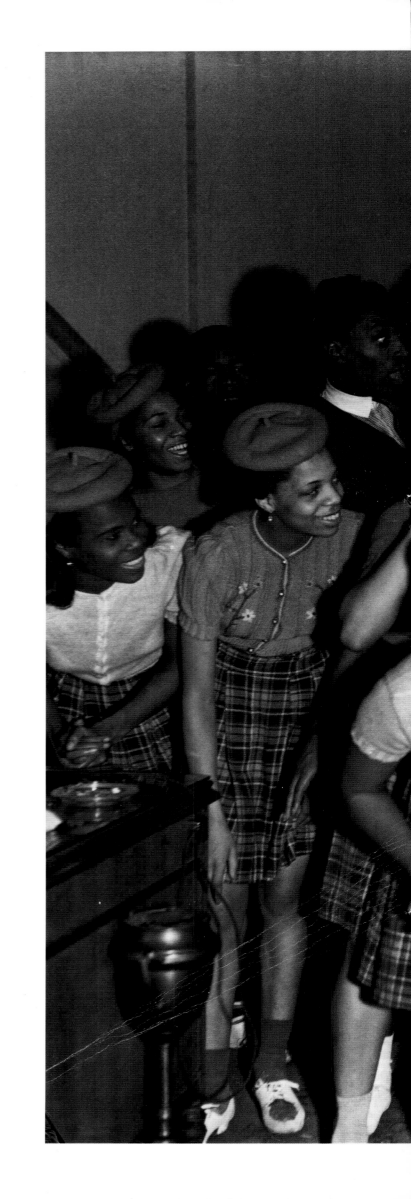

Brides and grooms kiss at a double wedding in Harlem.

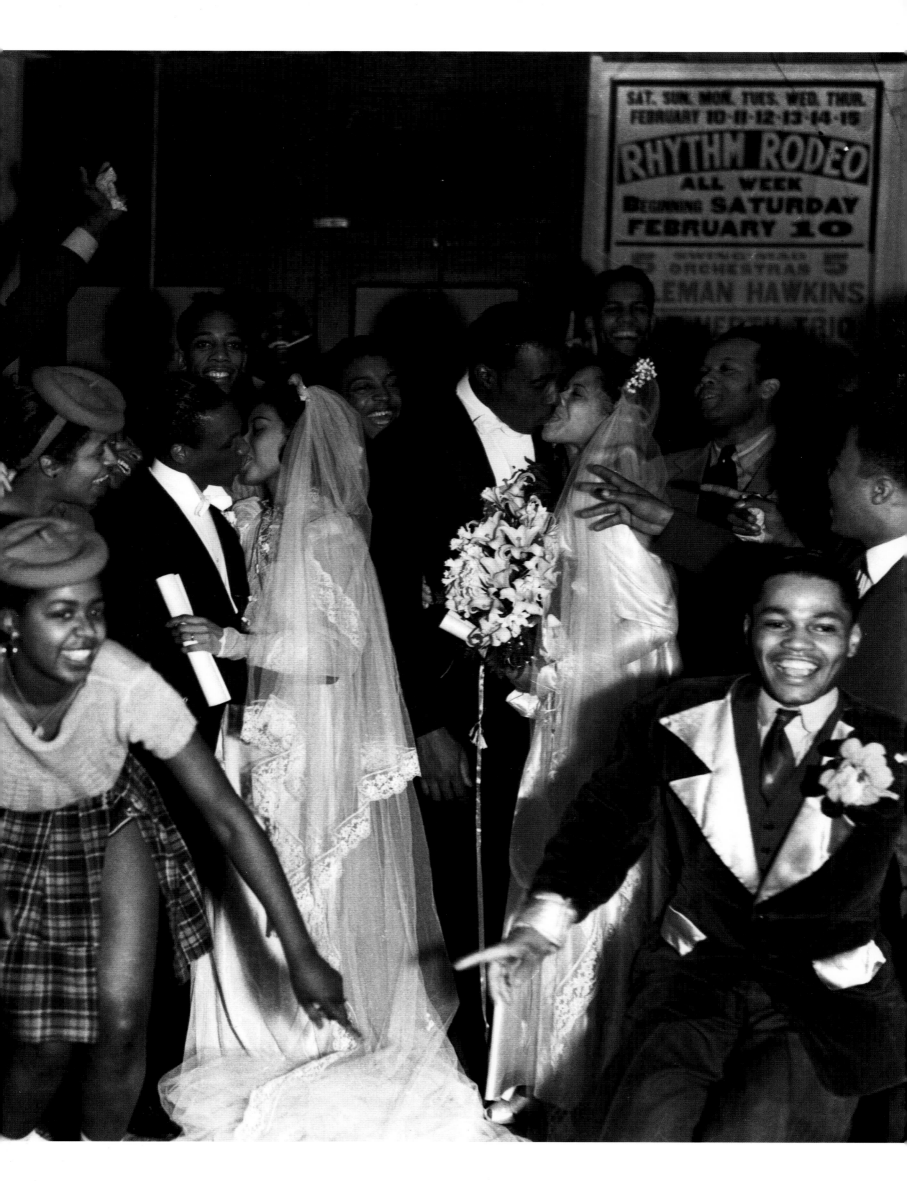

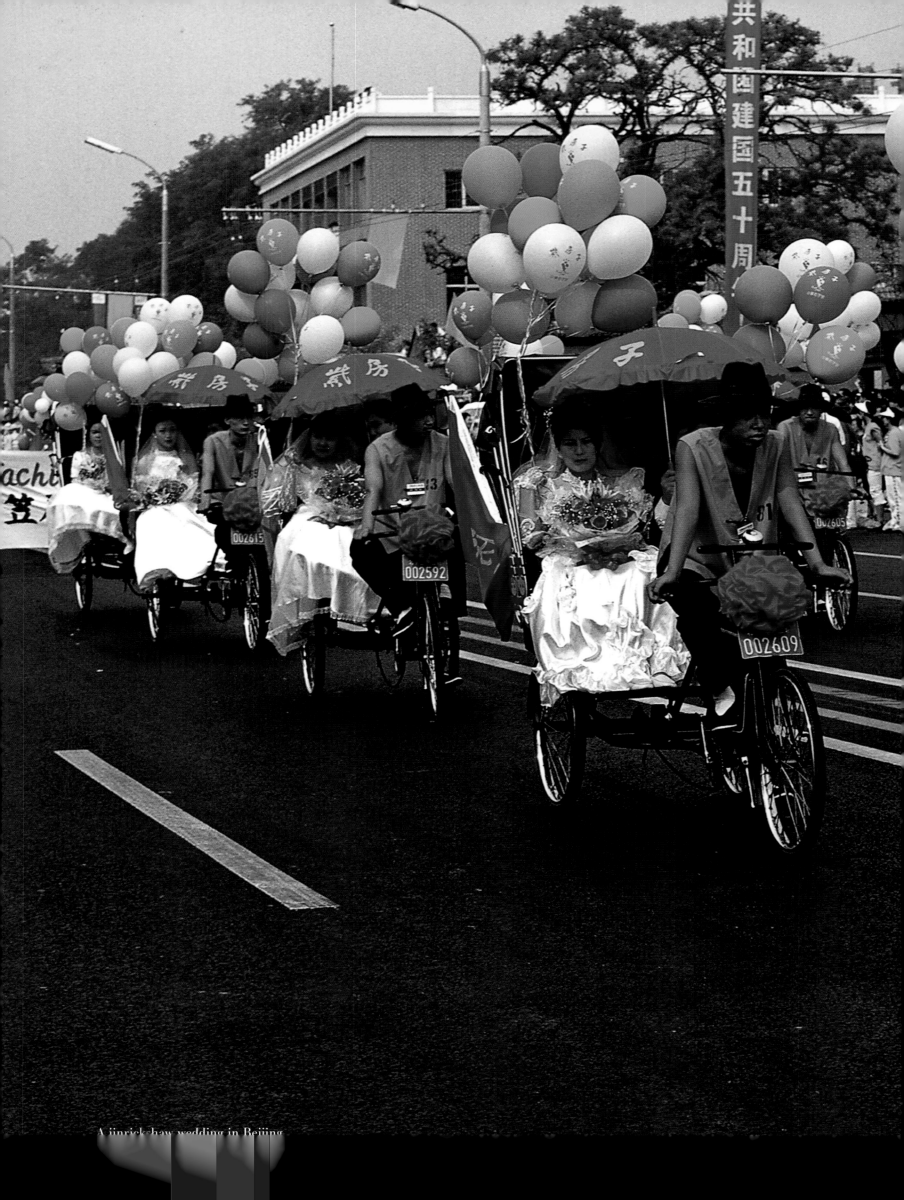

A jinrickshaw wedding in Beijing

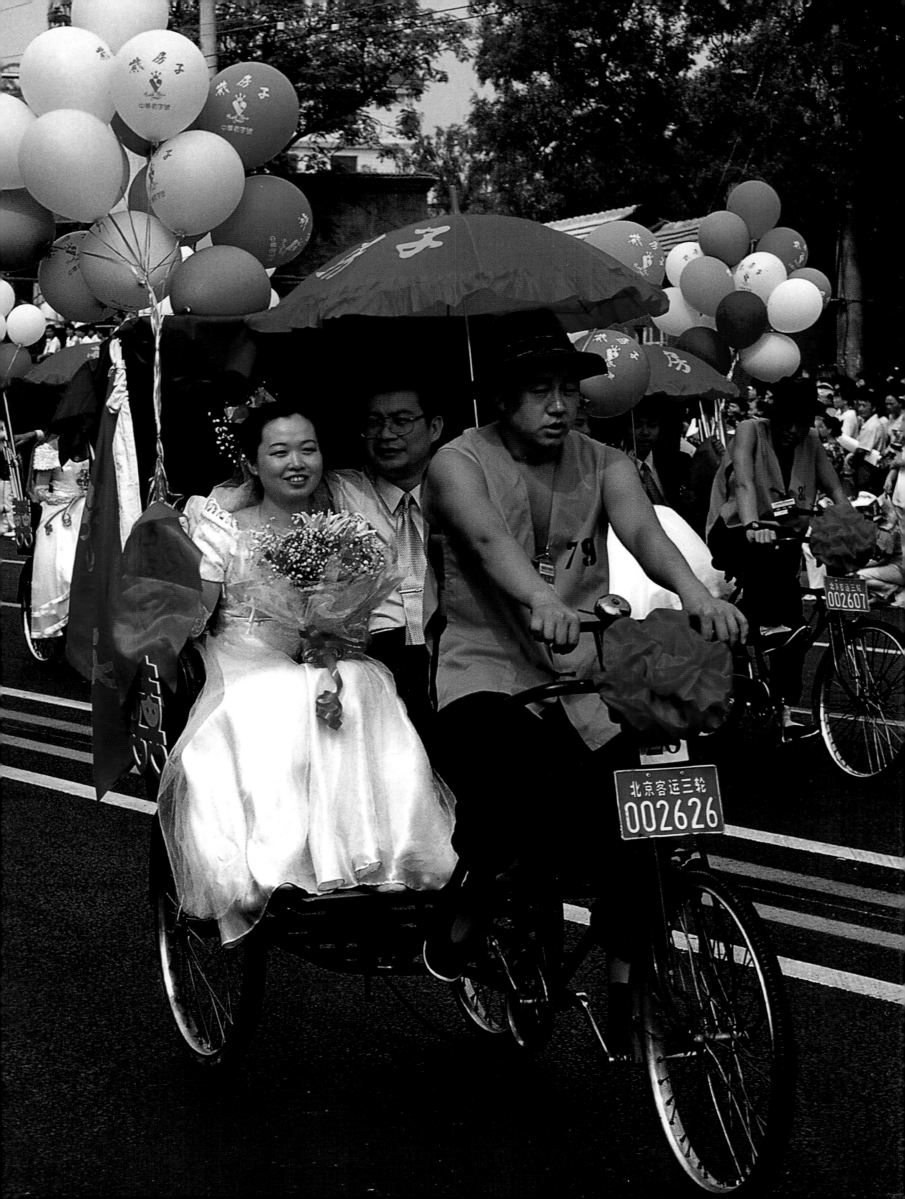

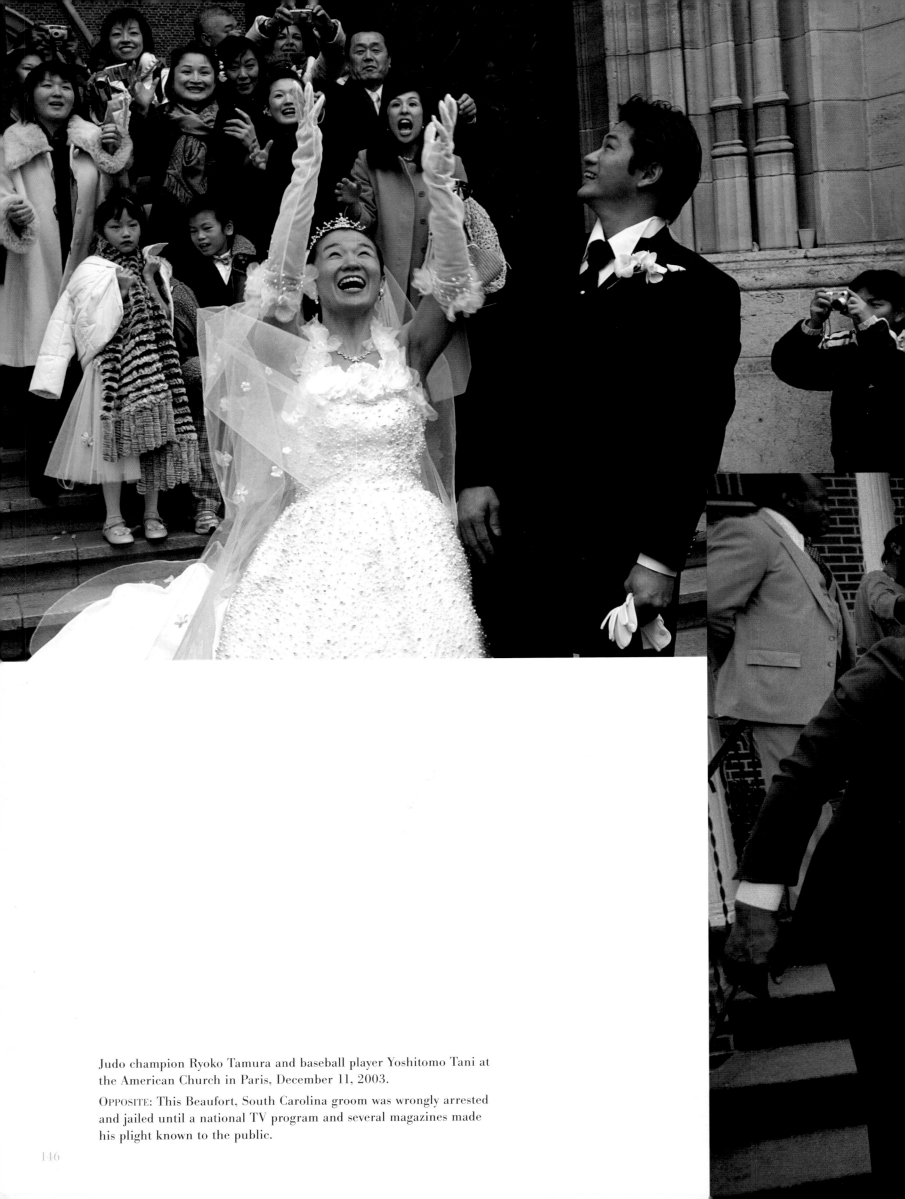

Judo champion Ryoko Tamura and baseball player Yoshitomo Tani at the American Church in Paris, December 11, 2003.

OPPOSITE: This Beaufort, South Carolina groom was wrongly arrested and jailed until a national TV program and several magazines made his plight known to the public.

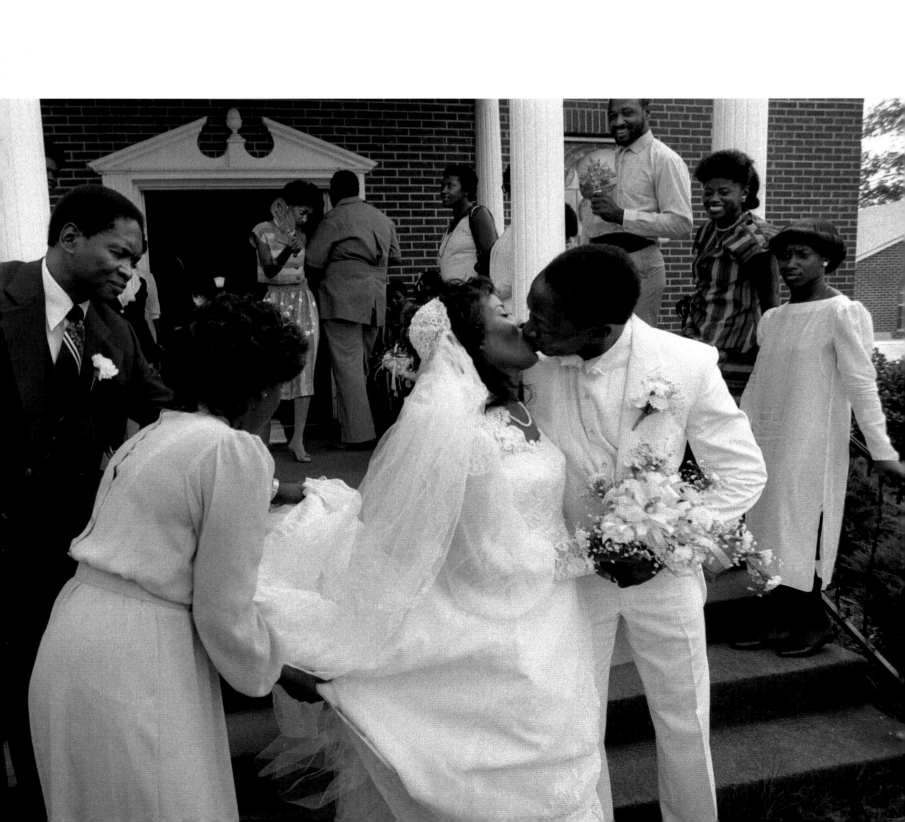

Jayne Mansfield and Mickey Hargitay following their wedding ceremony at the Wayfarer's Chapel, Palos Verdes, California, January 15, 1958.

Pictures are courtesy of the following individuals and collections:

4: © Bettmann/Corbis; 6-7: Erin Reed/LaCour; 8-9: Holger Thoss; 10-11: Johnson Lin/Associated Press; 12-13: Ellen von Unwerth/Art + Commerce; 14-15: © Louise Gubb/The Image Works; 16-17: Jodi Cobb/National Geographic Image Collection; 18: © Bettmann/Corbis; 19: Mirropix; 20-21: Fox Photos/Getty Images; 22-23: Marc Chagall © 2006 Artists Rights Society (ARS). New York/ADAGP, photo by Gérard Blot/Réunion des Musées Nationaux/Art Resource, NY; 24-25: Exio Petersen © Bettmann/Corbis; 26-27: © Wayne Scarberry/The Image Works; 28: Associated Press; 30: Hulton Archive/Getty Images; 31: © Burt Glinn/Magnum Photos; 32 (top): © Molly Thayer Collection/Magnum Photos; 32 (bottom left): *Marriage is a Private Affair* © 1933 MGM, courtesy of The Kobal Collection; 32 (bottom right): *It Happened One Night* © 1934, renewed 1962 Columbia Pictures Industries, Inc. All Rights Reserved. Courtesy of The Kobal Collection; 33: *Dancing Lady* ©1944 MGM, courtesy of The Kobal Collection; 34-35: George Hurrell/John Kobal Foundation/Getty Images; 36 (clockwise from top left): Eduardo Garcia Benito/*Vogue* © 1928 Condé Nast Publications, courtesy of The Advertising Archive, Mary Petty/*The New Yorker* © 1940 Condé Nast Publications; 37: Dick Winburn/*Time & Life Pictures*/Getty Images; 38 (top): Leonard McCombe/*Time & Life Pictures*/Getty Images; 38 (bottom left): AP Photo; 38 (bottom right): courtesy of The Advertising Archive; 39 (top left): Sasha/Getty Images; 39 (top right): *Harper's Junior Bazaar*; 39 (bottom): © Ferdinando Scianna/Magnum Photos; 40, 41: © France Keyser/In Visu/Corbis; 42-43: Nils Jorgensen/Rex USA; 45: John Chillingworth/Picture Post/Getty Images; 46: © Bettmann/Corbis; 47: Pamela Hanson/Art + Commerce; 48 (top left): © Hulton-Deutsch Collection/Corbis; 48 (bottom right): Tim Graham/Evening Standard/Getty Images; 49 (top left): Associated Press; 49 (bottom right): Central Press/Getty Images; 50, 51: © Pierre Vauthey/Corbis Sygma; 52: DMI/Getty Images; 53 (left): Michael Lipchitz/Associated Press; 53 (right): Michel Euler/Associated Press; 54: Lionel Cironneau/Associated Press; 55 (top left): Kathy Willens/Associated Press; 55 (top right): Udo Wetz/epa/Corbis; 55 (bottom left): © John Schults/Reuters/Corbis; 55 (bottom right): Stephane Cardinale/People Avenue/Corbis; 57: Alban Christ; 58-59: Danny Lehman/National Geographic Image Collection; 60 (clockwise from top left): Musa Sadulayev/Associated Press, Toshifumi Kitamura/AFP/Getty Images, © Bruno Barbey/Magnum Photos, Robert Patrick/Corbis Sygma, © Kojyo Tanaka/HAGA/The Image Works, Hideo Haga/HAGA/The Image Works; 61 (clockwise from top): © Guy Le Querrec/Magnum Photos, Thomas Wells/Northeast Mississippi Daily Journal/Associated Press, © Abbas/Magnum Photos, Keystone/Getty Images; 62-63: Ray Roberts/BIPs/Getty Images; 64: © Donovan Wylie/Magnum Photos; 65: © Thomas Hoepker/Magnum Photos; 66-67: James Van Der Zee; 68 (top): © Kerstin Geier/Gallo Images/Corbis; 68 (bottom): Scott Sady/Associated Press; 69 (top): © Lae Jae-Won/Reuters/Corbis; 69 (bottom): Michael S. Yamashita/Corbis; 70: © Bob Krist/Corbis; 71: Joanna B. Pinneo/National Geographic Image Collection; 72: © David Turnley/Corbis; 73: © Leonard Freed/Magnum Photos; 74-75: © Marc Riboud/Magnum Photos; 76 (top): Jon Raedle/Getty Images; 76 (bottom): © Abbas/Magnum Photos; 77 (top): © Patrick Zachmann/Magnum Photos; 77 (bottom): © Tim Page/Corbis; 78: © Abbas/Magnum Photos; 79 (top): © Philip Jones Griffiths/Magnum Photos; 79 (bottom): Vincent Yu/Associated Press; 80-81: Jodi Cobb/National Geographic Image Collection; 82-83: © Bruce Davidson/Magnum Photos; 84: James Van Der Zee; 85: Nat Farbman/Time & Life Pictures/Getty Images; 87: Pamela Hanson/Art + Commerce; 89: © Bettmann/Corbis; 90: Associated Press; 92-93: © Bettmann/Corbis; 94: © Tim Graham/Corbis; 95: AFP/Staff/Getty Images; 96 (top): Zandarin and Allen © Rex USA; 96 (bottom): Richard Young/Rex USA; 97 (top): David Hartley/Rex USA; 97 (bottom left): Evan Agostini/Getty Images; 97 (bottom right): Mikel Healey, Ho/Associated Press; 98-99: Central Press/Getty Images; 99 (far right): Associated Press; 100: Sydney O'Meara/Getty Images; 101: Associated Press; 102 (top row, from left to right): Rex Features, Co Rentmeester/Time & Life Pictures/Getty Images, © Thierry Orban/Corbis Sygma; 102 (bottom row, from left to right): © Bettmann/Corbis; 103: Kevin Carter/Associated Press; 104 (left): © Bettmann/Corbis; 104 (right): Neal Peters Collection; 105: © Bettmann/Corbis; 106: Lisa Larsen/Time & Life Pictures/Getty Images; 107 (bottom left): Denis Reggie; 107 (top right): Jim Bourg © Bettmann/Corbis; 108-109: © Bettmann/Corbis; 110 (top): Las Vegas News Bureau/Associated Press; 110 (bottom left): Pressens Bild-Ipol-Globe Photos, Inc.; 110 (bottom right): © 1993 Ken Regan/Camera 5; 111: Neal Peters Collection; 112-113: Associated Press; 114-115: © Bettmann/Corbis; 116-117: Embassy/Courtesy of Neal Peters Collection; 118-119: Roman Freulich/Paramount/Universal Pictures; 120: RDA/Getty Images; 121: *Funny Girl* © 1968, renewed 1996 Columbia Pictures Industries, Inc. All Rights Reserved. Courtesy of The Kobal Collection; 122-123: © Topham/The Image Works; 124-125: Craig T. Mathew/Associated Press; 126: © Vince Streano/Corbis; 127: Ed Bailey/Associated Press; 128-129: © Bettmann/Corbis; 130: © Henri Cartier-Bresson/Magnum Photos; 131: © Bettmann/Corbis; 132 (top): Dmitry Lovetsky/Associated Press; 132 (bottom): Phelan M. Ebenhack/Associated Press; 133: Toru Yamanaka/AFP/Getty Images; 134: © Elliott Erwitt/Magnum Photos; 135: Les Lee/Express/Getty Images; 136-137: Eddie Shih/Associated Press; 139: © Jean Gaumy/Magnum Photos; 140-141: Jim Richardson/National Geographic Image Collection; 142-143: © Bettmann/Corbis; 144-145: © Jia Dequan/Panorama/The Image Works; 146: Michael Euler/Associated Press; 147: © Eli Reed/Magnum Photos; 148-149: © Bettmann/Corbis

Special thanks to each of the photographers for their creative input. It was a privilege to work with such beautiful images.

Additionally, this book would not have been possible without the help of the following: Kim Apley and the scanning department/Corbis, Yaelle Pazzy and Jennifer Newman/Getty Images, Yvette Reyes, Kimberly D. Waldman, and Serena/Associated Press, Michael Shulman, Matt Murphy and the scanning department/Magnum Photos Inc., Mark Antman and Lorraine Goonan/The Image Works, Inc., Ashley M. Morton, Paula J.J. Washington and Joergen Birman/National Geographic Image Collection, Ricky Byrd/The Kobal Collection, Neal Peters/The Neal Peters Collection, Chuck Musse/Rex USA, Jessica Marx/Art + Commerce, Donna M. Van Der Zee/Estate of James Van Der Zee, Virginia Shannon and Karin S. Kato/*Harper's Bazaar*, Suzanne Viner and Ceri James/The Advertising Archives, Andy Howick/MPTV, Holger Thoss and Jen Yuson, Alban Christ, Rachel LaCour Niesen/ LaCour Photography, Danny and Laurie Lehman, Claire Fortune/Condé Nast Publications, Inc., Monique Diaz/Sony Pictures Entertainment, Julie Heath/Warner Bros. Entertainment Inc., Melissa M. Bugg and Steve Lasley/Denis Reggie Photographers, Cristin O'Keefe Aptowicz/Artists Rights Society, Jennifer Belt and Gerhard Gruitrooy/Art Resource, Regina Feiler/LIFE Branded Products, Brandon Andrusic/Aurora Photos, Richard G. Winburn & Charles Winburn/Estate of Dick Winburn, Mary Beth Whelan and Victor Maldonado/Globe Photos, Ken Reagan/Camera 5, Lisa Rayman and Rachel Samuels/Mirrorpix, Tiffany Palmeri/The Coca-Cola Company. Marvin Heiferman—thank you for your research assistance, dedication, and advice.

Finally, thanks to Alice Harris and Craig Cohen for the opportunity to work on this project and for setting such high standards, and to Yuko Uchikawa, for her faithfulness in presenting the images and for making intercontinental production so effortless.

—Sarina N. Finkelstein

For my husband, Stanley. Happily ever after does exist and it happened with you! Thank you for the man you are, my prince charming and best friend. I am grateful for my very blessed life with you and I love you with every breath I take! Oh...and by the way, you get the Oscar for living with me!

For my daughter, Samantha. Your love, support, and great sense of humor are a joy to me. You are so beautiful and have such fabulous style and will one day bring it all to your own wedding! I love you so very much!

For my Mom and Dad. A life well lived for 64 years together!
I love you and I miss you!

For Donna Summer Sudano. You are a rare and divine woman and I am blessed and grateful to call you my sister and my best friend!

For Bruce Charles Sudano. What a journey we have been on! I am blessed to have you as my friend and your support has been invaluable. I love you guys!

For the master professionals who have walked me down the aisle.

powerHouse Books: Craig Cohen, for your tremendous support on my projects.
Sara Rosen, you are terrific.

Alyce Alston, Hamida Belkadi, Desiree Charles, and Joan Parker of DeBeers: Your support has been amazing and enthusiastic. You are my precious gems!

Yuko Uchikawa, you are an amazing designer who has made this book chic, elegant, and in vogue!

Sarina Finkelstein, you assembled a photographic celebration!

Sara, thank you for your wedded words of Bliss!

With special thanks and love to Alison Brod, ABPR, Pamela Robinson Hollander, and Elycia Rubin Kaplan.

For the artists who keep my act together! Alain Pinon, Kao Hui, Susanna Romano, Mika Rummo, Rosemarie D'Antoni, Zhen Lin, J.Anthony, Gina Colaluca, Cara Lamberg, Alexis Mc Grath, and Boaz Aharoni.

Kristine Schueler and David Everard, thank you for your incredible collage: "Alice's Adventures in Weddingland!"

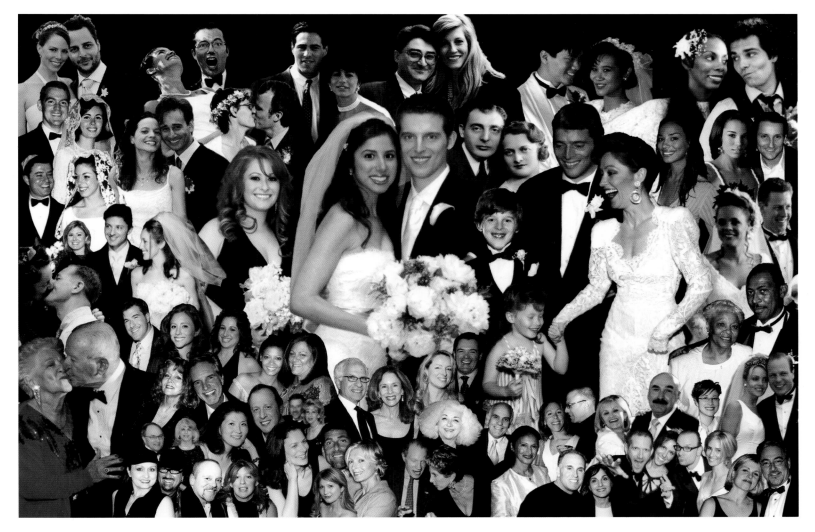

THE WEDDING ALBUM
© 2006 powerHouse Cultural Entertainment, Inc.
Text © 2006 Sara Bliss

Published in the United States by powerHouse Books,
a division of powerHouse Cultural Entertainment, Inc.
37 Main Street, Brooklyn, NY 11201-1201
telephone 212.604.9074, fax 212.366.5247
e-mail: info@powerHouseBooks.com
website: www.powerHouseBooks.com

First edition, 2006

Library of Congress Cataloging-in-Publication Data:

Harris, Alice.
 The wedding album / by Alica Harris ; text by Sara Bliss.
 p. cm.
 ISBN 1-57687-209-2
 1. Weddings--Pictorial works. 2. Weddings--History--Pictorial works. 3. Weddings--
 Cross-cultural studies--Pictorial works. 4. Celebrity weddings--Pictorial works. I.
 Bliss, Sara. II. Title.

GT2665.H37 206
395.2'20222--dc2

 2006047609

Hardcover ISBN 1-57687-209-2

Separations, printing, and binding by Pimlico Book International, Hong Kong

Art direction and design by Yuko Uchikawa

A complete catalog of powerHouse Books and Limited Editions is available upon
request; please call, write, or engage with our website.

10 9 8 7 6 5 4 3 2 1

Printed and bound in China